Prospecting Ocean

© 2019 the artists, the authors, the photographers, and TBA21–Academy.
All rights reserved. No part of this book may be reproduced in any form by any electronic or mechanical means (including photocopying, recording, or information storage and retrieval) without permission in writing from the publisher.

Library of Congress Control Number: 2019935753

ISBN 978-0-262-04327-4

10 9 8 7 6 5 4 3 2 1

TBA21–Academy

The MIT Press,
Cambridge, Massachusetts,
and London, England

Prospecting Ocean
Stefanie Hessler

Table of Contents

7 Preface: Is the Common Heritage of Humankind a Mining Code?
Markus Reymann

11 Foreword
Bruno Latour

15 Exhibition views of "Prospecting Ocean"

21 Prospecting Ocean
Stefanie Hessler

23 Who Has Known the Ocean?
 Climate Change, Representation, and Art
 How *Prospecting Ocean* Came into Being
 The Ocean Spaces in this Book
 Seabed Mining in Armin Linke's "Prospecting Ocean"

39 The Unevenly Distributed Oceanic Anthropocene
 Noticing the Uncertain Future of Deep-Sea Mining and Other Extractivisms
 A Condensed Modern History of Distance

49 *Visual Essay "Prospecting Ocean"*
Armin Linke
 Extractive Disembeddings

65 Oceanic Representations
 Mapping the Remote
 Viewing the Oceans
 Technologized Distance and Patterns of Vision
 Perspective in Art and Science
 Notions of the Sublime
 Visions of Earth from Afar

85 *Visual Essay "Science, Law, Policy, and Protest"*
Armin Linke
 Optical Consistency
 Mediated Reality
 Virtual Immersive Oceans
 Partial Perspectives

113 The Collapse of Distance
 Planetary Sensing and Cinematic Oceans
 The Pluripresence of Uneven Flows
 Leviathan, or Sensing the Oceans

129 The Ocean as Place and Space
 Smooth and Striated Ocean Spaces through Time
 Oceanic Heterotopias
 Water Like Land and Land Like Water
 Relational Oceans
 Place Making and Conflicts in the Seabed

145 *Visual Essay "Historical and Current Views of the Deep"*
Armin Linke

161 Technologies of the Deep
 Capsized Proportions
 Rendering the Mining Zone
 The Politics of Ocean Images

175 Watery (Dis)Solutions
 Connective Oceanic Distances

181 *Visual Essay "Maps, Models, and Representations"*
Armin Linke
 New and Old Frontiers in Deep-Sea Extractivism
 The Nuclear Past and Present of the Radioactive
 Ocean in French Polynesia
 Spills Beyond Space and Time
 Meaning Making Among Dissolving Causalities
 Knowledge and Appropriation

213 Material-Discursive Oceans
 Seawater
 Embodied-Material Techniques
 The Seabed as an Architectural Complex
 Aquatic Bodies that Matter
 Swimming with Matter
 Transcorporeal Sea
 The New Ocean Frontier Is Closing In
 Swim On

239 Colophon

At the time of writing, in the summer of 2019, Greta Thunberg is drawing worldwide attention by mobilizing huge numbers of students around the world demanding more decisive climate action from the political elites. Standing in front of the Houses of Parliament in London last year, she addressed the "declaration of rebellion" written by the organization Extinction Rebellion, established in May 2018, which calls for a new international nonviolent revolt to protest the looming climate breakdown.

Preface: Is the Common Heritage of Humankind a Mining Code?
Markus Reymann
Director, TBA21–Academy

The event followed a previous action, in which they parked a boat named after Polly Higgins, the Scottish lawyer who lobbied to recognize ecocide as an international crime, in front of the London court, reminding the world of the necessity of protecting nature through criminal justice. Against this background, a United Nations agency, the International Seabed Authority (ISA), is actively progressing the opening of a new frontier for exploitation of the ocean. The agency's Secretary-General Michael W. Lodge, along with the government of Nauru and the Secretariat of the Pacific Community, appear willing to sacrifice their official mandates and duties of care for global, regional, and national citizenry and the marine environments we all depend on, seemingly abandoning them in favor of a financially, socially, and environmentally dangerous industry: deep-sea mining.

These extraction operations, sanctioned by a small group of bureaucrats and members of the mining community, will be conducted on the ocean floor using monstrously heavy machinery which will dredge up the soft sediment in the deep sea. The goal is to extract prospectively precious manganese nodules, which take hundreds of millions of years to form, from an ecosystem we know hardly anything about. Deep in the Pacific, far from the public eye, rare earths and precious metals are allocated to be mined. The justification provided by the ISA for giving permission to these operations is, ironically, that these desired minerals will drive the green energy revolution and help humans achieve the climate goals we set ourselves in the Paris Agreement.

The remoteness of the operation and the promise that it would make the world a better place remind me too much of the hundreds of nuclear tests conducted in the Pacific in the second half of the twentieth century. The invisibility of the extraction process and the temporality of its effects recall the unseen yet immensely harmful properties of pesticides that Rachel Carson describes in her book *Silent Spring* (1962), which sparked widespread debate, followed by structural change. Her writing made us aware of a problem, then prompted change. One mandate of the arts is to make the invisible visible and provide society with a mirror allowing us to position ourselves in time but also question these times, circumstances, and systems.

The journey to *Prospecting Ocean* began years ago, when I read a Facebook post on Dr. Sylvia Earle's page,

Mission Blue, about the Clarion-Clipperton Zone and the International Seabed Authority, housed in Kingston, Jamaica. TBA21–Academy has already been collaborating at that point with the University of the West Indies on the analysis of a stretch of coastline in East Portland, Jamaica. We were planning to host a program titled Convening #1: The Kula Ring, a Gifting Economy (which took place in March 2016), as part of our newly established fellowship program The Current, led at the time by Ute Meta Bauer in Jamaica. Convenings are organized six months following the conclusion of an expedition aboard the research vessel *Dardanella* in order to elaborate on the questions and findings which emerged during the voyage with a wide circle of experts of different backgrounds and knowledge system and in front of an audience.

Armin Linke, whose artistic practice has involved a thorough investigation of the bureaucratic administration of nature, was a participant in the first expedition to Papua New Guinea in October 2015. For his work, we reached out to friends, colleagues, and collaborators to see if we could get access to the ISA. Linke then spent two days conducting interviews with the agency, which eventually led to us applying for and receiving observer status at the ISA, but also to TBA21–Academy's decision to embark on its first long-term artistic research commission. It was the beginning of a three-year journey with Linke through scientific organizations, UN conferences, meetings of the international law association dealing with sea level rise, and finally, a return to Papua New Guinea, where there was fierce civil revolt against the first deep-sea mining site in national waters. This extensive research culminated in a two-channel video installation, another, multi-channel, video installation made up of sourced footage, and eleven photographs. These were shown in "Prospecting Ocean," in the former laboratories and offices of the Istituto di Scienze Marine (CNR-ISMAR) in Venice in 2018, the exhibition that preceded and brought about this book. The show became exemplary for our organization's collaborative modus operandi: Linke worked closely with curator Stefanie Hessler, the architects Kuehn Malvezzi, the graphic designer Linda van Deursen, and several scientists in Venice and researchers in Cambridge, Massachusetts.

The artistic investigation of deep-sea mining in collaboration with Linke has become foundational for the practice of TBA21–Academy, working across the formats of

expeditions and Convenings, voyaging and sharing over an expanded period for immersion and research. The idea behind this way of working is to collaboratively sense and probe the conditions, relationships, and entanglements around an ocean-related topic like deep-sea mining, and establishing networks of contributing experts. The process led to our involvement in the ISA and is an example of another characteristic of TBA21–Academy's practice—methodically inscribing ourselves in frameworks and arenas outside of art, commenting on the contexts of our inquiries by entering them on an organizational level.

In the past forty years, we have mandated scientists to moderate and mediate climate change and its effects on the planet, and they have done as much as possible in terms of research, publishing papers and consulting on policy to raise awareness. Maybe it's time for members of communities that are not tied to scientific values like neutrality and impartiality to bring forth a critical, affective, and experiential discourse and add to the knowledge that we already have, ensuring that the common heritage of humankind is not made manifest through a mining code. *Prospecting Ocean* is an example of the possibilities of art to make entanglements visible, draw our attention to an otherwise maybe intentionally removed topic, and perhaps incite change.

I am incredibly thankful for the support Francesca Thyssen-Bornemisza has given to the work and the organization, for fostering these ambitious projects, and for allowing us to break new ground. My thanks go to Stefanie Hessler for realizing Linke's commission and exhibition, and for writing this important book. Finally, I am immensely grateful to Armin Linke for his extreme generosity and close collaboration in realizing "Prospecting Ocean."

The oceans are a key topic of what I call the New Climatic Regime. They cover two thirds of the planet, and provide half of its oxygen. They absorb the heat of the sun, transfer it to the atmosphere, redistribute it to the continents, and by this process help to regulate atmospheric temperatures. They are key to the Earth system and therefore an integral part of our conditions of existence ("our" referring here to a myriad of humans and nonhumans).

Foreword
Bruno Latour

One could argue that by describing them as part of our environment, the very notion of "environment" implies a form of passivity, of set objects near one another. But the oceans are far from passive. They are one of the main actors of the active system which allows life to prosper on Earth.

Among exploding inequalities, as elites realize the absence of a common world, they are increasingly taking flight. And so, turning our eyes downward, to this planet, is crucial. In the New Climatic Regime, we need to consider geo-social dynamics and turn toward the Earth with its land and oceans, rather than the global or the national. Armin Linke's exhibition "Prospecting Ocean" at the Institute of Marine Sciences (CNR-ISMAR) in Venice in 2018, commissioned by TBA21–Academy and curated by Stefanie Hessler, and the book you are reading, which is an extension and deepening of the topics the exhibition approached, do precisely that.

With these issues in mind, both the exhibition and this book track the networked set of actors that constitute the legal, scientific, and economic infrastructure of the oceans. In his practice, Linke enters places which are hard to access and conducts interviews which we otherwise rarely hear. Perhaps the most captivating image in the work, which Hessler also discusses, is that of the remote-controlled underwater vehicle whose arms collect samples from a depth of some 5000 meters for research as well as for soil exploration for various industries. The choreography led by these arms of iron in the depths of the ocean remains striking as it stirs up sediments. It is symbolic of the tools with which humans map and alter the Earth.

When I first encountered Linke's work, I was immediately convinced that the domain of science and technology studies had found one of "its" photographers just as it had found in Richard Powers "its" novelist. Linke's work became even more important when he started to document the exhibition series the "Anthropocene Project" at the Haus der Kulturen der Welt, in Berlin, in 2013–14 which, even though it started in stratigraphy, Linke immediately seized as a major artistic project. It is in this context that I encountered the research project *Prospecting Ocean*, which is simultaneously a sociological observation of scientists at work and an extraordinary monument to the Anthropocene in the ocean.

In 2016, Linke visited Sciences Po in Paris several times to interview me in his usual manner, bringing archives from

his latest investigations and letting the interviewee unwrap the reading and interpretation that arose when viewing the archived scenes. After one of these sessions, as he was pointing Linke toward the closest metro, curator Martin Guinard asked him a fairly genuine question: "What makes an interesting picture?" Linke, about to go into the metro, answered in a relaxed manner: "My pictures don't need to be interesting, the world is interesting enough."

Of course, when we see the mastery with which Linke realizes his exhibitions, we should not be fooled by this. In the context of "Prospecting Ocean," every detail was thought through with care. The prints were embedded in white-painted wood blocks that allowed a simple dialogue with the space while ensuring a certain presence of the photographs. The wall labels, with texts by the curator and marine scientists from the CNR-ISMAR, carefully affixed onto the sides of the wooden plinths, made it possible for viewers to make their way through the investigation without disturbing the observation of the visuals. And, of course, the photographs were imposing, especially because of their format and their presentation in angular displays, which in a way gave them the pictorial aspect of a tableau.

These archives are reminiscent of the "Anthropocene Observatory," a collaborative project in four phases between Linke, Territorial Agency (John Palmesino and Ann-Sofi Rönnskog), and Anselm Franke. The third episode, *Down to Earth*, documented the Superdeep Borehole, drilled 12 kilometers into the Kola Peninsula, at a time when the USSR tried simultaneously to go as far as possible in space as well as into the Earth crust. Today only the ruins of this experiment remain. What these works have in common is the systematic way in which Linke investigates explorations related to the New Climatic Regime over the past ten years. But it is also his interest in the depths, whether those of the land, the ocean, or a network: an earthbound exploration rather than a celestial one.

The cosmological turmoil in which we are plunged in the Anthropocene reminds us of the situation in which Galileo found himself in the seventeenth century. His contemporaries had to absorb the shock that the Earth was not where they thought it was, just as we have to absorb the news that the land and oceans govern our actions, when we thought they were indifferent.

In this context, what tools should we develop in order to accurately capture the unprecedented situation in which we find ourselves? In their book *Terra Forma, Manuel de cartographies potentielles* (Terra Forma, a Manual of Potential Cartographies, 2019), Frédérique Aït-Touati, Alexandra Arènes, and Axelle Grégoire offer an exciting alternative mapping of these issues. The authors discuss how, unlike Galileo, who turned his lens to the moon, they turn their eyes toward the ground to observe it in this new context and restore to the landscape the life taken from it by classical mapping. This is also what the book you are reading does, by turning its perspective toward the spaces disrupted by human activity. *Prospecting Ocean*, which emerges from the exhibition in Venice and expands on the topics it studied by looking at various disciplines and their engagement with the ocean and its socio-political histories, dives deep into the waters of the Earth. In showing how we both affect the planet and are in turn affected by it, Hessler proposes that we look downward. She suggests that tuning into the oceans by way of artistic research is a political endeavor that may help us devise new ways of inhabiting the Earth.

15 Installation views of Armin Linke's exhibition "Prospecting Ocean," CNR-ISMAR, Venice, 2018. Curated by Stefanie Hessler, commissioned and produced by TBA21–Academy. Photos in this section by Giulia Bruno.

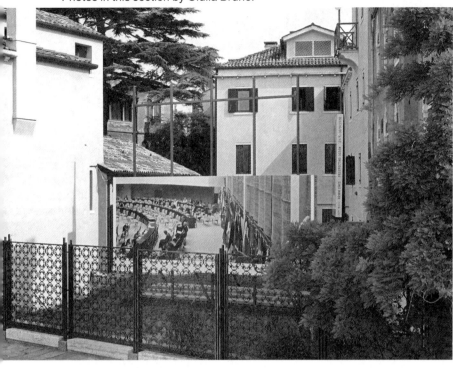

Entrance to the exhibition.

16 Room 00, view of the main film in the *Prospecting Ocean* project.

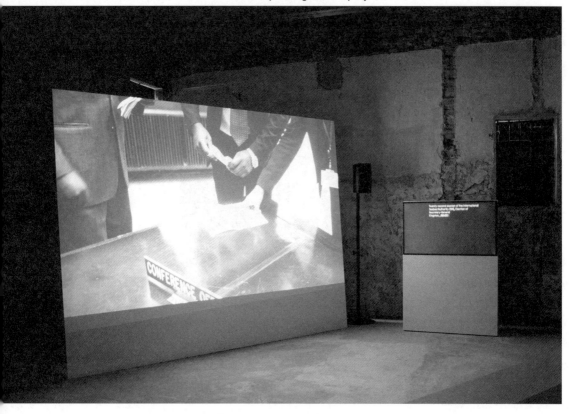

Room 02, typography animations by Mevis & van Deursen of extracts from the United Nations Convention on the Law of the Sea, exhibition architecture by Kuehn Malvezzi.

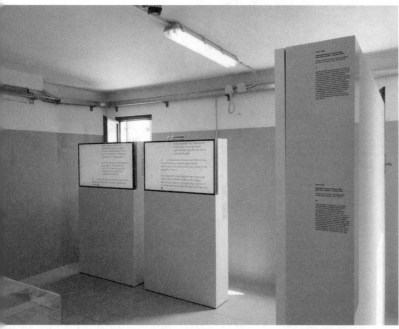

Room 02, Armin Linke, *International Seabed Authority ISA, legal office, Kingston, Jamaica*, 2016, and vitrine with United Nations Convention on the Law of the Sea materials.

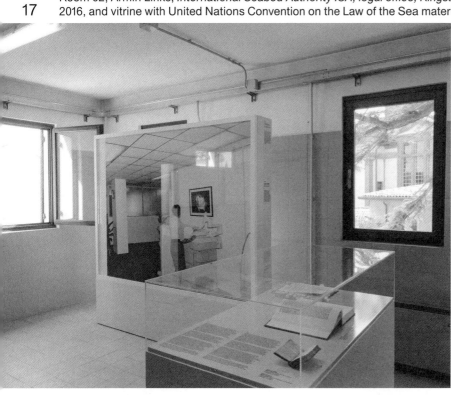

Room 03, genome archive at the Massachusetts Institute of Technology and video from the International Tribunal for the Law of the Sea in Hamburg.

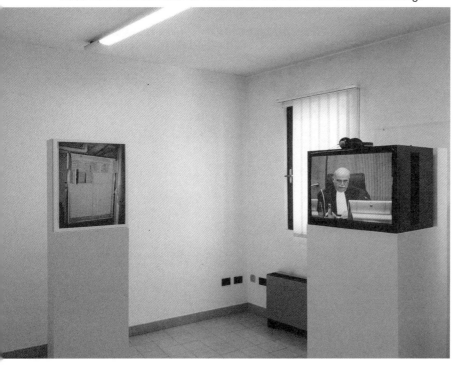

Room 04, Armin Linke, *MARUM, International Ocean Discovery Program (IODP) and Integrated Ocean Drilling Program (IODP), seabed core deposit, Bremen, Germany*, 2017, and drilling sample from CNR-ISMAR.

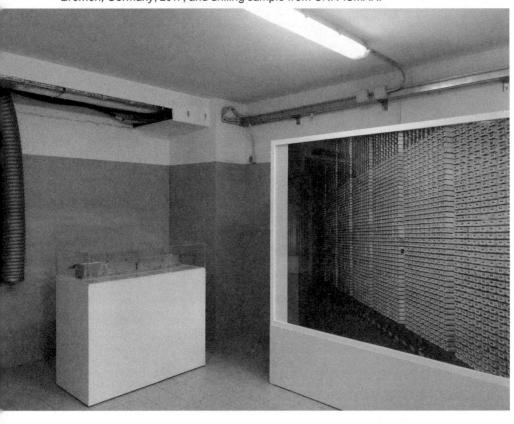

Room 04, underwater photographs and books on bathymetric oceanic explorations.

Room 10, Armin Linke, *International Seabed Authority ISA, manganese nodule, Kingston, Jamaica*, 2016.

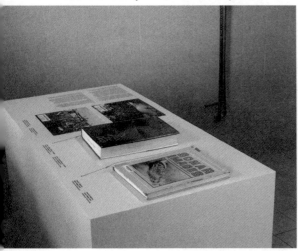

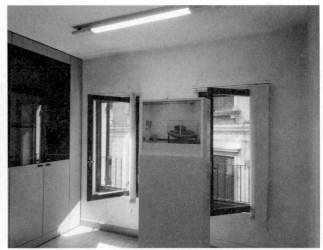

Room 07, Armin Linke, *OCEANS. Dialogues between ocean floor and water column*, 2017. © Video Archive Material GEOMAR Helmholtz Centre for Ocean Research Kiel and MARUM – Center for Marine Environmental Sciences, University of Bremen. © ROV KIEL 6000 (video stills).

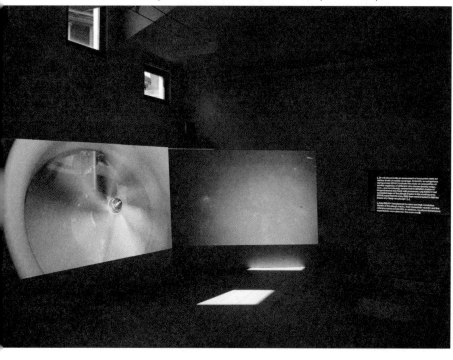

Room 08, archival materials selected together with scientists at CNR-ISMAR.

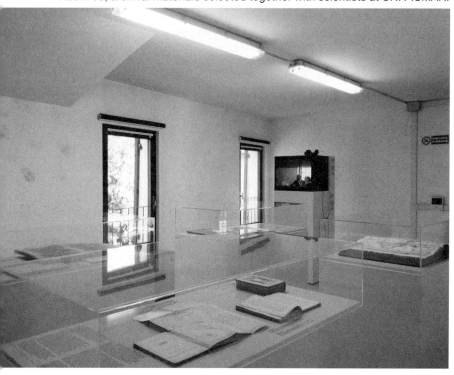

Room 09, Armin Linke, *Protest against deep-sea mining project in the Bismarck Sea, Karkar Island, Papua New Guinea*, 2017.

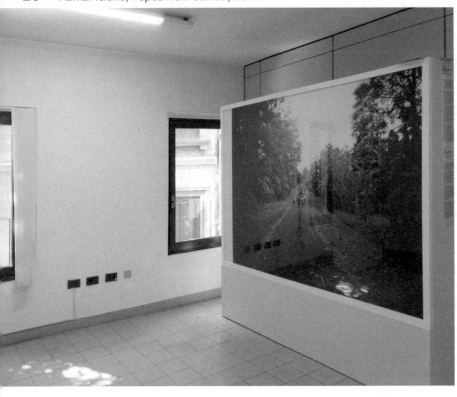

Room 11, lecture room with recorded talks by marine biologists, lawyers, policymakers, and other experts.

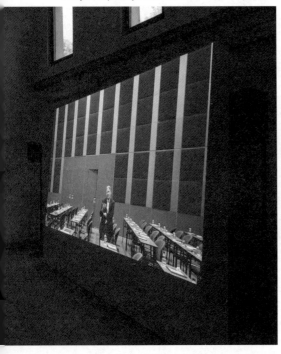
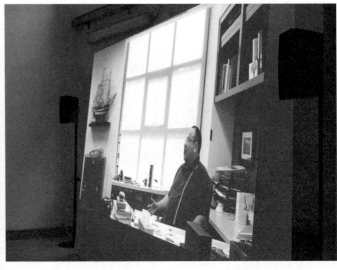

Prospecting Ocean
Stefanie Hessler

"Who has known the ocean? Neither you nor I, with our earth-bound senses, know the foam and surge of the tide that beats over the crab hiding under the seaweed of his tide-pool home; or the lilt of the long, slow swells of mid-ocean, where shoals of wandering fish prey and are preyed upon, and the dolphin breaks the waves to breathe the upper atmosphere."[1]

Who Has Known the Ocean?

[1] Rachel Carson, "Undersea," *The Atlantic*, vol. 160, no. 3 (September 1937): 55–67.

[2] Leah Maree Gibbs and Andrew T. Warren, "Transforming Shark Hazard Policy: Learning from ocean-users and shark encounter in Western Australia," *Marine Policy*, vol. 58 (August 2015): 116–124.

I've been drawn to marine biologist Rachel Carson's words ever since I first encountered them. They are an offer to take readers on a journey into the depths of the waters she describes. Her literary voyage to the seafloor viscerally brings to life what usually remains hidden beneath the ocean's reflective surface. She takes readers with her as she evokes how sunlight decreases the further she dives, how the pressure on her body increases, and how she encounters ever more otherworldly creatures as she sinks under. Beyond its literary ardor, her writing is also faithful to the scientific world. In bright language, Carson brings the hidden subaquatic worlds closer to readers—vividly, attentively.

Who has known the ocean? Carson thought that none of her earth-bound, human readers could ever fully grasp it. And still, attempts to know it prevail, from colonial expeditions to ongoing endeavors to chart and map the ocean, and up to sonar beam soundings meant to sense the bathymetry of the ocean floor. Contrary to Western scientific efforts to "know" the oceans, people living on or near them may consider knowledge very differently. Knowing could mean being familiar with the ocean's scent or reading information in the ever-changing patterns of the waves. Epistemologies rooted in intimate engagement with the ocean—by "ocean-users,"[2] as geographers Leah Maree Gibbs and Andrew T. Warren refer to fishermen, swimmers, and surfers, from Western and non-Western contexts alike—are often disregarded by the sciences emanating from the Global North. And so are the perspectives of more-than-humans with their nonhuman sensorial apparatuses. Yet, as feminist theorist Karen Barad asserts, we can't separate knowing and being: "We do not obtain knowledge by standing outside of the world; we know because 'we' are *of* the world."[3]

In this book, I unpack how modernist efforts of knowing are linked to extractive-destructive utility, from territorial expansionism to industrial-scale exploitation of aquatic life.

3 Karen Barad, "Posthumanist Performativity: Toward an Understanding of How Matter Comes to Matter," *Signs: Journal of Women in Culture and Society*, vol. 28, no. 3 (Spring 2003): 829.

4 Conversation with Autumn Brown from the communications department of Woods Hole Oceanographic Institution, May 23, 2019.

5 Donna J. Haraway, *Modest Witness@Second Millennium.FemaleMan Meets OncoMouse: Feminism and Technoscience* (London: Routledge, 1997), 24.

6 Astrida Neimanis, "Water and Knowledge," Dorothy Christian and Rita Wong, ed., *downstream: reimagining water* (Waterloo: Wilfrid Laurier University Press, 2017), 58.

Seeking to account for the complexity of the topic of the oceans, and in particular the deep sea, I add additional questions to Carson's query. I ask *how* have we known the oceans? *Why* have we known or attempted to know them? And what are the consequences of such knowledge, however partial it may be?

Despite manifold attempts to know the ocean, it remains largely unexplored by "modern" science. At the prestigious Woods Hole Oceanographic Institution in Massachusetts, scientists discover numerous previously unknown species on each dive in the twilight zone, between 200 and 1000 meters below the surface.[4] Yet, in research institutes as well as the popular imaginary in the Global North, science remains the paradigmatic realm through which knowledge is primarily created. Within the paradigm of science, knowledge is deemed grounded in empirical facts and thus valuable. This is a necessarily limited view, based on systems that have racialized and gendered histories, which they tend to reaffirm rather than radically undo. While we do need sciences, today perhaps more than ever, in this book I argue for the necessity of interdisciplinary work and the indispensability of multiple ways of knowing, in which science is demythologized and the scientist ceases to be the "authorized ventriloquist for the object world."[5] As gender and cultural studies scholar Astrida Neimanis suggests, rather than see the world as a place revealing itself to us, we may think of it through water, which eludes being known in its entirety. Thinking with water may be a way to "imagine and cultivate a much-needed *epistemology of unknowability*."[6]

At a time of ecological urgency such as the first quarter of the twenty-first century, disciplinary limitations are not only shortsighted, but dangerous. Our future hinges on the

7 Rebecca Solnit, "Are We Missing the Big Picture on Climate Change?," *New York Times* (December 2, 2014). https://www.nytimes.com/2014/12/07/magazine/are-we-missing-the-big-picture-on-climate-change.html.

8 The term was first introduced by Eugene F. Stoermer, with Paul J. Crutzen contributing to its wider use: "I began using the term 'anthropocene' in the 1980s, but never formalized it until Paul contacted me," Eugene F. Stoermer quoted in Jacques Grinevald, *La Biosphère de l'Anthropocène: climat et pétrole, la double menace* (Geneva: Georg/Editions Médecine and Hygiène repères transdisciplinaires, 2007), 243.

ocean as cooler of the atmosphere, surface for transportation, provider of food, and increasingly also microbial molecules used in medicine. Besides these utilitarian purposes, we may also think of the ocean's spiritual and cultural value. Many cosmologies in the Pacific refer to specific sandbanks or rock formations caressed by the waves. Numerous Icelandic sagas are imbued with intimate knowledge of the sea. The time ahead turns on how we treat the oceans, how we conceive of them, how we know them.

 In this book, I riff on the modernist history of attempts to know the oceans to then focus on a new area of prospective exploitation: deep-sea mining. I do so from the position of a curator engaged in artistic research. As a curator, art is the framework from within which I encounter the world. Throughout the book, I draw on the work of artists whose practice is deeply anchored in the oceanic space. I bring in feminist materialist, ecofeminist, and postcolonial theory to examine concepts of distance, visibility, and materiality, as well as many of the lacunae in between. I tune into fragments of discursive, technological, scientific, visual, and affective ways of knowing and seek to carefully and tentatively draft new ones. And, as if the ocean were a cinematographic device that captures different stories in molecules and waves similar to how a film captures light, I attempt to look at it as a moving image that gathers myriad narratives. In the words of writer Rebecca Solnit, with *Prospecting Ocean* I "seek out new kinds of stories."[7] Those stories, I hope, can inspire different knowledges and actions to grapple with the dawning emergencies of the oceanic Anthropocene.[8]

9 Rachel Carson, *Silent Spring* (Boston and New York: Mariner Books, 2002 [1962]), 188.

10 Such a position transcends abstractions like globe or globalism in the sense elaborated by feminist critic Gayatri Chakravorty Spivak. See Gayatri Chakravorty Spivak, *An Aesthetic Education in the Era of Globalization* (Cambridge: Harvard University Press, 2013).

Climate Change, Representation, and Art

Today, as reality is changing beyond recognition in the Anthropocene, established methods of naming and depicting, if always flawed, are ever more prone to falling short. Rachel Carson pointed this out already in 1962, writing about the toxicological impact of pesticide use: "Their presence casts a shadow that is no less ominous because it is formless and obscure, no less frightening because it is simply impossible to predict the effects of lifetime exposure to chemical and physical agents that are not part of the biological experience of man."[9] In a similar vein, today's climate catastrophe casts a vast and formless shadow. It defeats unidimensional understandings. Its formlessness and the uncertainty it points toward shatter established forms of representation—even if their unintelligible abundance may also increase uncertainty—and thus ways of communicating about and grappling with the imminent climate disaster.

 I suggest that art can assist us in sensing the slow and uncontainable violence that goes beyond the boundaries of landscape and can only be approximated from a position of situatedness and planetarity.[10] Art is a visual category that many artists have used to challenge common forms of representation as a response to feminist concerns (in the work of Pictures Generation artists like Barbara Kruger, Cindy Sherman, and Louise Lawler), queer issues in the work of artists like Gordon Hall, gendered and racialized depictions for artists like Tracey Rose and Martine Syms, or Rosanna Raymond, whose *SaVage K'lub* performances undo colonialist Pacific stereotypes. Being able to grapple with the changes that established onto-epistemological realities, to borrow Karen Barad's term for agential realism, which is at once ontological and epistemological, are undergoing as a result of the climate catastrophe, representations can be helpful. Yet, as the artists I mention know very well, representations are based on processes, convictions, and regulations that derive from a patriarchal and racist system. Moreover, modernist divides

11 Catriona Sandilands, *The Good-Natured Feminist: Ecofeminism and the Quest for Democracy* (Minneapolis: University of Minnesota Press, 1999), 181.

12 Karen Barad, *Meeting the Universe Halfway: Quantum Physics and the Entanglement of Matter and Meaning* (Durham: Duke University Press, 2007).

13 "If what appears as an aggregation of different and separable entities in the world is a chiasmatic mangle of the world's own individual perceptions of itself, then our very becoming is articulated through the intricate and comprehensive refractions of this processual inquiring/perceiving. In other words, life's self-reflexivity is a working science, a *dispositive*, whose myriad methodologies/perceptions confound subject with/in object in the will to be/other." Vicki Kirby, "Matter out of Place: 'New Materialism' in Review," in Vicki Kirby, ed., *What if Culture was Nature all Along?* (Edinburgh: Edinburgh University Press, 2017), 1–25, 18.

14 Astrida Neimanis, "Nature Represents Itself: Bibliophilia in a Changing Climate," in Kirby, ed., *What if Culture was Nature all Along?*, 179–198.

15 Ibid., 196.

between nature and culture also infer divides between the "real" thing and its representations. We need to find ways to challenge such assumptions.

Addressing representational failure, environmental humanities scholar Catriona Sandilands asks: "What place does a posture of embracing the limits of language and representation have in a radical democratic vision that includes nature, not as positive, human-constructed presence but as enigmatic, active Other? How can the recognition of the limits of representation coexist with a desire to include—to represent—more voices more fully?"[11] Sociologist Vicki Kirby suggests that we consider representation as part of the real thing, as construed in "intra-actions"[12] with the thing's materiality.[13] Neimanis similarly rejects the idea of a pre-representational reality as something separable from its representation.[14] She responds to Sandilands's question by suggesting that nature, including water, writes or represents itself. Therefore, "representation must also be responsivity."[15] Recognizing the limits of representations, such responsivity may be achieved in art.

In short, to resist divisions between nature and culture and between reality and representation, as well as ways of articulating or speaking on behalf of nature, we need to

16 Astrida Neimanis, "No Representation without Colonisation? (Or, Nature Represents Itself)," *Somatechnics*, vol. 5, no. 2, (September 2015): 135–153.

17 Donna J. Haraway, "The Promises of Monsters: A Regenerative Politics for Inappropriate/d Others," in Lawrence Grossberg, Cary Nelson, and Paula A. Treichler, ed., *Cultural Studies* (London: Routledge, 1992), 295–337, 311. Neimanis, "No Representation without Colonisation? (Or, Nature Represents Itself)."

18 Sara Danius, Stefan Jonsson, and Gayatri Chakravorty Spivak, "An Interview with Gayatri Chakravorty Spivak," *boundary*, vol. 20, no. 2 (Summer 1993): 24–50.

19 Sociologist and historian of science Andrew Pickering refers to mangle realism as noncorrespondence realism, in which the "mangle" emerges temporarily to produce a historicist understanding of science and objectivity. Andrew Pickering, "The Mangle of Practice: Agency and Emergence in the Sociology of Science," *American Journal of Sociology*, vol. 99, no. 3 (November 1993): 559–589.

20 Anna Lowenhaupt Tsing, *The Mushroom at the End of the World: On the Possibility of Life in Capitalist Ruins* (Princeton: Princeton University Press, 2015), 132.

21 Speaking nearby is a term coined by artist and theorist Trinh-T. Minh-ha, introduced in her film *Reassemblage* (1982).

think them together as one.[16] Rather than representations, we need to conceive of, in the words of feminist scholar Donna J. Haraway, "a possible politics of articulation."[17] For the purpose of temporarily slipping into and wringing political-environmental discourse, throughout this book I do, at times, return to representations. I carefully borrow feminist critic Gayatri Chakravorty Spivak's "strategic essentialism"[18] from its context of postcolonial theory to think through nature—not as pre-existing, "pure" nature, but as "mangle realism."[19] Nonetheless, I attempt to discuss such temporary representations in terms that surpass modernist meta-perspectives consisting of techno-utopias but also corporate media, militarized tropes, and political imagery. To use techno-scientific mediating tools, which are involved in the making of and result from these same paradigms, uncritically means risking falling short of constructive critiques. The results can be reinforcing self-affirming views, hardly different perspectives.

Besides art, pulling in ideas from other disciplines may help us construe assemblages of situated fragments of knowledge or, in the words of anthropologist Anna L. Tsing, "patches of livelihood."[20] Interdisciplinary methods moored in the arts can help us synthesize such patchy parts in new ways, and speak nearby that which is hard to talk about.[21] If most studies that engage a modernist view of the topic focus on "the ocean as resource provider, the ocean as transport surface, and the ocean as battleground or 'force-field,'"[22]

22 Philip E. Steinberg, *The Social Construction of the Ocean* (Cambridge: Cambridge University Press, 2011), 11.

23 Cresantia Frances Koya Vakaʻuta, "TAPU: Is Anything Sacred Anymore?," talk at The Current Convening #3 at the NTU CCA, Singapore, organized by the CCA and TBA21–Academy, January 27, 2018.

I acknowledge such views but seek to transcend them. And so, from within the messy reality I write from, with *Prospecting Ocean* I attempt to offer an attuned, multidimensional engagement with the ocean.

How Prospecting Ocean Came into Being

This book is anchored in many of the topics at the center of the interdisciplinary art and research platform TBA21–Academy, founded by Francesca Thyssen-Bornemisza and Markus Reymann in 2011. As curator of the organization, my research began with a three-year project by artist Armin Linke, commissioned by TBA21–Academy in 2016. Since then, Linke and I dove deep into the investigation, and in 2018, I curated his exhibition "Prospecting Ocean" at CNR-ISMAR, the Institute of Marine Sciences in Venice, Italy. Building on the show and beyond it, this book explores further perspectives and deepens the different strands we touched upon. In addition, on the occasion of this publication, Linke created a visual essay of imagery deriving from his extensive research, proposing a parallel reading of my text through a photographic narrative published alongside it. The visual essay has been drafted in close collaboration with designer Linda van Deursen to include a plurality of voices and media.

As part of its fellowship program The Current, TBA21–Academy organizes two-week-long journeys aboard the *Dardanella*, a boat which serves as a research vessel hosting interdisciplinary teams of artists, curators, and other thinkers and practitioners. Each of the journeys revolved around a topic, such as the nuclear past and present of the Pacific Ocean. Another session focused on the traditional practice of declaring a certain area of the ocean or land as taboo for human use, known as the sacred institution of *tabu/tapu*, originating in the islands of Fiji and Tonga.[23] Linke joined TBA21–Academy on three of these research expeditions, at the invitation of curator Ute Meta Bauer. On the boat and back on land, Linke and I continued our conversations about deep-sea mining and other threats facing the oceans today. Linke had begun his work on institutions that "administrate nature" a decade ago, and he

presented that research as an exhibition titled "Anthropocene Observatory," which took place at the Haus der Kulturen der Welt, in Berlin, in 2013–14. As part of this exhibition, Linke highlighted how human attempts at calculating, modeling, and managing geologic and organic processes since the dawn of modernity have led to a sense of control over the environment. Some of the effects thereof are human-altered landscapes, extractivist appropriation and accumulation, and shifts in ecological and social systems. These processes are enabled and facilitated by an intertwined geopolitical network of information, finance, materials, intentionality, and their uneven distribution in a globalized world economy. Through its networked potential, colonial capitalism continues to incur significant changes in the social and ecological tissues of the places where it acts, and its reverberations reach far beyond.

With the exhibition "Prospecting Ocean," Linke and I dove deeper into the oceanic realm of his investigation of the Anthropocene. During the research, he spent time with marine scientists in their labs, interviewed experts on the jurisdiction of the sea at the International Seabed Authority (ISA) in Jamaica, visited the United Nations Headquarters during the 2017 international conference dedicated to the future of the oceans, and met with environmental activists in Papua New Guinea. Over the course of our three-year collaboration, he traced the frameworks that administer, permit, and contest ocean exploitation, the intricate networks of power and the inequalities they produce and maintain, as well as the co-dependencies and effects on material-immaterial levels. The exhibition's focus was the imminent threat of deep-sea mining, as well as additional forms of resource extraction, be they microbial, sedentary, organic, or inorganic. At a tipping point for oceanic ecologies, "Prospecting Ocean" wove an intricate network of the technocratic entanglement of industry, science, politics, and economics at the new frontier of deep-sea excavations.

The exhibition unfolded in eleven chapters, each taking up a different space in the former offices of CNR-ISMAR. The results ranged from highly detached images of machinery and supposedly clinical incisions in the seabed to infrastructural apparatuses and local communities who live in close proximity to the oceans and object to deep-sea mining. The presentation comprised several multichannel video installations, a new

series of photographs, and a selection of key documents and books from the library of CNR-ISMAR and from private collections. Critical texts presented alongside the works portrayed the complex of infrastructure, legal frameworks, policy, and resistance at play with regard to the extraction of ocean resources. Moreover, "Prospecting Ocean" documented the simultaneous fascination and alienation we experience in front of the modern technologies used to map, visualize, and exploit marine resources.

The exhibition was the culmination of Linke's work, as well as our collaboration, and it was representative of the interdisciplinary way in which TBA21–Academy operates and commissions research. In addition to Giulia Bruno (camera, editing), Giuseppe Ielasi (sound, editing), Renato Rinaldi (sound), and Kati Simon (project management), we relied closely on interviews and support from Antje Boetius (Group Leader, HGF MPG Joint Research Group for Deep-Sea Ecology and Technology, MPI for Marine Microbiology, Bremen, Germany); Cliawi Netam Cecilia (Activist in the west coast Barok area of the New Ireland Province, Kono Village, Papua New Guinea); Sallie Chisholm (Institute Professor, Civil and Environmental Engineering, Department of Biology, Massachusetts Institute of Technology, Cambridge, MA); Stefan Helmreich (Elting E. Morison Professor of Anthropology, Massachusetts Institute of Technology [MIT], Cambridge, MA); Kai Kaschinski (Activist, Project Manager of "FairOceans," Verein für Internationalismus und Kommunikation e.V. [IntKom], Bremen, Germany); Sandor Mulsow (Director of the Office of Environmental Management & Mineral Resources, International Seabed Authority, Kingston, Jamaica); Cardinal Sir John Ribat (Archbishop of Port Moresby, Papua New Guinea); Ann Vanreusel (Head of the research group Marine Biology of Ghent University, Ghent, Belgium); Davor Vidas (Director of Marine Affairs and Law of the Sea Programme, and Senior Research Fellow with Professor competence at the Fridtjof Nansen Institute, Oslo, Norway); and many others.

As is often the case, the more we learned, the more we realized that the exhibition could only ever be a limited presentation of the topics we were examining. This realization brought about the idea to publish a book that would expand our research and make it accessible in a different format. The book you're reading is the result of this quest.

The Ocean Spaces in this Book

Inspired by Rachel Carson, I too hope to bridge scientific knowledge and embodied writing, imbued with experience. Besides my analysis of Linke's work, I focus on a selection of case studies by other artists whose works grant valuable insights into the dynamics at play in ocean extraction—some explicitly, some implicitly. They include CAMP, Lucien Castaing-Taylor and Véréna Paravel, Marjolijn Dijkman and Toril Johannessen, Charles and Ray Eames, Geocinema, Karrabing Film Collective, Yuki Kihara, Lisa Rave, Susanne M. Winterling, and others. Alongside their works, I ruminate on how distance and detachment are evoked through technologies used to study, analyze, and utilize the oceans as a central notion of our mediated and destructive relationship to the world's hydrosphere. I scrutinize modern and contemporary visualizations of the sea through maps, photographs, moving images, and lately also computer renderings, aided by the development of technology and fueled by an expansionist, often colonialist, spirit. I discuss the role of visibility for extractivist projects, and how it makes both protection and exploitation possible. I consider materiality, and how the disembedding of entities from their surroundings changes sets of relations, both physical and imaginary. I examine the divides between life and nonlife and how they are becoming increasingly untenable. And I trouble the trope of the new frontier, which is repeated over and over in the rhetoric of mining on land, in space, and at sea. I complicate that notion and suggest that we urgently need to throw it overboard as antiquated and dangerous.

 The artworks and ocean spaces I delve into, often through a lens borrowing from various disciplines, are partial. But as such, I also hope *Prospecting Ocean* remains fluid and urgent, and that it inspires readers in many ways.

Seabed Mining in Armin Linke's "Prospecting Ocean"

Darkness envelops the first scene of the main film in Armin Linke's exhibition "Prospecting Ocean." Sounds of distant splashing water, the damp noise of industrial work, and the screeching of a door opening and closing are audible as the camera focuses on a moving light, the only visible entity in the scene. The light shifts ever so slightly, bobbing in response to what we can only assume are waves, while the rest of the

screen is dark. Cut, and we see an image on a screen, its graph-like dotty shape produced by a digital device used to gauge the bathymetry in the sea. With this sequence, Linke introduces viewers to the technologically mediated world of oceanography, situated at the intersection of science and industry, and the hardware and software used to penetrate the sea. Much of the 56-minute video depicts interior spaces, which may contradict viewers' expectations of the vast blue expanses that may come to mind when thinking of the oceans.

Prospecting Ocean (video stills).

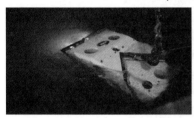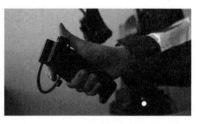

The video is comprised of interviews with representatives of the companies that advance deep-sea mining, shots of a geographer explaining the law of the sea, and scenes filmed at the UN, where international agreements affecting the future of the oceans are negotiated. It is only toward the end of the video, at minute 41:00, that outside, or natural, spaces are shown. The camera zooms in on a woman carving a wooden rod in a hut on Karkar Island in Papua New Guinea, a man mows the lawn in a landscape of palm trees as a chicken walks across the grass, another man weaves a mat from leaves as he sits on the ground, hunched over. Rather than suggesting an anthropological gaze on the Other, removed from capitalist and technological advances, the scenes that follow depict the fierce grassroots opposition of the local community of Karkar Island, who fight the planned deep-sea mining operations off their shores. A group of approximately thirty people sits in the shade of the trees holding up banners with slogans such as "Ban Sea Bed Mining" and "Join the Alliance." Speaking through a megaphone, a woman proclaims that foreign companies come to Papua New Guinea to exploit the land, a land which "is not their land."[24] As the protest progresses, viewers learn that 24000 people across the country signed a petition against seabed mining. It also becomes clear that this petition will

25 Nautilus Minerals website, http://www.nautilusminerals.com/irm/content/png.aspx?RID=258.

most likely not be heard, since, the protesters explain, the government is seeking short-term profit in providing their territorial waters as testing ground for ocean extractions to international corporations.

The video ends as it started, in darkness. In the final scenes, filmed on Ramoaina Island (Duke of York Islands Group), viewers hear, mostly without seeing, activists during a nighttime convening, where the only illumination comes from a handheld battery-powered light. The speakers denounce the for-profit exploitation of their natural resources: "Seabed mining will not benefit us, it will only benefit the government and foreign companies' interests." Reminding their community of the long history of colonialism in the region, one of them points out: "We are not animals they can simply use to experiment on." Another says, "my life depends entirely on the sea," followed by the applause from his community.

At the time of writing of this book, mining in Papua New Guinea has yet to begin. However, the path is currently being paved for it to start as soon as newly designed extraction machines, which are currently in production, are ready. The targeted location is the mineral-rich area of Solwara 1, which was "discovered" by Australia's Commonwealth Scientific and Industrial Research Organisation (CSIRO) in 1996.[25]

Prospecting Ocean (video stills).

 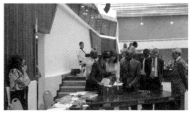

In 2011, the Canadian company Nautilus Minerals Inc. was granted an initial mining license. This will make Papua New Guinea the first country in whose territorial waters seabed mining will take place. The distinction between territorial and international waters is important. In a scene in Linke's video, Donald Rothwell, Professor of International Law with

26 The United Nations Convention on the Law of the Sea (UNCLOS) defined the areas beyond the limits of national jurisdiction by the High Seas, beyond the Exclusive Economic Zone (EEZ), or beyond the Territorial Sea where no EEZ has been declared, which, according to Article 86 "are open to all States, whether coastal or land-locked," and the "Area" beyond the limits of the continental shelf, defined in Article 76, which "means the seabed and ocean floor and subsoil thereof, beyond the limits of national jurisdiction" (Article 1). https://www.un.org/depts/los/convention_agreements/texts/unclos/UNCLOS-TOC.htm.

27 Arvid Pardo, Maltese Ambassador to the UN, in a speech in November 1967 called to define the seabed beyond national jurisdiction as common heritage of mankind. https://www.oxfordbibliographies.com/view/document/obo-9780199796953/obo-9780199796953-0109.xml.

a specific focus on the law of the sea at the College of Law at the Australian National University in Canberra, explains the difference between law that applies to the Exclusive Economic Zone (EEZ) of a country, and laws stipulating the rights and limitations in what is defined as the "area beyond national jurisdiction."[26] While the former is under each country's jurisdiction, the latter is designated "common heritage of mankind,"[27] from which no single nation shall profit exclusively. Mining is currently only permitted according to specific countries' jurisdiction in their respective EEZ, but not in international waters. The International Seabed Authority (ISA), a UN arm located in Kingston, Jamaica, is tasked with the administration of international waters beyond national jurisdiction. Administration here does not mean ensuring protection. The authority has already begun to distribute claims to sponsoring nations for purposes of exploration, and soon also exploitation.

Prospecting Ocean (video stills).

Companies like Nautilus Minerals Inc. directly target the governments of resource-rich yet economically deprived countries in the South Pacific (as well as the Azores Islands

28 Colin Filera and Jennifer Gabriel, "How Could Nautilus Minerals Get a Social Licence to Operate the World's First Deep Sea Mine?" *Marine Policy*, vol. 95 (September 2018): 394–400.

29 Ibid.

30 "Environmental and eco risk unknown in Cooks' deep sea mining," blog post on Papua New Guinea Mine Watch, https://ramumine.wordpress.com/tag/pang/.

of Portugal) for mining deals. Post-colonialism, the economic situation of countries such as Papua New Guinea is often dire. International corporations exploit their desperation with short-term promises of economic benefits and misinformation about the extent of environmental and social risks of deep-sea mining.[28] In the case of Papua New Guinea, the government proceeded with the mining deal without the citizens' consent.[29]

Prospecting Ocean (video stills).

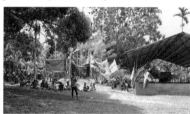
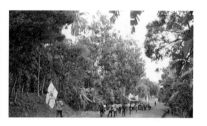

As Maureen Penjueli, coordinator of the Pacific Network on Globalisation (PANG) and activist against deep-sea mining, relates concerning the situation in Papua New Guinea: "There was very little understanding about the potential impacts. There was an overemphasis on the potential economic benefits. So the legislations were set up under the broad narrative that seabed mining was considered small risk, very high return."[30]

Currently comprising 167 member states and the European Union, the ISA has a council of thirty-seven members, elected by the UN General Assembly. It has two advisory bodies, the Legal and Technical Commission consisting of thirty members, and the Finance Committee with fifteen members. The ISA grants exploration licenses, for which member states can apply. This makes the ISA structurally vulnerable to being hijacked by corporate interests. While all member states can apply for exploration licenses, few companies are considered to have the necessary resources and know-how to partner with the sponsoring nations.

Prospecting Ocean (video stills).

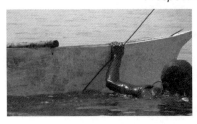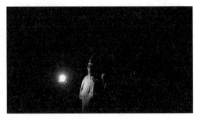

The result are oligopolies by mainly Canadian, Australian, and UK-based companies that lobby for their (extractivist) interests. At the time of writing, the ISA has approved twenty-nine contracts for exploration from twenty-two different countries. The overall area currently approved for exploration covers more than 1.3 million square kilometers of the seabed, 0.25 percent of the Earth's surface, or 0.36 percent of the world's oceans. Considering that the oceans cover more than two thirds of the planet, the fact that thirty-seven representatives oversee administering international waters is daunting. As they push for mining, their biased interests are in diametrical opposition to the ISA's mandate of protecting the common heritage of humankind. They rely on ideas of modernist distance and containability, which are among the notions that make these mining endeavors so dangerous.

Rachel Carson understood her time as one of ecological urgency. The marine biologist magnificently brought the oceans closer to her readers from a scientifically founded literary perspective, warning them about environmental degradation and maltreatment. She conveyed complexity, convincing arguments, and aesthetic irresistibility simultaneously.

The Unevenly Distributed Oceanic Anthropocene

31 Val Plumwood, *Feminism and the Mastery of Nature* (London: Routledge, 2003), 7.

32 "The Anthropocene Working Group (AWG) is an expert body tasked with evaluating the stratigraphic case of the Anthropocene [...] The AWG was established in 2009 as a working group within the International Commission on Stratigraphy (ICS), which regulates the way in which the time, name, rank, and stratigraphic markers of new geological periods are approved." Johannes Lundershausen, "The Anthropocene Working Group and its (inter-)disciplinarity," *Sustainability: Science, Practice and Policy*, vol. 14, no. 1 (2018): 31–45.

33 Elisabeth A. Povinelli, *Geontologies: A Requiem to Late Liberalism* (Durham: Duke University Press, 2016), 13.

34 Jason W. Moore, "Anthropocene or Capitalocene? Nature, History, and the Crisis of Capitalism," *Sociology Faculty Scholarship*, vol. 1 (2016): 5–6.

The imminent threat of deep-sea mining shows that the time that has passed since Carson was writing is by no means better. Two decades ago, ecofeminist philosopher Val Plumwood warned that capitalist-colonial progress continues to reproduce deeply engrained inequalities, "where technological mastery extinguishes both nature and less technologically 'rational' cultures."[31] In 2009, the interdisciplinary Anthropocene Working Group[32] was assembled to examine whether what has largely come to be referred to as the Anthropocene should indeed be considered a new geologic epoch. In 2016, the group issued its positive recommendation to formalize the chronostratigraphic/geochronologic unit, with a boundary in the middle of the twentieth century. Yet, anthropologist Elizabeth A. Povinelli suggests that we should assess the Anthropocene not only as a geological phenomenon and climate change not merely as a meteorological event, "but as a set of political and conceptual disturbances that emerged in the 1960s—the radical environmental movement, Indigenous opposition to mining, the concept of Gaia and the whole earth."[33]

Povinelli and other scholars are promoting notions that don't assume an evenly distributed global condition or create a naturalizing universal language. Human ecology researcher Andreas Malm and environmental historian Jason W. Moore first introduced Capitalocene as an alternative, proposing, in Moore's words, "an ugly term for an ugly system."[34] In accord, art historian and cultural critic T. J. Demos suggests that the neologism Capitalocene is useful to differentiate who and what is primarily causing the lasting environmental and

35 Zoe Todd, "Indigenizing the Anthropocene," in Heather Davis and Etienne Turpin, ed., *Art in the Anthropocene: Encounters Among Aesthetics, Politics, Environments and Epistemologies* (London: Open Humanities Press, 2015), 241–254, 244.

36 Kathryn Yusoff, *A Billion Black Anthropocenes or None* (Minneapolis: University of Minnesota Press, 2019), xiii.

37 Donna J. Haraway, "Anthropocene, Capitalocene, Plantationocene, Chthulucene: Making Kin," *Environmental Humanities*, vol. 6 (2015): 159–165.

political effects, namely the Western patriarchal Anthropos, not indigenous people or the Global South. Métis scholar Zoe Todd astutely critiques this universalizing species-paradigm: "the current framing of the Anthropocene blunts the distinctions between the people, nations, and collectives who drive the fossil-fuel economy and those who do not."[35] As we discuss the Anthropocene, we need to be careful not to homogenize. We need to acknowledge whose footprint manifests, and whose does not.

The environmental crisis is a relatively new phenomenon only in the West. Human geographer Kathryn Yusoff suggests that the Anthropocene is a term developed to diagnose the damages experienced by white liberal communities, whereas "these harms have been knowingly exported to black and brown communities under the rubric of civilization, progress, modernization, and capitalism."[36] Acknowledging these racialized and gendered histories, politics, and geologies is important. It is crucial to be more precise, to reach further, if we are to devise future imaginaries that don't reiterate these narratives. The term Chthulucene, put forward by Haraway, may be useful for that.[37] Rather than repeating the generalizing anthropocentric outlook that is part of the very problem it describes, it incites us to imagine other, monstrous, multiscalar, multidimensional, and multispecies alternatives. Keeping its limitations in mind, throughout the book I use the term Anthropocene, and sometimes Capitalocene and Chthulucene interchangeably, depending on which is most suited to the context and discourse I refer to.

How can we work toward ways of knowing and being that undo the racialized, gendered, and class-biased histories deeply inscribed not only into knowledge production, but also into legal frameworks and policies? Since deep-sea mining is a compound shaped by science, technology, economy, and law, I discuss these frameworks that enable it throughout the book.

38 Ecocide Law website, see https://ecocidelaw.com/the-law/what-is-ecocide/.

39 Polly Higgins, *Eradicating Ecocide: Exposing the Corporate and Political Practices Destroying the Planet and Proposing the Laws to Eradicate Ecocide* (London: Shepheard-Walwyn, 2015).

40 Winona LaDuke, "Succeeding Into Native North America: A Secessionist View," in Ward Churchill, ed., *Struggle for the Land: Native North American Resistance to Genocide, Ecocide and Colonization* (San Francisco: City Lights, 2002), 11–14.

41 Mary Graham, "Some Thoughts about the Philosophical Underpinnings of Aboriginal Worldviews," in *Worldviews: Environment, Culture, Religion*, vol. 3 (1999): 105–118.

As international policies and laws are born of patriarchal-colonial-capitalist histories, I argue that we need to work to undo them from within. The term ecocide has gained traction in recent years. Coined by barrister Polly Higgins, it denotes "the extensive destruction, damage to or loss of ecosystem(s) of a given territory, whether by human agency or by other causes, to such an extent that peaceful enjoyment by the inhabitants of that territory has been severely diminished."[38] The governments of Bolivia and Ecuador have inscribed the inalienable rights of Mother Earth into their legislations and constitution respectively.[39] While this is a laudable step toward developing the notion of ecocide as a definition universal enough to be multi-jurisdictional and transboundary, it also opens up loopholes for business to go on as usual. Moreover, environmentalist and Native American advocate Winona LaDuke argues that we cannot think about ecocide and genocide as isolable.[40] Consequently, we need to consider the motivations and scope of how recent environmental sustainability discourse is thought of and inscribed in Western structures and institutions.

To give an example, Kombumerri historian Mary Graham unpacks how Aboriginal custodial ethics are informed by close ties to land and oceans. Aboriginal law is woven into the social fabric, and is inclusive, local, and long-term.[41] It is a law based on customs and lived experience from which it cannot be separated the way it is in the European legal system. The laws and policies put into place by colonial settler states often hinder indigenous people from continuing to put into practice their experience, based on collective memories and earlier adaptations to changes in ecological-social conditions. As environmental humanities scholar Kyle Whyte shows, the legal systems of settler states force indigenous jurisdictions

[42] Kyle Whyte, "What Do Indigenous Knowledges Do for Indigenous Peoples?" in Melissa K. Nelson and Daniel Shilling, ed., *Traditional Ecological Knowledge: Learning from Indigenous Practices for Environmental Sustainability* (Cambridge: Cambridge University Press, 2018), 57–84.

[43] Claire Colebrook, "Archiviolithic, Archiviolithic: The Anthropocene and the Hetero-Archive," *Derrida Today*, vol. 7 (2014): 21–43.

to become fixed, like theirs. This constrains the adaptability necessary for indigenous livelihoods and cultural practices, whereas indigenous populations often weren't asked or didn't consent to such laws being established in the first place.[42] Revisions of international law and legal apparatuses need to take into consideration these different practices and cosmologies and radically revise notions of justice. Our ways of knowing and being at large should be part of such revisions.

These are but a few examples of the complex conundrums we are faced with in the oceanic Anthropocene. If we are to understand and counteract the effects brought about by some parts of humanity more than others, and affect some humans and nonhumans more than others, we require all efforts of imagination and action. Only then can we, perhaps, grapple with the current planetary demise.

Noticing the Uncertain Future of Deep-Sea Mining and Other Extractivisms

Environmental doomsday scenarios abound today. They may help shake up those who previously didn't care. They may contribute to growing political momentum. However, they can also paralyze and lead to a short-sighted proto-mourning[43] of "our" own, human, disappearance. While nightmarish forecasts are plentiful these days, there are few scenarios that are both incisive and exuberant, both carefully analytic and wildly daring. And yet, we need such imaginaries to help us conjure different possible futures, some of which are already in the making, even if in precarious spaces. Not many disciplines dare to take risks like the arts. And while the arts may hardly save us, they could, possibly, generate momentary flashes of light that touch us, that wake us up, that show us that there may still be other ways.

For those people to whom the idea of climate catastrophe is new, waking up is necessary, and quickly. Tsing suggests that we need to cultivate new "arts of noticing,"[44] from which urgently needed alternative imaginaries could evolve.

44 "The problem is that progress stopped making sense. More and more of us looked up one day and realized that the emperor had no clothes. It is in this dilemma that new tools for noticing seem so important. Indeed, life on earth seems at stake." Tsing, *The Mushroom at the End of the World*, 25.

45 Stacy Alaimo, *Exposed: Environmental Politics and Pleasures in Posthuman Time* (Minneapolis: University of Minnesota Press, 2016).

46 Macarena Gómez-Barris, *The Extractive Zone: Social Ecologies and Decolonial Perspectives* (Durham: Duke University Press, 2017), xvi.

Considering the colonial past and present across the globe, the question of whose voice is noticed, or heard, is key. As is the question of what is visible. The plastic gyre moving through the Pacific Ocean is a well-known image, not least thanks to the outrageous fact that it is visible from space. So are images of cute, anthropomorphized polar bears floating on lonely sheets of ice, a visual of just how threatened their species is by rising temperatures. Other threats, however, are hidden from view. Microplastics, toxins in fresh water, or radioactivity are not readily visible, but they nonetheless capture our imaginations and manifest their temporally and spatially distributed effects. Feminist environmental studies scholar Stacy Alaimo writes about how the fact that the threat of radioactivity is invisible has led to it being visualized in popular culture as bright, toxic-green matter.[45] That which is visible seems less threatening and more containable than that which evades the eyes. Yet, the colonialist nuclear past of test sites in "nature" and on humans leaks into the present. So do other atrocities whose effects cannot be contained by space or limited in time. We can begin to sense these effects by developing new ways of noticing, which can be facilitated by the way artworks make us see and feel things differently and help us notice things we previously didn't.

Deep-sea mining is hidden from plain sight as it occurs in sites that are located several thousand meters below sea level. Social science and cultural studies scholar Macarena Gómez-Barris refers to such sites as "extractive zones," shaped and defined by the "colonial paradigm, worldview, and technologies that mark out regions of 'high biodiversity' in order to reduce life to capitalist resource conversion."[46] Extractive zones are usually sited in geographically "remote" areas, such as the South Pacific. Deep-sea mining fields in Papua New Guinea are a pertinent example. Their representation as faraway places is intended to make the environmental effects of extraction seem negligible to Western investors and publics. This begs the question: Remote for whom, and for what?

47 "Environmental and eco risk unknown in Cooks' deep sea mining," blog post on Papua New Guinea Mine Watch, https://ramumine.wordpress.com/tag/pang/.

48 Ecological here shall be understood in the sense defined by philosopher Félix Guattari as a third, generalized ecology that "questions the whole of subjectivity and capitalist power formations." Félix Guattari, "The Three Ecologies," *new formations*, vol. 8 (Summer 1989), 140.

Beyond the colonial intentionality rendering non-Western people and places as distant, the effects of these mining projects are tangible and visceral. They affect communities living close to the extraction sites who "are heavily dependent on the ocean for livelihoods [and] food security," as Maureen Penjueli points out.[47] In addition to the immediate effects on local communities, the repercussions of deep-sea mining also leak to other geographies. Ultimately, we all rely on the oceans for earthly survival.

Deep-sea mining endeavors rely on knowledge created by public universities and private research institutes. They are technologically advanced forms of extraction, requiring high-tech engineering to withstand water pressure and sophisticated cameras to visualize that which cannot be seen by the naked eye above sea level. They insert themselves into complex webs of relations—social, cultural, economic, political, and ecological.[48] Mining projects extract what they define as "resources" from these webs in the present, without attempting to or being able to grasp their long-term and spatially uncontainable, overflowing effects. While very tangible for some, the concrete materiality and meaning of these extractions are hard to pinpoint or isolate, making it difficult to organize concerted efforts for their prevention. Invisibility is in their favor, in terms of visual perception and with regard to the supposed distance that is invoked to (psychologically) buffer the effects in the Global North.

The uncertainty brought about by these extraction projects is exemplary of the unprecedented ecological disaster of anthropogenic climate change and its handmaidens, capitalism and colonialism. As they continue to alter the world as we know it, precariousness abounds. This does not only apply to the future of complex intertwined discursive, political, social, and material relations, but also to the forms of tracing and representing them. If modern science is more or less based on a positivist belief in established facts,

49 Elizabeth M. DeLoughrey, *Allegories of the Anthropocene* (Durham: Duke University Press, 2019).

50 Val Plumwood, *Feminism and the Mastery of Nature* (London: Routledge, 2003), 21. See also Val Plumwood, "Nature in the Active Voice," *Australian Humanities Review*, vol. 46 (May 2009).

51 Alice Te Punga Somerville, "Where Oceans Come From," *Comparative Literature*, vol. 69, no. 1 (2017): 25–31.

52 Bruno Latour, *Politics of Nature: How to Bring the Sciences into Democracy* (Cambridge: Harvard University Press, 2004).

53 Mary Douglas, *Purity and Danger: An Analysis of Concepts of Pollution and Taboo*, (London: Routledge, 1966).

then the Anthropocene is not only an ecological but also an epistemological and ontological crisis.[49] As such, it is deeply unmodern, defying much of what has been established as causal relationships and clear correlations. What's more, as Val Plumwood argues, nature, women, and indigenous people have long been "providing the background to a dominant, foreground sphere of recognised achievement or causation."[50] If such constructs that divide culture from nature no longer seem convincing, this moment of dissolved boundaries and vanished certainties may also harbor opportunities for different ways of knowing and being. And such ways of knowing and being need to revise flawed certainties and undo colonialist genealogies altogether.[51]

A Condensed Modern History of Distance

I am writing these lines sitting in a room with a window that overlooks a city. You are most likely reading this chapter while being indoors somewhere. Maybe a temperature-controlled building. Perhaps you are feeling too cold, or too warm, and wish you could insulate your body better from the outdoors seeping into the space. Humans have mastered the task of creating enclosed spaces for comfort and for distance from what is conceived as the outside world. Separation implies progress, but also safety, isolating the inside from perceived and potential dangers lurking outside. These dangers are mostly conceived as "nature," a category humans in the West have, since the dawn of modernity, considered themselves as distinct from.[52] Rather than *with* nature, the modernist conception positions humans *against* nature. We are animals, yes, but unique ones, unlike anything else.[53]

Distance relies on spatial scales that situate bodies and places in fixed relation to one another. This also applies in a

54 Joseph Rouse, *Engaging Science: How to Understand Its Practices Philosophically* (Ithaca: Cornell University Press, 1996), 209.

55 Latour, *Politics of Nature*.

56 Latour, *Politics of Nature*, 244. Latour's well-known argument is that we have never been modern.

57 Latour, *Politics of Nature*, 244.

conceptual sense, measuring how closely or distant cultures or ideas are thought to relate to one another. Distance is an ideological category that structures our relationship to the natural world and to each other. It is a powerful construct buttressing (Western) human exceptionalism. Language and other modes of representation, while not exclusively determinant, play an important role in such distancing. The ability to represent abstract concepts such as temporal modes is often considered unique to humans. As philosopher of science Joseph Rouse argues, a belief in the ability of language to explore representations of things, while never being able to access things themselves, privileges thinking and intellect over the "external" world in a Cartesian modernist split.[54] As mentioned above, scholars including Kirby, Neimanis, and others assert that in order to undo such distancing, we need to conceive of things not as separate from their representations, but co-constitutive. Let us look how such distancing came to be construed in the first place, then work to undo it.

Representations and categorizations are founded on modernist separations, as Bruno Latour contends.[55] We thus need to consider modernity as "not a period, but a form of the passage of time."[56] The separation of culture as discrete from the organic-natural world derives from scientific and rational attempts to categorize and organize. By devising universalizing principles, the interpretations modernity offers are aimed at externalizing that which might hinder progress. Hence, whatever cannot fit into the modern passage of time is considered "nonmodern or ecological."[57] Such uncoupling facilitates adversarial treatment of nature and an assertion of the primacy of human agency. Since verdicts of the "nonmodern" are founded in modernist Eurocentrism, they also facilitate colonialist structures of power. As sociologist Aníbal Quijano argues, these structures produce and naturalize racial, ethnic, anthropological, and national categories, presenting them as founded on "objective" and "scientific" terms.[58]

Anthropocentric and Eurocentric exceptionalism, both pervasive and destructive, has been touted over centuries to thoroughly permeate Western modernity. While its roots

58 Aníbal Quijano, "Coloniality and modernity/rationality," *Cultural Studies*, vol. 21, nos. 2–3 (March–May 2007): 168–178, 178.

59 Theodor W. Adorno and Max Horkheimer, *Dialectic of Enlightenment* (New York: Verso, 1997), 3.

60 Plumwood, *Feminism and the Mastery of Nature*.

61 Sociologist Patricia Hill Collins points to such relationality as pivotal for intersectionality. Patricia Hill Collins, *Intersectionality as Critical Social Theory* (Durham: Duke University Press, 2019).

62 Francis Bacon, *The Works of Francis Bacon* (London: C. and J. Rivington, 1819), 72.

63 Fernand Braudel, *The Structures of Everyday Life: The Limits of the Possible, Vol. I, Civilization and Capitalism 15th–18th Century* (New York: Harpers & Row Publishers, 1981), 385.

reach back long before the Enlightenment, philosophers Theodor Adorno and Max Horkheimer identify the eighteenth century as a key moment of modernity expressed in the "disenchantment of the world [and] the dissolution of myths."[59] Once animist spirits had been driven out of nature, and nature was inanimate, so the argument goes, it could be controlled by enlightened, rational Man. Plumwood incisively shows how Western rationality subordinates nature, women, and non-Western cultures.[60] Since modernity hinges on separations of culture and nature, male and female, civilized and savage, and so on, we must think the compound of gender, race, class, indigeneity, ability, and species exclusivity together, intersectionally.[61]

Philosopher Francis Bacon, in his late sixteenth-century *Miscellaneous Tracts upon Human Knowledge*, identifies printing, artillery, and the compass needle as key inventions that have shaped the modern world and subsequently formed the base and justification for the mastery of nature.[62] These "rational" and largely effective tools replaced the futile alchemic experiments of the past. Knowledge became the reason, possibility, and justification for sovereignty over nature. Of the three technological "revolutions," the compass, used for ocean navigation, had the most lasting and widespread effect, as suggested by historian Fernand Braudel, since it "eventually led to an imbalance, or 'asymmetry' between different parts of the globe."[63] It was a key technology for colonialism and slavery, both of which led to and reinforced the imbalance between centers and peripheries, Global North and Global South.

The more advanced technological tools and science—and with them, a specific type of knowledge—became, the more nature could ostensibly be controlled. In the centuries

49 University of Texas, visualisation room at the Institute for Computational Engineering and Sciences (ICES), Computational Research in Ice and Ocean Systems (CRIOS), Austin, Texas. This and all photos by Armin Linke unless indicated otherwise.

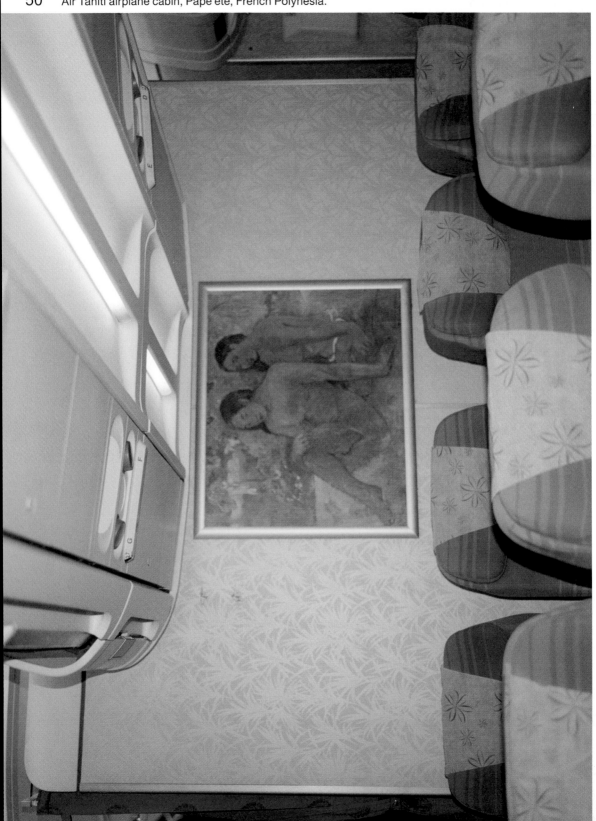

Air Tahiti airplane cabin, Papeʻete, French Polynesia.

51 MARUM – Center for Marine Environmental Sciences, International Ocean Discovery Program (IODP) and Integrated Ocean Drilling Program (IODP), seabed core deposit, Bremen, Germany.

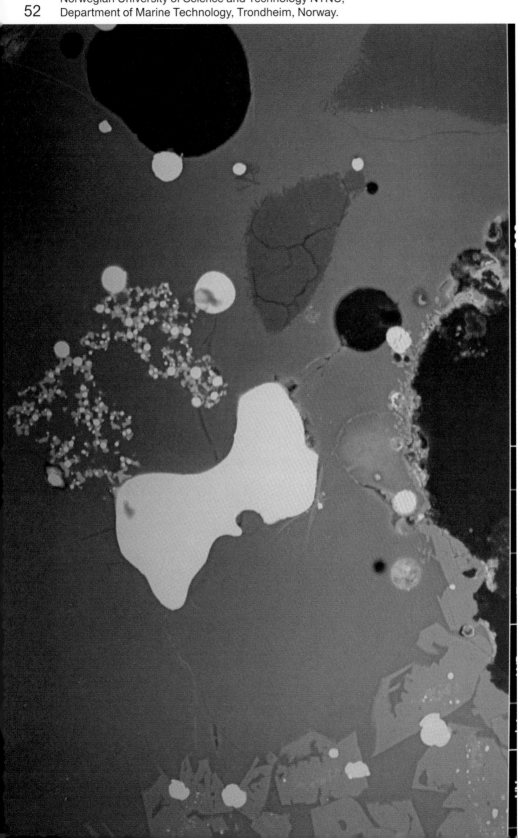

MARUM – Center for Marine Environmental Sciences, University of Bremen, core laboratory, Bremen, Germany.

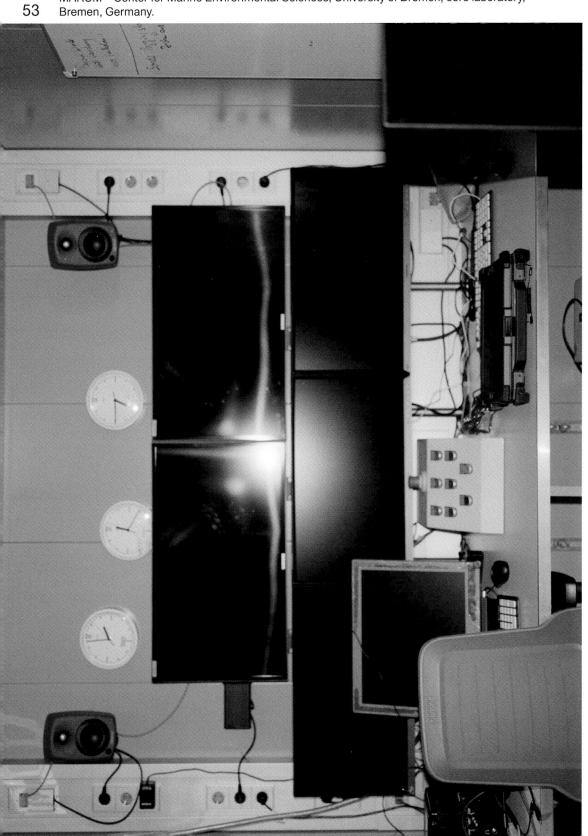

Institute for Advanced Sustainability Studies (IASS), discussion on the principle of the common heritage of mankind, Potsdam, Germany. Photo in collaboration with Giulia Bruno.

since Bacon, the loss of animism was accompanied by Western philosophy working to define the latter's everlasting natural order.[64] Naturalization was a prerequisite for the sovereignty of modern thinking, whose destructive colonial, genocidal, and ecocidal ramifications persist and haunt us to this day. Feminist scholar and activist for indigenous rights Aileen Moreton-Robinson identifies this epistemological and ontological naturalized a priori as that which serves the possessiveness of white settlers in a way similar to how the legal fiction of the *terra nullius* (a land belonging to no one) serves white sovereignty.[65] Knowledge of the "rational" mind, with the sphere of reason attaining to white men, not women nor indigenous people, people of color, and so on, came to be used to justify the maltreatment of nature and the colonization of land, humans, and more-than-humans.[66]

Bacon asserts that modern humans must extract themselves from nature and their dependence on it: "Now we govern nature in opinions, but we are thrall to her in necessity; but if we would be led by her in invention, we should command her in action."[67] Yet, as Plumwood reminds us, precisely the consideration of necessity as a derogatory quality of life has been a key paradigm of the inferior positions ascribed to nature and women.[68] Humans with embodied knowledge who hadn't extracted themselves "sufficiently" from the realm of necessity became considered inferior. This also served the purpose of expanding and redefining the Western image of self and its extractivist reasoning; scholar of indigenous education Linda Tuhiwai Smith argues that science, European "discoveries," and colonizing "new" worlds turned indigenous knowledge

[64] As Adorno and Horkheimer write: "Bacon's view was appropriate to the scientific attitude that prevailed after him. The concordance between the mind of man and the nature of things that he had in mind is patriarchal: the human mind, which overcomes superstition, is to hold sway over a disenchanted nature. Knowledge, which is power, knows no obstacles: neither in the enslavement of men nor in compliance with the world's rulers." Adorno and Horkheimer, *Dialectic of Enlightenment*, 4.

[65] Aileen Moreton-Robinson, *The White Possessive: Property, Power, and Indigenous Sovereignty* (Minneapolis: University of Minnesota Press, 2015).

[66] Aileen Moreton-Robinson, "Towards a new research agenda?: Foucault, Whiteness and Indigenous sovereignty," *Journal of Sociology*, vol. 42, no. 4 (2006): 383–395.

[67] Francis Bacon, "In Praise of Knowledge," *The Works of Lord Bacon*, Vol. 1 (London: Henry G. Bohn, 1850), 217.

[68] Plumwood, *Feminism and the Mastery of Nature*.

into commodities in the same way that these processes commodified natural resources.[69]

An illusion of permanence emerged as the world was no longer contingent on spiritual renewal and humans no longer complied with the conditions of their environment. The human mind, or rather the mind of (white, Western) men, was to claim tight-grip control over nature.[70] The "fear-driven battle for domination"[71] of the natural world, deriving from the intersection of different modes of domination, was fought largely by employing ideology, artifacts, architecture, and infrastructure. These modes of domination affected not only space in an expansionist sense and left traces in geological layers, ecosystems, and social relations, but also time. The illusion of durability and linearity of time and progress rendered the natural world passive, continuous, and inexhaustible. Nature became increasingly subdued to and guided by gendered and raced human will and actions.

Extractive Disembeddings

In current excavation endeavors, the modernist delusion of control over nature continues to be exercised. Extraction relies on separation, intentionality, and what anthropologist Tim Ingold calls "purposeful action," which ostensibly distinguishes humans from the animal and object world.[72] While animals also forage and remove foods and objects to build shelters, humans appropriate and alienate the "goods" they wring from their surroundings. And, we must add, some humans do so more than others. Mississauga Nishnaabeg writer and musician Leanne Betasamosake Simpson writes succinctly: "You use

[69] Linda Tuhiwai Smith, *Decolonizing Methodologies: Research and Indigenous Peoples* (London: Zed Books, 2012).

[70] Ecofeminist scholar and activist Marti Kheel further unpacks how Aristotelian and Platonic conceptions of nature as inert imposed a hierarchical order onto the world. They allowed Man to achieve his highest goal—rational contemplation—for which nature served as a background, while animals and women were dismissed as "mindless objects." In the Enlightenment, Western philosophy tried to separate ethics from the natural world. Feelings of closeness (considered female) were no longer at the basis of action, but were replaced by a distanced (male) sense of duty. Marti Kheel, "From Heroic to Holistic Ethics: The Ecofeminist Challenge," in Greta Gaard, ed., *Ecofeminism: Women, Animals, Nature* (Philadelphia: Temple University Press, 1993), 243–271.

71 Veronica Strang, "Conceptual Relations: Water, Ideologies and Theoretical Subversions" in Cecilia Chen, Janine MacLeod, and Astrida Neimanis, ed., *Thinking with Water* (Montreal: McGill-Queen's University Press: 2013), 185–211, 194.

72 Tim Ingold, *The Appropriation of Nature: Essays on Human Ecology and Social Relations* (Iowa City: University of Iowa Press, 1987).

73 Leanne Betasamosake Simpson, "Not Murdered, Not Missing: Rebelling Against Colonial Gender Violence," https://www.leannesimpson.ca/writings/not-murdered-not-missing-rebelling-against-colonial-gender-violence.

74 Karl Polanyi, *The Great Transformation: The Political and Economic Origins in Out Time* (Boston: Beacon Press Books, 1944).

gender violence to remove Indigenous peoples and their descendants from the land, you remove agency from the plant and animal worlds and you reposition aki (the land) as 'natural resources' for the use and betterment of white people."[73]

In Linke's work, the removal of resources from their environment is what distresses the community on Karkar Island in Papua New Guinea. The same separation ideas, goaded by the prospect of profit, are what fuels companies like Nautilus Minerals Inc. to invest in the sites of these extraction projects. These sites are considered far removed from the global centers of power, and thus the initiators construe arguments based on the assumption that the environmental impacts of their actions won't reach them. Such attempts at separating, extracting, and alienating are essentially imperialist, colonialist projects. Now that climate change is moving in on us, with its effects perceptible even in the "modern" world, the epistemologies apparently enabled by such separations are considered growingly dubious and their insufficiency to make sense of the world is increasingly obvious.

Extraction was industrialized as capitalism advanced. It spread like a disease with the colonizing explorers' ships to the "new world," and accelerated to meet the lopsided demands of a globalized economy. Treating nature as a resource or "background" against which humans operate, enables them, in the words of economist, historian, and philosopher Karl Polanyi, to "disembed" entities from their environment of material and immaterial relations.[74] In commodifying these entities, "capitalist economic institutions achieved their own, autonomous logic vis-à-vis other dimensions of modern society."[75] Capitalism turns into value not only labor and nature into commodities for the production of surplus, but also affect, socialities, bodies, intelligence, tradition, and memory.[76]

75 Alf Hornborg, *The Power of the Machine: Global Inequalities of Economy, Technology, and Environment* (Walnut Creek, CA: Altamira Press, 2001), 163.

76 David Harvey, *Spaces of Global Capitalism: A Theory of Uneven Geographical Development* (New York: Verso, 2006).

77 Frantz Fanon, *Alienation and Freedom* (London: Bloomsbury, 2018).

78 Glen Sean Coulthard, *Red Skin, White Masks: Rejecting the Colonial Politics of Recognition* (Minneapolis: University of Minnesota Press, 2014).

79 Tsing, *The Mushroom at the End of the World*.

80 Haraway uses the term sympoiesis to describe how we think and make together with other species and our surroundings. Donna J. Haraway, *Staying with the Trouble: Making Kin in the Chthulucene* (Durham: Duke University Press, 2016).

81 Tsing, *The Mushroom at the End of the World*, 5–6.

A result of such accumulation is alienation, which, as political philosopher and psychiatrist Frantz Fanon argues, is both a result and a source of colonial-capitalist injustice.[77] Given the perpetuity of extractivist actions such as deep-sea mining, we need to recognize accumulation and forceful territorial acquisition not as a capitalist strategy of the past, but as a continuation. And yet, First Nations studies scholar Glen Sean Coulthard contends that the practices of dispossession of settler colonialism are not inevitable but contingent, arguing that we need to recognize and renounce the normative development also inherent to Marxist theory.[78]

In extraction, things are removed from their contexts to become exchanged as assets elsewhere.[79] As a consequence, the entanglement of life worlds is precluded and eliminated. A "sympoietic"[80] relationship of processes is disavowed as individual parts become isolated. The mutual influence and co-dependency of things is ignored. Tsing writes: "The dream of alienation inspires landscape modification in which only one stand-alone asset matters; everything else becomes weeds or waste."[81] In deep-sea mining, minerals are removed as resources, while the remaining scarred environment is considered waste. Since it no longer bears immediate economic value, it is abandoned as extraction operations are moved to the next site. Yet, as we will see, the removed minerals play an important role in the health of interconnected ecosystems. Assumptions that wastelands can be isolated or environmental effects contained are, once again, dangerous modernist notions.

Early maps of the sea were often drawn as teeming with sea monsters.[82] Famous examples are Olaus Magnus's *Carta Marina* from 1539, and Abraham Ortelius's *Islandia* from 1585.[83] In these maps, some of the "wonders," as the monsters were commonly referred to, are depicted as danger, issuing a warning to sailors and explorers. Others were considered to represent commodities to be found in faraway lands, or as cognitive passions to be marveled at and enjoyed by the onlooker.[84]

Oceanic Representations

82 "Brave seamen do battle with fierce sea monsters, in sharp contrast to the happy landlubbers…. They also display a feature commonly found in maps of the era: the sea is portrayed as topographically more textured than the land, hardly an inviting environment for navigation. The sea monsters on these maps are not mere decorations; rather, they represent actual creatures thought to exist in the sea." Steinberg, *The Social Construction of the Ocean*, 99.

83 Lindsay J. Starkey, "Why Sea Monsters Surround the Northern Lands: Olaus Magnus's Conception of Water," *Preternature: Critical and Historical Studies on the Preternatural*, vol. 6, no. 1 (2017): 31–62. Joseph Nigg, *Sea Monsters: A Voyage Around the World's Most Beguiling Map* (Chicago: University of Chicago Press, 2013).

84 Chet Van Duzer, *Sea Monsters on Medieval and Renaissance Maps* (London: The British Library, 2013).

85 Tony Campbell, *Early Maps* (New York, NY: Abbeville, 1981), 81–89, quoted in Steinberg, *The Social Construction of the Ocean*, 99.

86 Gómez-Barris, *The Extractive Zone*, 5.

These maps serve as a reminder of the spiritual, totemic, and mythological depth with which the oceans were once imbued. The back of Ortelius's *Islandia* map describes the animals thereon in ways meant to inspire fear and awe: "One, we are told, "sleepeth twelve hours together hanging by his two teeth upon some rocke or cliffe"; another "hath bene seene to stand a whole day together upright upon his taile… and greedily seeketh after mans flesh"; and a third "hath his head bigger than all the body beside."[85] In maps of later periods, these narrative elements were replaced with grids and numbers. Rather than imbued with living creatures, fantastical or not, the waters are drawn as abstract, blank, spaces of geometrical projection succumbed to a universalizing regime of study and visualization. Emphasis lies on the surface, not their depths. Homogenizing and reducing the oceans to but a few parameters, these techniques make the sea appear less mystical. Such quantifiers objectify the land as well as the sea, and render all travel across it the same. In turn, these depictions attribute heightened agency to humans, their ships, and navigational technologies.

In the compound modes of domination, colonization, separation, naturalization, and commodification act together. Beside land and resource grab, extraction also affects social and cultural realms. It devalorizes "the hidden worlds that form the nexus of human and nonhuman multiplicity."[86] Hence, in ongoing patriarchal-colonialist-capitalist dynamics, we need

87 Sarita Echavez See, "Accumulating the Primitive," *Settler Colonial Studies*, vol. 6, no. 2 (April 2015).

88 Trevor Paglen, "Experimental Geography: From Cultural Production to the Production of Space" in Emily E. Scott and Kirsten J. Swenson, ed., *Critical Landscapes: Art, Space, Politics* (Berkeley: University of California Press, 2015), 34.

89 Saskia Sassen and Hans Haacke, "The Spaces of Occupation," *Artforum* (January 2012), 85. https://www.artforum.com/print/201201/the-spaces-of-occupation-29814.

90 As cultural and translation studies scholar Michael Cronin writes: "If the sphere presupposed a world experienced and engaged with from within, the globe represented a world perceived from without." Michael Cronin, "Inside Out. Time and Place in Global Ireland" in Eamon Maher, ed., *Cultural Perspectives on Globalisation and Ireland* (Bern: Peter Lang, 2009), 23–24.

91 Tim Ingold, *The Perception of the Environment: Essays on Livelihood, Dwelling and Skill* (London: Routledge, 2000), 211.

to pay close attention to representations, composed of images and metaphors, but also, importantly, maps.[87] If navigation and the compass needle were pivotal for shaping the modernist mastery of nature, so were the maps created as a result of these expeditions. In order to discern assets as exploitable, they need to be charted, analyzed, and categorized.[88] In the late nineteenth century, vertical cartographies were added to the canon, to show the mineral resources found underneath the Earth's surface. The same way extraction separates "goods" from their surroundings, geographical representations single out and excerpt entities of interest. Maps are key instruments used to fathom the complexity of territories including their topologies, material realities, and the relations between them. We need to understand territory here not as a "neutral" ground or "actuality" of land and sea, but per sociologist Saskia Sassen's definition of it as "a complex condition with embedded logics of power and of claim making."[89] Maps are mirrors of the intentions of power.

If representations are shaped by our worldviews, they also affect them. In premodernity, a sense of connection between the Earth, humans, and the cosmos was depicted as lines running from the world to the heavens above. The Galilean shift from the geocentric to the heliocentric view of the universe is considered a key moment that altered the way humans conceived of their place in the world.[90] As the Earth went from being shown as a sphere to being comprehended as a globe, it presupposed experience no longer from within, but from outside, or above. The Earth was "drawn ever further from the matrix of our lived experience."[91] As a result, our sensory

92 Cronin, "Inside Out."

93 Paul Virilio, *Speed and Politics* (Los Angeles: Semiotext(e), 2006).

94 The territorial waters, however, extend only 12 nautical miles from the coast, and are thus included in the EEZ. https://www.un.org/depts/los/convention_agreements/convention_overview_convention.htm.

engagement with land and the oceans is replaced by a modern regime of detachment and control.[92]

In short, in modernity, when the globe was continuously charted, the entirety of its elements—cultural or natural, human or nonhuman—was subject to re-examination. Colonial domination particularly required logistical expansion across faraway territories. Aided by naval techniques, military geography expanded from land to sea, spinning a calculated web across the globe with the promise of easy administration and subjugation. Maps were instrumental to tracing and altering the topologies of land and controlling the people inhabiting them.[93] And new depictions of land and sea also affect people's attitudes toward them.

Mapping the Remote

Geopolitical representations of territory today still rely on the abstract and systematizing language of science. As a result, land and water continue to seem controllable and exploitable. In his interview in Linke's *Prospecting Ocean*, Rothwell, the law professor specializing in the law of the sea, explains how the abstract juridical concept of the baseline has very real effects on the territory and exclusive economic rights of a country. A country's baseline is defined by its continental shelf, a geological formation which lawmakers have agreed represents the outer limits of a coastal state's territory. According to the 1982 United Nations Convention on the Law of the Sea (UNCLOS), a state's Exclusive Economic Zone (EEZ) extends 200 nautical miles from its geographic baseline. In its EEZ, a nation enjoys undivided rights to marine resources and energy production, for example through wind.[94] If a state's continental shelf exceeds its EEZ, it has rights to the seabed up to 350 nautical miles from the baseline. The baseline plays a key role in territorial decisions but is also the subject of various disputes. Each shelf has different topological and geological characteristics, and could be shared by two nations. In such cases, geopolitical territorial claims need to be settled legally.

Linke films Rothwell using the carpet in the latter's office as a support for visual representation: the graphic shapes

on the floor stand in for abstract legal definitions. Models are a recurring theme in Linke's work. While they help us understand the world, Linke also shows how they are simplified notations that never adequately represent that which they are meant to stand in for. Another scene in *Prospecting Ocean* focuses on the Clarion-Clipperton Zone (CCZ), between Hawaii and Mexico. This is the area of the seabed beyond national jurisdiction where the International Seabed Authority is distributing subaquatic land to sponsoring nations for exploration and potential exploitation. Linke interviews Michael W. Lodge, Secretary-General of the ISA since January 2017, who points out the area for deep-sea mining on the high seas on two maps printed out on letter-size papers. Most contracts for mineral exploration have been issued in this area, which measures about 2400 kilometers east to west and 800 kilometers north to south. The depth ranges from 3500 to about 5000 meters at the deepest end. Lodge explains that it takes more than three hours to traverse the area from east to west by plane. Contractors go out to their allocated zone at least once a year, traveling for five days on a research ship, then spending thirty to sixty days at sea. The high costs of these trips are justified by expectations of even higher profits.

Prospecting Ocean (video stills).

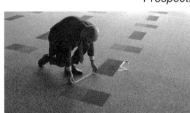 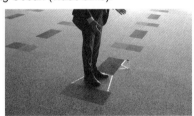

On Lodge's sheets of paper, the ocean is shown as a somewhat uniform blue area, in line with its representations in atlases and popular media. The CCZ is represented as a kind of strange new island that seems to have appeared in the middle of the Pacific Ocean: like a colorful puzzle, a long stretch of the sea marked in different hues, each indicating which nation claims which part of the ocean floor. The licenses are granted with certain restrictions. For each area used for exploitation, an area of the same size must be set aside for protection in order to allow the marine environment to recover. But damage in one place cannot simply be offset by conserving an area nearby. The top layer of the seabed is composed of

95 Diva J. Amon et al, "Insights into the abundance and diversity of abyssal megafauna in a polymetallic-nodule region in the eastern Clarion-Clipperton Zone" *Scientific Reports*, vol. 6 (2016). https://www.nature.com/articles/srep26808.

96 K. L. Shrivastava, *Economic Mineralization* (Jodhpur: Tanay Sharma, 2009).

97 A study published in *Nature Microbiology* in 2016 found that the last universal common ancestor is an anaerobe that lived in oxygen-deprived environments with extremely hot temperatures, feeding on hydrogen gas that emanates near black smokers in the deep sea. William F. Martin, Natalia Mrnjavac, Shijulal Nelson-Sathi, Sinje Neukirchen, Mayo Roettger, Filipa L. Sousa, and Madeline C. Weiss, "The physiology and habitat of the last universal common ancestor," *Nature Microbiology*, vol. 1 (2016), article number 16116, https://www.nature.com/articles/nmicrobiol2016116.

soft sediment, and when the minerals are dredged, silt plumes asphyxiate the organisms present. The harm to the seabed and the organisms that live and grow there is estimated to be fundamental.[95] Furthermore, marine ecosystems are intricately interconnected, and the effects of the dredged zone will also spill over to neighboring areas. Like water, sediments don't simply stay in one spot, they move. Thus, the idea of containment and control is proven faulty once again. Mining is justified by conceptual shortcomings that assume the seabed would stay the same and that the environmental effects can be localized. If land can't ever fully be contained, the moving waters of the oceans much less so.

Later in the video, Linke interviews Ann Vanreusel, a biologist at the Ghent University Marine Biology Research Group in Belgium. Vanreusel explains that deep-sea mining prospectors are particularly interested in the CCZ because of the abundance of metallic nodules found there. While the nodules were discovered in 1868, it wasn't until the 1960s that technological developments made their extraction seem possible.[96] The nodules develop near black smokers, or hydrothermal vents, at extreme temperatures in the deep sea, where the last universal common ancestor of all life on Earth is supposedly still found today.[97] Vanreusel emphasizes the importance of the nodules for the biodiversity of the deep sea. She points out that scientists still don't know enough about this flora and fauna, much less the beginnings of life, to accurately gauge just how extensive the environmental impact of seabed mining will be.

These scenes in Linke's work underscore the way that in the Western tradition what matters can be identified by what is mapped, named, and analyzed. New technologies or extractive interests also change what is deemed relevant to be charted.

98 Cecilia Chen, "Mapping Waters: Thinking with Watery Places" in Chen, MacLeod, and Neimanis, *Thinking with Water*, 274–298, 275.

99 Ana Hilario, Lenaick Menot, Pedro Martínez Arbizu, Pedro A. Ribeiro, and Ann Vanreusel, "Threatened by mining, polymetallic nodules are required to preserve abyssal epifauna," *Scientific Reports*, vol. 6 (2016).

100 Matthew H. Edney, *Cartography: The Ideals and Its History* (Chicago: University of Chicago Press, 2019).

The parameters of maps and the measures used to create them determine what is seen and noticed in the first place, and what is ignored and excluded from experience. The assumed authority of maps exists in tension with what is conceived as noisy excess "babble"[98] of water, or of indigenous cosmologies and other forms of knowledge that don't comply with Western ideas of information. Legal concepts, buttressed by such simplified maps, allow prospectors to take unprecedented risks with incalculable effects.[99]

Prospecting Ocean (video stills).

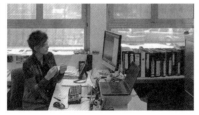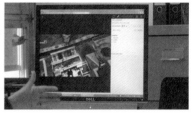

Maps of the ocean, in contrast to terrestrial cartography, demand of their makers the difficult task of accounting for a moving sea. They would need to picture movement of the waves, how ocean swells and winds change the conditions of the sea, and the way layers of water are influenced by the geological formations in the deep sea upon which they roll. The sea's liveliness is in tension with reductionist blueprints that universalize their subject as one to be grasped, mastered, and made useful.[100]

We could say, then, that Western mapmaking is implicitly contradictory. On the one hand, it attempts to standardize and bring into closer proximity places that are considered remote from the centers where the maps are made. The aim of such universalizing is often to facilitate conquest and exploitation. Yet on the other hand, by measuring and standardizing, maps also reify certain places. Their remoteness from other places—particularly the Global North—is often called upon

In terms of the oceans, relations with the observed area no longer come into being by accessing it physically, but instead depend on visual technologies. The telescope eliminates direct contact with the seen. Cameras utilized on land and underwater record these environments, extracting visual information from their site of origin. This information, collected at a remove, is utilized to intervene in the seabed not only in order to observe, but also to extract from it with the help of robotic intermediaries. And, in subjugating the ocean to representations deriving from a patriarchal-colonial history, these systems reinscribe these visions and their accompanying exploitations.

Prospecting Ocean (video stills).

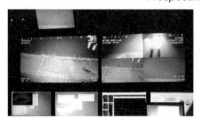

Linke's work exemplifies to viewers how these image-making techniques are put to use. Integrated into remotely operated vehicles (ROVs), many of these technologies were originally developed for military purposes. Alvin, the first manned deep-sea submersible, which was used for wide-ranging observations and data collection, was built by the General Mills Electronics Group in Minneapolis and operated by the Woods Hole Oceanographic Institution in 1964 on behalf of the United States Navy. Scientific reality here is constructed with the help of technological apparatuses enhancing and enabling human perception. Developed by interdisciplinary teams of roboticists, engineers, and marine scientists, the camera captures depths at the ocean floor that are otherwise impossible for human observers to access. At a distance, in control rooms on vessels or on land, scientists use computers to analyze the images transferred back to them from the ROVs.

If mapping defines what matters within a modern episteme, so does visibility. Parameters of maps and measures define what is seen or noticed in the first place, and technologies help us notice that which we subsequently value. We might say that the tools making things visible bring them about in the first place. Barad shows with her analysis of the fetal

115 Barad, "Getting Real," 93.

116 Ibid.

117 Ibid., 94.

118 "Apparatuses are themselves material-discursive phenomena, materializing in intra-action with other material-discursive apparatuses." Barad, "Getting Real," 102.

119 Gómez-Barris, *The Extractive Zone*, 6.

sonograph that technology "does not simply map the terrain of the body"[115]—or, in our case, the ocean—but "it maps the geopolitical, economic, and historical factors as well."[116] In short, the technology is an integral part of making something matter. The thing depicted gains political significance, which has material, political, and ethical consequences. In Barad's example, it is the status of the fetus as an autonomous entity, which protects it, but is also often utilized against the mother's right to abortion. In our case, visibility can make the ocean both protectable and exploitable.

Seventeenth-century representationalism and Newtonian physics have contributed to creating a view on science that considers observation "to be the benign facilitator of discovery, a transparent and undistorting lens passively gazing at the world."[117] However, as we have seen, technologies of observation are not passive but come about in conjunction with the observed.[118] Power is dependent on and emanates from instruments involved in observation and categorization. As part of observation, judgement, and examination, the technologies of seeing exert control over the seen. Moreover, mapping and recordings make visible only certain parts of the ocean, those that are considered "valuable" in a capitalist-colonialist exploitative sense. And yet, we must not forget the role that invisibility plays—what is obscured and excluded from vision and history. Gómez-Barris observes that colonial practices of seeing "render invisible the enclosure, the plantation, the ship, and the reservation, quintessential colonial spaces where power was consolidated through visual regimes."[119] In deep-sea mining, vision is focused on minerals. What is rendered invisible are the intricate ecosystems from which it extracts, the colonialist perpetuity, and the effects on humans and nonhumans.

[120] William Ivins Jr., *Papers: On the Rationalization of Sight with an Examination of Three Renaissance Texts on Perspective* (New York: The Metropolitan Museum of Art, 1938).

[121] Ibid.

[122] Ibid., 10.

Perspective in Art and Science

As a curator, I am particularly fascinated by tracing how different phenomena resonate with art. Equivalents to the development of technologies, such as the example of the telescope that I outline above, can be found in the history of painting. Linear perspective was a pivotal invention in Renaissance painting, developing from the one-point perspective designated to Leon Battista Alberti around 1435–1436. As curator William Ivins Jr. shows, before the development of pictorial perspective, "there was no rule or grammatical scheme for securing [...] logical relations" between represented elements, their scale, position in space, and relation to one another. Alberti introduced a logical system, which would become important not only to painting, but to thought in a wider sense.[120] The introduction of perspective in art supported a homogenized notion of space (and, by extension, nature). It made it possible to visualize that spatial shifts are indeed what alters the visual appearance of an object, rather than the thing itself or its interior properties. Through findings occurring simultaneously, the science and technology of modernism "proved" the latter notion wrong. Perspective became a key factor for science and technology, because it evokes an optically consistent view of space.[121] The invention of perspective allowed a viewer to draw connections under a common sky and cosmos. From this followed the development of natural laws and modern unifying systems, with all the incisions and limitations they bring with them.

In 1604, astronomer Johannes Kepler mathematically proved in his treatise *Paralipomena to Witelo whereby The Optical Part of Astronomy is Treated* the technique that was already practiced in painting since Alberti, namely that "parallel lines meet at a point at infinity."[122] Supported by findings from the fields of art and astronomy, and soon also mathematics, the singular perspective would inform the position of the discrete modernist subject. The ocean became exposed in like manner, there to be grasped from a singular viewpoint,

123 Hito Steyerl, "In Free Fall: A Thought Experiment on Vertical Perspective," *e-flux journal*, vol. 24 (April 2011), https://www.e-flux.com/journal/in-free-fall-a-thought-experiment-on-vertical-perspective/.

124 Svetlana Alpers, *The Art of Describing: Dutch Art in the 17th Century* (Chicago: University of Chicago Press, 1983), 51.

125 Ibid., 27.

126 Ibid., 122.

available and attainable to the viewer, even if this homogenized view also undermined the viewer's individuality.[123] The invention of linear perspective in the Renaissance had further effect on geopolitical expansion of territory: if everything could be viewed from a single, linear perspective, it could be controlled and conquered. Art historian Svetlana Alpers points out that the distance point employed by seventeenth-century Dutch artists is even more striking than the Renaissance one-point perspective. The "wide vista" made possible by including within the same surface an "aggregate of views,"[124] places emphasis on what is captured in the viewer's eye. This assemblage of sights does not rely on a fixed position and perspective of the viewer, but rather, "made possible by a mobile eye, the retinal or optical has been added on to the perspectival."[125] The Dutch distance point makes it seem as if the depicted landscape or objects unfold themselves rather than depend on a viewer positioned at the center as it is in the Renaissance perspective. If the Renaissance dictated the view, making it linear and measurable according to the same unified parameters, the Dutch moved toward a lifelike depiction, thus naturalizing the depicted. "Like the mappers, [Dutch painters] made additive works that could not be taken in from a single viewing point. Theirs was not a window on the Italian model of art but rather, like a map, a surface on which is laid out an assemblage of the world."[126]

Artist and theorist Allan Sekula, who has worked extensively on the subject of the container ship trade, notes in reference to Alpers's account that the Dutch perspective implied a mobile viewer. I imagine it as inquisitive, perhaps in the way that Dutch seafarers and other colonizing powers traversed the oceans. Sekula identifies a shift in the mid-nineteenth century, when financial accounting procedures spread by industrialization added to a universalizing view of the previously limited knowledge of the world. By the time of the invention of the camera, the panoramic view

became mechanized and standardized, replacing the mobile spectator who became "transformed into a figure of passive consumption."[127]

The panoramic view of the oceans produced a new sense of overview and availability, of panoramas to be consumed or subjected to instrumental uses.[128] The camera further replaced the subjective view of paintings by a supposedly objective view, one that is both distanced and reproducible. Today, phone cameras and personal underwater recording devices veer from the distanced consumer perspective. Many ocean-users create their own footage of the sea. Yet, as I show later, in these representations, the panoramic view is mostly upheld, making the ocean seem as if, once again, it is there simply for us to record.

Notions of the Sublime

If the Renaissance invented linear perspective both in geo-political territorial expansion and in art, and the Dutch wide vista emphasized the view of a mobile spectator, it wasn't until Romanticism in the eighteenth and nineteenth centuries that the sensation of control and overview of nature found its counterpart in the sublime. In the Romantic era, paintings of rough seas under ominous skies abounded. These were representations of the ocean as force of nature beyond human control, surrendering its seafaring subjects to the will of the elements. Famous examples of Romantic era artists are J. M. W. Turner or Caspar David Friedrich, both of whom were drawn drawn to the limits of human experience and the psychologized turmoil of the sea in violent motion.[129] At a time when technological innovations made sea passages safer and more frequent, Turner, in particular, aestheticized the oceans.[130] Contemporary artist Sondra Perry's animation

[127] Allan Sekula, *Fish Story* (Düsseldorf: Richter Verlag, 2002).

[128] "The railroad elaborated a new world of experience, the countries and oceans, into a panorama…. It turned the eyes of travellers outward, offering them a rich diet of changing tableaux, the only possible experience during a trip." Dolf Sternberger, *Panorama of the Nineteenth Century*, trans. by Joachim Neugroschel (New York: Urizen, 1977), 39.

[129] Ronald Rees, "Constable, Turner, and Views of Nature in the Nineteenth Century," *Geographical Review*, vol. 72, no. 3 (1982): 253–269. Joseph Leo Koerner, *Caspar David Friedrich and the Subject of Landscape* (London: Reaktion Books, 2009).

130 Philip Ursprung, *Der Wert der Oberfläche: Essays zu Architektur, Kunst und Ökonomie* (Zurich: gta Verlag, 2017).

131 Sekula, *Fish Story*, 44.

132 Hugo Grotius, *The Free Sea* (Indianapolis: Liberty Fund, 2004), 47.

installation *Typhoon coming on* (2018), featuring a manipulated digital moving image of Turner's painting *Slave Ship (Slavers Throwing Overboard the Dead and Dying, Typhoon Coming On)* (1840), incisively critiques the racial and colonialist undercurrent in these notions of the sublime.

Sekula traces how the depictions of the ocean changed from the time of increasing trade in the pre-Romantic era toward the sublime. In his writing and image-based work, he identifies the sublime in art history as a reaction to what was perceived as the sea's infinitude. It was the same infinitude that had given "rise to a doctrine of free trade,"[131] that would become the foundation for the aesthetic sublime in the eighteenth century. The sublime indexed that which was beyond the limits of human reach despite the attempts at godlike omnipresence by way of linear perspective, naturalizing laws, and the charting of land and water. I would add that in eighteenth- and nineteenth-century Romanticism, the sublime seems to foreshadow the sense that control, hitherto situated within human agency, is slowly withering away.

The sea's infinitude is also evident in the law of the sea written in the late Renaissance, which I return to later on. Dutch lawyer Hugo Grotius writes in his influential treatise *Mare Liberum* from 1609: "For it is manifest that if many hunt on the land or fish in a river, the forest will soon be without game and the river without fishes, which is not so in the sea."[132] Depictions of the sea in Dutch painting are open, implying unlimited expanses to be explored and colonized, as well as infinite resources. Beyond that, according to Dutch understanding, the sea was irreducible to complete ownership—hence the notion of the free sea. Precisely this idea of excess reverberates with Romantic notions of the sublime.

The sublime is still with us today, even if in a revised form. In our current context of climate catastrophe, it has shifted from inexhaustible nature to include our heightened sense of human agency. Anthropogenic actions affect nature directly and irreversibly. While this would seem to induce a sense of control, the vast changes occurring on land and in the sea also produce feelings of powerlessness.

[133] Bruno Latour, "Waiting for Gaia: Composing the Common World through Arts and Politics" in Alejandro Zaera-Polo and Albena Yaneva, ed., *What is Cosmopolitical Design?* (Farnham, UK: Ashgate, 2015), 21–32.

[134] Francis Bacon, "In Praise of Knowledge" in *The Works of Lord Bacon, Vol. 1* (London: Henry G. Bohn, 1850).

[135] Robert Poole, *Earthrise: How Man First Saw the Earth* (New Haven: Yale University Press: 2010).

[136] James Lovelock, *Gaia: A New Look at Life on Earth* (Oxford: Oxford University Press, 1979).

The sensation of being overwhelmed and "totally dominated by the spectacle of 'nature'"[133] is comparable to the Romantic-era sublime. The sense that humans can't, to return to Bacon, command nature in action[134] is further amplified as climate change is destabilizing many of the—if always flawed—certainties that have previously provided some humans with a sense of control. Today we are caught in a divide between our actions and the impossibility to fully grasp their effects. Amid the unprecedented anthropogenic overturning of "laws of nature," with their multi-causal effects, today the sublime is revived in a zombie form.

Visions of Earth from Afar

On December 24, 1968, the photograph known as Earthrise was taken by Apollo 8 astronaut William Anders.[135] The image depicts Earth from space as a distant planet in dark emptiness, with an area of the moon's surface visible in the bottom of the photo. Earthrise is one of the first photographs in which the Earth is shown in its entirety. It evoked the vulnerability of this exceptional planet that hosts life in a large universe, as the search for life on other planets continues. This vulnerability is reflected, among other things, in environmentalist James Lovelock's Gaia hypothesis, which considers the Earth and its organic and inorganic matter as intricately interconnected ecosystem.[136]

On February 14, 1990, a similar photograph was taken from Voyager 1 upon the suggestion of astronomer Carl Sagan. In his book, *Pale Blue Dot: A Vision of the Human Future in Space* (1994), Sagan describes how the Earth appears as a tiny dot in this image taken from a distance of approximately 6.4 billion kilometers: "Look again at that dot. That's here. That's home. That's us. On it everyone you love, everyone you know, everyone you ever heard of, every human being who ever was, lived out their lives."[137] Similar to the Gaia hypothesis, Sagan suggests that the Earth, depicted as a vulnerable blue dot

137 "A Pale Blue Dote," The Planetary Society, www.planetary.org/explore/space-topics/earth/pale-blue-dot.html.

138 Kheel, "From Heroic to Holistic Ethics."

should make us acutely aware that any assumptions that us humans have a privileged position of power or control in the universe, are utterly delusional. No one will come to our rescue from the depths of other galaxies, and once we destroy what we have here, there is no escape.

Yet, while the Gaia hypothesis was originally met with enthusiasm, as ecofeminist scholar and activist Marti Kheel shows, its insistence on the planet as a living being that could be observed (and thus controlled) in its entirety served the conclusion that it could also sustain human insults.[138] This view thus partly reaffirmed, rather than radically revised, patriarchal-ecocidal attitudes. I find this tension interesting, as it is representative of many of the conundrums we face in the Chthulucene. Let me explain by way of looking at an artwork. I first encountered Rachel Rose's video *Everything and More* (2015) in the exhibition "The Infinite Mix" curated by Ralph Rugoff for the Hayward Gallery at The Store in London in 2016. In the video installation, Rose homes in on new forms of images and depictions enabled by space travel and updated technologies in the twentieth and twenty-first centuries.

Rachel Rose, *Everything and More*, 2015, HD video, 10:31 minutes. Courtesy of the artist and Gavin Brown's enterprise, New York/Rome.

Rachel Rose, *Everything and More*, 2015, HD video, 10:31 minutes. Courtesy of the artist and Gavin Brown's enterprise, New York/Rome.

The pivot of her work are the experiences of NASA astronaut David Wolf, who was on the Mir space station in 1997. The Mir station operated between 1986 and 2001 in the low Earth orbit in an altitude of up to 2000 kilometers. After listening to Wolf's accounts of his first spacewalk, where he describes moving through space without seeing Earth and experiencing a profound sense of tranquility and nothingness, Rose decided to track him down and interview him. In *Everything and More*, Wolf narrates: "When I first came back to Earth, after 128 days in space, I thought I'd ruined my life," referring to the radical change of perspective he experienced after having seen the planet in its entirety from space. This was confounded by the absence of gravity that precipitated a shift in his bodily sensorium, which Wolf describes as follows: "The weight of your body is overwhelming. Even my ears felt heavy on my head. […] And when the hatch of the spacecraft door is open, you're overwhelmed with the smell of grass and the air. It must be like a dog feels when he can smell bushes when you walk by them."

Rose's interview with Wolf was conducted over the phone and is accompanied by a live recording of Aretha Franklin's song "One More Time," edited with a spectrograph, a tool used to measure the properties of light or sound frequencies. Wolf and Franklin's voices are laid over moving images filmed in three sites: a neutral buoyancy lab in Maryland where astronauts learn to spacewalk in a five-story-tall pool of water;

Department of Marine Technology at NTNU, engineering test for an ROV autonomous control system, Trondheim, Norway.

International Seabed Authority, Kingston, Jamaica.

00.08.31.07

Michael W. Lodge, Secretary-General (former Deputy to the Secretary-General and Legal Counsel) of the International Seabed Authority, Kingston, Jamaica.

00.12.46.24

00.06.51.08

00.12.25.12

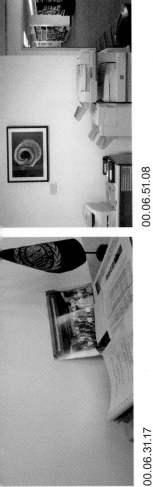

00.06.31.17

00.07.24.03

00.13.41.21

Twenty-second session of the International Seabed Authority, report of the Art. 154 review committee, Kingston, Jamaica.

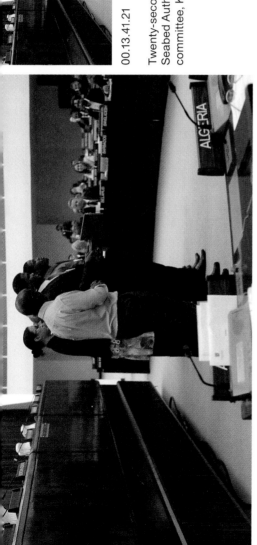

00.13.03.08

00.17.19.20

00.17.04.05

Marine Biology Research Group of Ghent University, Ghent, Belgium.

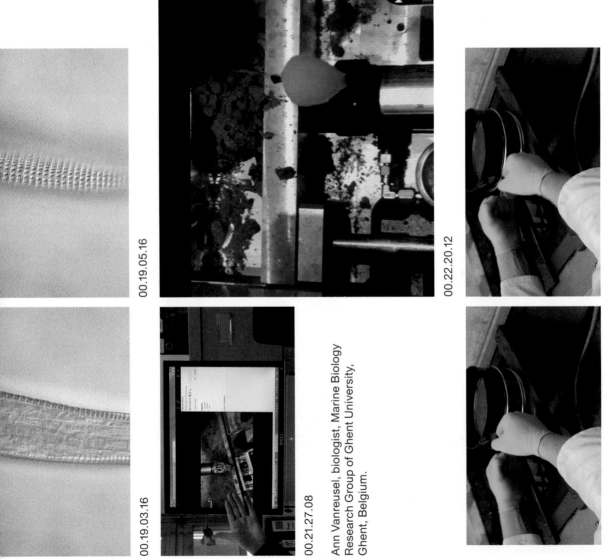

00.19.03.16

00.19.05.16

00.21.27.08

00.22.20.12

00.23.11.21

00.23.12.12

Ann Vanreusel, biologist, Marine Biology Research Group of Ghent University, Ghent, Belgium.

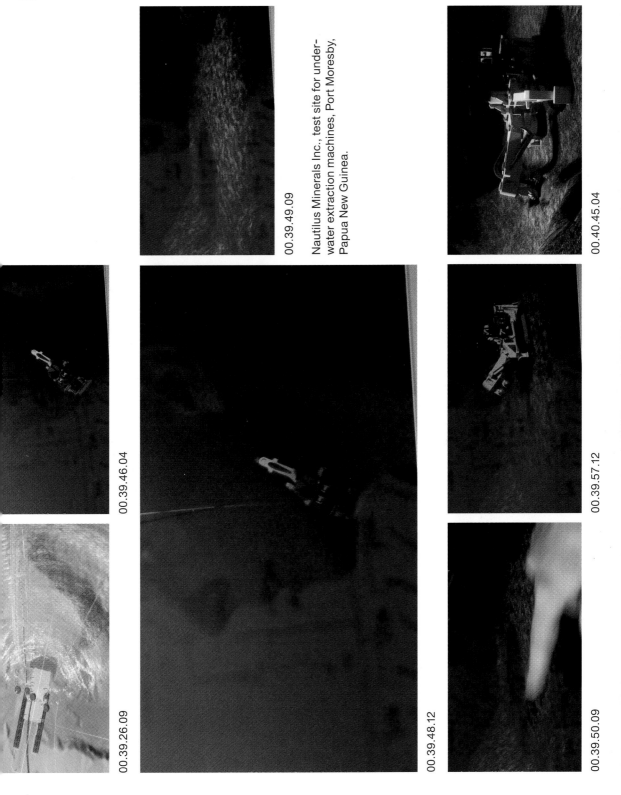

Nautilus Minerals Inc., test site for underwater extraction machines, Port Moresby, Papua New Guinea.

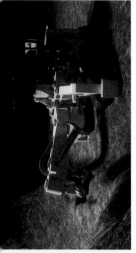

00.40.46.16

Nautilus Minerals Inc., test site for underwater extraction machines, Port Moresby, Papua New Guinea.

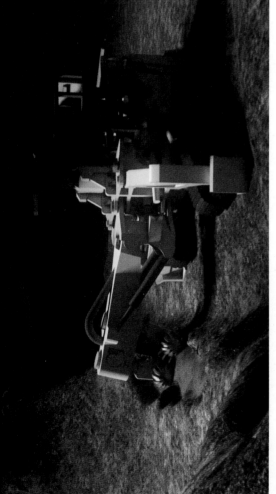

00.40.45.10

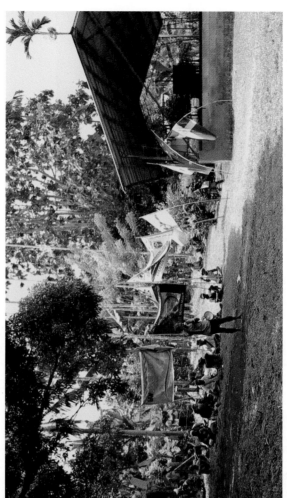

00.43.33.00

00.41.48.23

Karkar Island, protests against deep-sea mining experiments in the Bismarck Sea, Papua New Guinea.

00.47.37.24

00.47.51.23

Fishermen, Urakukur Village, Ramoaina Island (Duke of York Islands Group), Bismarck Sea, Papua New Guinea.

00.44.57.09

00.44.20.13

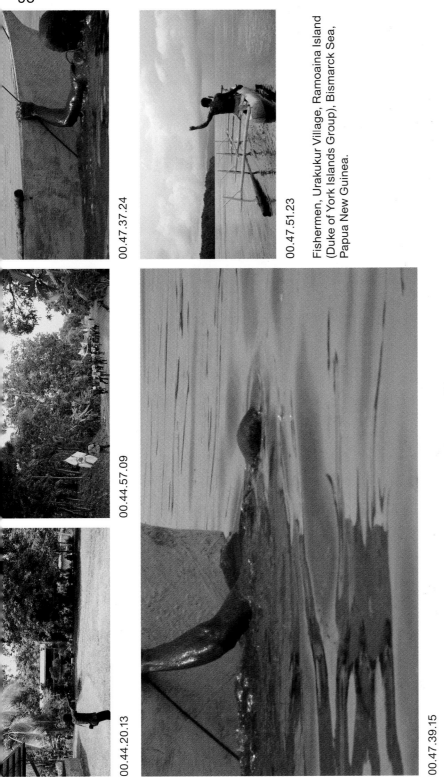

00.47.39.15

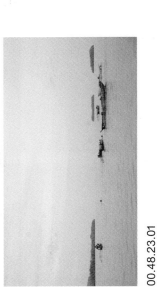

00.48.23.01

00.47.56.20

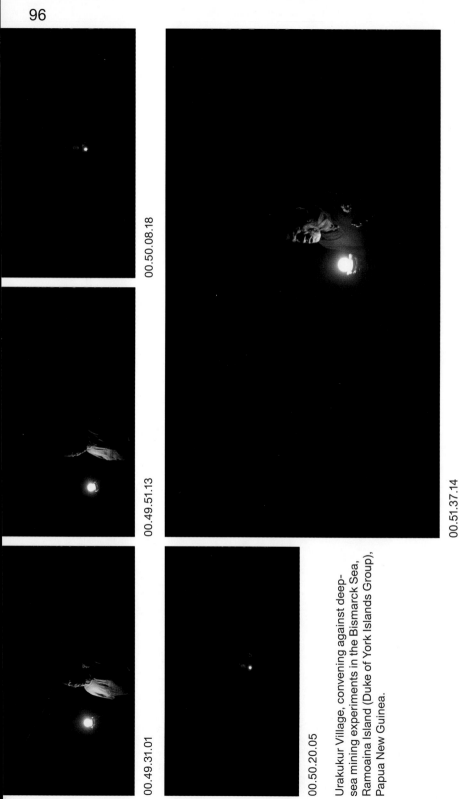

00.49.31.01

00.49.51.13

00.50.08.18

00.50.20.05

00.51.37.14

00.52.03.11

Urakukur Village, convening against deep-sea mining experiments in the Bismarck Sea, Ramoaina Island (Duke of York Islands Group), Papua New Guinea.

139 Frank White, *The Overview Effect: Space Exploration and Human Evolution* (Virginia: American Institute of Aeronautics and Astronautics, Inc., 1998).

140 Nadia Drake, "We saw Earth rise over the moon in 1968. It changed everything," *National Geographic* (December 21, 2018), https://www.nationalgeographic.com/science/2018/12/earthrise-apollo-8-photo-at-50-how-it-changed-the-world/ and Ian Sample, "Earthrise: how the iconic image changed the world," *The Guardian* (December 24, 2018), https://www.theguardian.com/science/2018/dec/24/earthrise-how-the-iconic-image-changed-the-world.

electronic dance music concerts, where the camera focuses on ecstatic crowds; and in the artist's kitchen, where everyday materials such as food dye, baby oil, milk, and water are mixed together. Rose chose the analogue blending of quotidian materials for creating abstract swirls of liquids that slowly merge with and repel each other after learning that many of the special effects in Stanley Kubrick's film *2001: A Space Odyssey* (1968) were not made using a computer, but by hand, and processed utilizing different camera lenses. In Rose's work, the filmed images of the neutral buoyancy lab are further distorted by passing through an editorial process in Adobe After Effects. Akin to the effects produced with the kitchen materials, which are concocted together as in a chemistry experiment and manipulated with an air compressor and ferromagnetic fluid, these distortions create a warped perspective of our usual visual sense.

Writer Frank White refers to the term "overview effect" in his 1987 book of the same name to describe the profound shift in perspective experienced by astronauts after having seen Earth from space.[139] White cites architect R. Buckminster Fuller's book *Operating Manual for Spaceship Earth* (1968), suggesting that we are all astronauts who need to take care of the vehicle on which we travel through space—the Earth. The overview effect denotes the fragility of the planet evoked by its depiction as a blue marble, and has helped alter the attitude of many people to usher in the green movement.[140] However, the Earthrise image has also created a new sensation of control, as we saw via Kheel. The removed human view provides that we are literally outside of the planet we are looking at. Since it can be depicted as a single entity by a human-engineered machine, we are tricked by the illusion that it can be understood in its entirety. And thus, this view of the Earth as a

pale blue dot also makes it appear manageable, oscillating between modernist control and a new sublime, which is not restricted to a local storm or shipwreck, but unfolds on a planetary scale.

In a video interview with the Louisiana Museum of Modern Art, in Denmark, Rose describes how in addition to the interview with Wolf, the movies *Gravity* (2013, directed by Alfonso Cuarón) and *Interstellar* (2014, directed by Christopher Nolan) inspired her to make *Everything and More*.[141] After watching *Gravity* at the cinema, a film centering on two astronauts lost in space after their spaceship is destroyed, Rose says that "she felt completely deconditioned"[142] from her environment and even her own body. She refers to the sensation as a sense of the sublime, of awe at the smallness of humans faced with the vast expanses of the universe, and analogously with the utterly urbanized environment of New York City, where she lives. The sublime is juxtaposed with the quotidian present in her use of materials from her kitchen, but also in using water to emulate the effect of zero gravity. Using cinematic methodologies of triggering deep emotional response through light and sound sequences, Rose's work mediates the tensions between the vast scale of outer space and the miniscule details of mundane materials. In bringing together these different scales and materialities, Rose highlights the incompatibility of our experiences of phenomena too large to grasp (like the overview effect or climate change) and a simultaneous sense of fear and awe present in the contemporary sublime.

Optical Consistency

As I think and live with art, I am interested in works that have shaped art history and continue to influence artists, curators, and art historians today. One of those works is Charles and Ray Eames's famous film *Powers of Ten* (1968). Like in Rose's video, views from outer space are at the core of the work, yet it presents a rather techno-utopian perspective. The nine-minute film starts with a view of a couple sitting on a picnic blanket in a park in Chicago. Every ten seconds, the camera zooms

Rachel Rose, *Everything and More*, 2015, HD video, 10:31 minutes. Courtesy of the artist and Gavin Brown's enterprise, New York/Rome.

away by the power of ten. The image distances to give a view of the park, then a frame of the city with the lake from above, then moves on to images of clouds above the landscape, to the Earth as a solid sphere, visible in its entirety. As the planet disappears into the distance, we see the stars and our galaxy, a small part of the path the Earth orbits around the sun, other planets, and the sun. A voice-over says: "Ten to the fourteenth: as the solar system shrinks to one bright point in the distance, our sun is plainly now only one among the stars." Rather than single stars, we soon see several galaxies in the same frame, as the camera moves toward the vast emptiness of the universe. Once all we see is almost entirely dark, the direction of travel of the image changes, and we find ourselves falling back toward Earth with sped-up velocity.

As the view goes back to the original scene of the couple in Chicago, the camera continues to zoom in on a proton in the nucleus of a carbon atom beneath the hand of the man sleeping on the picnic blanket. The movement slows down to reduce the distance to the end by 90 percent every 10 seconds. We view skin cells, DNA, and double helixes. Next is the atomic scale: three hydrogen atoms bonded to a carbon atom, which appear in quantum motion. The camera homes in on the outer electrons, then on the inner electrons, entering an inner space of the carbon nucleus, then zooming in on a single proton.

Moving out into space and returning to look at a single proton in a human hand, the film transcends distance in space

and matter as if there were no physical boundaries or thresholds. It creates an illusion of sameness of matter and plays into notions of human control over the environment and the overcoming of spatial and temporal distance. It produces a linear narrative accompanied by graphic indications of the perspective each frame presents—a new kind storytelling made possible by technology. Whereas cameras enable the appearance and preservation of things over long periods of time and distances, here the moving image collapses that, occupying time itself.[143]

In *Powers of Ten*, the untethered perspective and distance evoked by images of the planet seen from afar, but also by the same technological devices helping us see the depths of the ocean, bear an aftertaste of the recognizable settler-colonialist imagery of conquering remote spaces. Sixteenth-century explorers were sent by their respective courts and companies to explore, and the measurements they made were created under the assumption that scientific objectivity could replace the historical embeddedness of knowledge in a wider field of social, political, economic, legal, and cultural stakes. I see what Ivins calls "optical consistency" in *Powers of Ten*'s universal system to categorize the observed in relation to each other, in a similar way to how linear perspective organizes vision.

As indicated earlier, the image of our fragile globe as "one world," precipitated through the visualizing techniques of technology and science, may also be positive. After all, the Eameses show our connectedness, and highlight the way in which cameras have made it possible to see that which can be destroyed. As sociologists Bronislaw Szerszynski and John Urry argue, imagery of "banal globalism" could be helpful to "create a sensibility conducive to the cosmopolitan rights and duties of being a 'global citizen,' by generating a greater sense of both global diversity and global interconnectedness and belonging."[144] Translation is important. So is seeing things in a web, even if that overview is always reductive. Art historian James Elkins refers to these unifying procedures as a "'cascade' of successive abstractions."[145] Such abstractions

[143] Eric Schuldenfrei, *The Films of Charles and Ray Eames: A Universal Sense of Expectation* (London: Routledge, 2015).

[144] Bronislaw Szerszynski and John Urry, "Visuality, mobility and the cosmopolitan: inhabiting the world from afar," *The British Journal of Sociology*, vol. 57, issue 1 (2006): 122.

145 James Elkins, *The Domain of Images* (Ithaca: Cornell University Press, 1999), 40.

can help us approximate the irreducible multiplicity of phenomena. Data brought together across vast scales could even help us speculate on connections between diverse parts and attribute responsibility. In terms of the oceans, understanding the interconnectedness between ecosystems on multiple temporal and spatial scales is necessary to devise emergency solutions, even if they are always necessarily limited. And yet, while we need to continue undoing the patriarchal-colonialist past embedded in such abstractions, we could also find ways to strategically apply these methods in order to grapple with the oceanic Anthropocene. They may assist us in bringing the oceans closer to those of us who have lost contact with them or never had it. They may help us mark out the urgency of our planetary situation.

Mediated Reality

Let us return again to the main video in Linke's exhibition "Prospecting Ocean," and use this example to further discuss mediated images. Putting aside the questions of the images' indexicality or how closely they operate near the "real-world" referent they end up capturing, I want to focus here on the mediating function they fulfil. The camera in this case is the in-between human eye, an organ that has been trained, through civilization, to perceive in a specific way. I want to consider the epistemological turn that looking glasses and other technologies create. Being able to zoom in on minute details of the universe, observing the deepest areas of the seabed previously not perceptible to the human eye, marks a decisive cut in how we perceive the world.

Linke's photographs are often printed in a format that might guide us to call them "off." Rather than centered in the frame, the pictures are held by irregularly large mounts on one of the four sides of the image. The white area fills the standard-size frame around the photograph whose proportions do not fit it. The "perfectly" framed representation of reality is questioned in the way the photographs are mounted, exposing that they are a construct on a pictorial, epistemological, and ontological level. What's more, Linke's aesthetics often

defy representative conventions of aesthetics, beauty, and spectacle. Rather than photographing, for instance, a serene ocean landscape or reproducing the imagery of science that exists in the popular imagination, supported by advertising and pop cultural representations, the subjects, coloration, and feel of his photographs are often mundane and, I would argue, removed. We seem to be witnessing a processed and sobered perspective on science, an approach that does not buy into the representations often perpetuated in other fields. Through printing and framing, he questions the positions of both photographer and onlooker as situated outside of, or as being external to the reality they depict.

 The effect of the way Linke mounts his photographs is achieved in his videos as well, by the presence of mediating screens. Viewers are often presented with screens within screens—a character on a computer, a machine of sorts, a phone, and so on. They see what they look at via a screen, while we, the viewers, look at a screen watching them look at mediated reality. In *Prospecting Ocean*, we witness a scene the artist filmed during the UN conference on the oceans in New York in 2017. A group of Fijian participants, dressed in traditional attire, perform a cava ceremony on the floor of the UN conference room. They sit down on the mat, and for a brief moment seem to interrupt the business-as-usual of the international conference staged according to official protocols. While world leaders discuss the future of the oceans from a perspective of abstract quota, geopolitical strategies, and negotiations that resemble resource grab more than the struggle for a sustainable future, the Fijian leaders bring to the table a perspective of those who are directly affected by the climate catastrophe. The UN summit was headed under the stewardship of Fiji that year, and the scene powerfully reminds us that the people most immediately affected by these short-sighted and predominantly politico-economical, rather than ecological, debates are those that live in close proximity to the oceans.

 Linke's perspective, showing the Fijian delegates through the screen of a camera person filming the summit, also points to how conferences such as this capitalize on displays of "ethnic authenticity." Neimanis analyzes such stagings in reference to Spivak's assessment of a similar case during a conference organized by the Bangladeshi Green Party at the European Parliament in 1993 to discuss the Flood Action

Plan (FAP). Abdus Sattar Khan, a leader of the Bangladeshi peasant movement, was invited as "subaltern" to speak on how the FAP was going to destroy rural livelihoods.¹⁴⁶ Khan did not stick to protocol, and he didn't address the assembly in English, and the organizers had failed to provide a translator. This case painfully shows how platforms such as the ones provided by the UN often invite "subaltern" representatives as Others who come to share a redemptive truth. The organizers do not, however, accommodate such different forms of contributions. As a result, non-Western voices often go unheard (literally, in Khan's case) or are perceived as folkloristic showings. By capturing another filmmaker's screen, Linke's video highlights the limitations of these forums between good-willed naivety at best and profiting off people's desperation to be listened to at worst.

Prospecting Ocean (video stills).

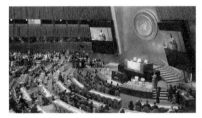

Through his aesthetic choices, Linke points to the conundrums of optical consistency and universalizing knowledge inherent in Western sciences. These paradigms are neither fit for nor intended to accommodate other forms of narration. Linke's photographs and films call attention to the modernist mode of creating an outside, which is often replicated in science, that presupposes an external position from which the subject of study is analyzed. The mediating properties of technologies, and especially lenses (in cameras, in telescopes), privilege the eye over other organs. They bolster the disembodied gaze as controlling, knowing, and coldly observing, but not involved in the messiness of the world. By suggesting an untethered perspective of truth, the camera mediates reality in the same objectifying way the viewfinder objectifies the seen. As such, the camera is a perfect paradigm for three things: the distancing of viewer and world, a plane of supposed equal value of all things depicted (considering in principle that

everything is depictable) that elude the admittance of other values, and the apparent creation of an outside from which the inside can be observed without being part of it.

Apparatuses are never "outside" or isolable from the contexts and other apparatuses by which they are shaped. They are implicit, they are part of the matter they observe, they affect it, as we learn from the work of physicist Niels Bohr, and as Barad convincingly argues. A camera will always alter the scene it captures. And thus, while pointing out the problems inherent in the production of images, Linke also produces another, critical and conscious, way of seeing. His work doesn't merely posit the artist as observer, but shows his own interference in the creation of artifactual reality. In fact, I would argue that at its most successful this is what all art does. It can call forth new constellations, in which artist and viewer are implicated. It can suggest that things may be different than previously assumed.

Virtual Immersive Oceans

In recent years, new visual forms and experiences have proliferated via virtual reality (VR) technologies. These immersive devices, often configured as headsets with a screen and sometimes audio features and remote controls, are gaining importance for the shaping of the contemporary visual regime. In this chapter I tend to VR as a mediator as it is more and more prominently used in the arts. As often happens when artists adopt new technologies as they become available for wider use (think of video art in the 1960s), in some cases the works result in gadget fascination, and in others they critically put forth processes that conjure new observations. As VR ushers in a new optical paradigm, I want to analyze the implications for both art and ocean excavations.

VR devices place subjects at the center of the world they observe. The screen occupies the core of vision. The visual periphery of the outside world is blocked out by the headset to create an immersive experience entirely composed of the stimuli provided by the technology. Virtual reality devices grant the user a first-person perspective that is created by interweaving "real" and "virtual" experiences. Artist and hacker Ricardo Dominguez calls digitally devised scenes that are difficult to discern as unreal "minor simulations."[147] Works created in VR by artists such as Dominique Gonzalez-Foerster, Jon Rafman, and Daniel Steegmann Mangrané depict abstract

147 Coco Fusco, "On-Line Simulations / Real-Life Politics: A Discussion with Ricardo Dominguez on Staging Virtual Theatre," *The Drama Review*, vol. 47, no. 2 (Summer 2003): 151–162.

148 The exhibition was the 8th Momentum Nordic Biennial of Contemporary Art in Moss, Norway, titled "Tunnel Vision."

149 "From science fiction to (virtual) reality in deep-sea research," Monterey Bay Aquarium Research Institute (MBARI), February 7, 2018, https://www.mbari.org/underwater-virtual-reality/.

images as they transform, as well as elements from modernist paintings or rain forest environments that a user can explore from within. I showed Steegmann Mangrané's work *Phantom (kingdom of all the animals and all the beasts is my name)* (2013–15), which transports viewers into a rain forest, in an exhibition I co-curated in Norway in 2015, and juxtaposed it with an analogue film (titled *16mm,* 2007–11) Steegmann Mangrané shot in the same forest in order to highlight how differently but also similarly spaces and the situatedness of the viewer are treated in these media.[148]

This kind of works, like updates of nineteenth-century dioramas, are now also entering the realm of ocean exploration. At the Monterey Bay Aquarium Research Institute (MBARI), scientists are experimenting with VR technology to capture and analyze features from the deep sea. Using remotely operated vehicles, the team scans and digitizes 360-degree perspectives of oceanic ecosystems. Construed from video sequences as well as thousands of photographs of rocks and other features found in the ocean, the structure-from-motion photogrammetry process allows scientists to build 3D models of these sites. The MBARI website suggests that these tools can be beneficial for scientific research as biologists can analyze deep-sea organisms such as fragile squids without capturing and damaging them. They can also measure the biomass on rocks by creating 3D recordings of the multi-matter conglomerates and virtually separating organic from inorganic materials.[149]

To render a deep-sea coral in computer-generated pixels, the 3D-scanned material is analyzed with the help of algorithms. While this is certainly a way to examine vulnerable organisms as stand-ins for deep-sea dives available to those who do not have access to these experiences, at the moment, experiencing VR as mere simulation of "reality" is quite disappointing. I say so, of course, because I've been lucky enough to go on actual dives. And yet, the computer-generated

[159] Jodi Dean, "The Anamorphic Politics of Climate Change," *e-flux journal*, vol. 69 (January 2016), https://www.e-flux.com/journal/69/60586/the-anamorphic-politics-of-climate-change.

[160] Thomas Albert Sebeok, *Contributions to the Doctrine of Signs* (Bloomington: Indiana University Press, 1976). Jacob von Uexküll, "The new concept of Unwelt: A link between science and the humanities," *Semiotica* (2001): 111–123.

like world-building algorithms that are devised by corporations whose interests hardly lie in the advancement of knowledge—however flawed these ideological attempts and methods may be—but in the creation of profit.

In her analysis of partial perspective in relation to climate change, political science scholar Jodi Dean turns to Jacques Lacan's writing on the 1533 painting *The Ambassadors* by Hans Holbein the Younger, a work featuring anamorphosis in the form of a painted skull which can only be discerned from a specific vantage point. Dean suggests that in Lacan's analysis of anamorphosis "the space of vision isn't reducible to mapped space but includes the point from which we see."[159] Thus, to perceive the distorted picture, the viewer needs to adopt what Dean calls a partial or partisan perspective. Anamorphosis not only requires a singular vantage point, but it also brings out a hidden reality in the most convincing way since it can, after all, be seen by a human observer. Anamorphosis is thus a reversal of the illusion of space. The artist does not depict an existing space in the most realistic manner, but brings out a hidden reality via the illusion of space. In a similar way, the hidden, or alternative, reality that virtual images bring forward may indeed supersede or become more important than the reality that is visible to the mere eye without the use of technology. It can bring about interesting new worlds. Its immersive features make it all the more convincing. In VR, adopting a partial perspective that interrogates the depicted, suspending its immediate acceptance, becomes increasingly difficult.

Caught in the tension between creating an all-enveloping, immersive visual (and auditory) situation and a manipulable outside whose workings don't affect us in the end, VR environments are conceived as spaces that are inexhaustible, permit only a predetermined set of actions, and can be reset if necessary. Virtual worlds imitating underwater environments propose a new kind of "Umwelt."[160] In the early twentieth century, biologist Jakob von Uexküll adopted the term

Umwelt to describe an organism's perceptual world. While Uexküll thought that different creatures' Umwelts are incommensurable and fixed, biologist and evolutionary theorist Lynn Margulis critiques this view as too limited. She proposes that life worlds are symbiotic and permeable.[161] In a similar vein, gender, technology, and culture researcher Zoë Sofia suggests the term container technologies instead of Umwelt. She likens the function of containers as a "safe preserve for humans or other entities to become themselves"[162] to the environment or the (feminized) care for a child. As I discuss earlier, humans attempt to reproduce this function in built environments, from adobe cottages to skyscrapers, for protection and functionality. Unlike tools, containers fulfil their purpose of holding without any work, yet they are not passive. Rather than an impermeable Umwelt, containers are processes that emerge together with humans and are responsive to other things in a sympoietic way. They are "spatially and temporally contingent manifestations that are part of a whole environment, field, or network."[163]

The way VR is currently designed, however, is caught within the paradigm of an impermeable Umwelt that mostly serves as a passive envelope. If there is a zombie new sublime lurking from the vast spatial and temporal unmooring caused by climate change, with stupefying effects impossible to grasp, the orb-like representations of VR may be an attempt to pretend that we can still control things in a contained, human-created reality.

Construing worlds through visual parameters designed for a human observer is not sufficient to account for the co-emergence and sympoiesis of humans and nonhumans with each other and their environment. In these relations, care leads to blossom and neglect to injury. To limit the representation of our Umwelt to optical and auditory immersion is a reductionist and inherently violent view of the way life worlds interact and emerge together. As such, VR is often not used as an alternative to but as a continuation of constructions of reality drawing on optical consistency and placing humans at the center to suggest that everything is at hand to them. It does so ever

[161] Lynn Margulis, *The Symbiotic Planet: A New Look at Evolution* (New York: Basic Books, 1999).

[162] Zoë Sofia, "Container Technologies," *Hypatia*, vol. 15 no. 2 (Spring 2000): 193.

[163] Ibid., 194

more convincingly for the experiencing subject, partly because participation and immersion reduce the capacity of criticality.

As someone who has experienced VR on several occasions, I have come across instances in which VR *does* produce exciting new assemblages, and some in which it doesn't. Steegmann Mangrané's work *Phantom (kingdom of all the animals and all the beasts is my name)* succeeds in producing a ghostly simulacrum of a rain forest to highlight it as a space of projections for Western fantasies, which always remains inaccessible. In the cases when VR doesn't work, it produces illusionary spaces from which the outside world can be shut out, creating isolationism and escapism. This may be precisely one of the reasons why such technologies are so attractive to us today. Romantic notions of the sublime sit so well with seascapes because their overwhelming force reminds us of our own limits. In VR, the physical risk can be shut out, as can the consequences of environmental degradation, apparently. Users have little material presence in VR experiences. They are neither acknowledged as creator nor as affected and implicated by their own anthropogenic effects and the mutually constituting relationality with other entities. And so, when used uncritically, VR produces a stand-in for reality that appears controllable if everything around the modern Western subject ceases to appear so.

The distance upheld through technological mediation, the distance that enables us to think of ourselves as separate from nature, is challenged by climate change. Sediments move, critters migrate, and global heating is not contained in a single location. Philosopher Timothy Morton proposes the term "hyperobjects"[164] to refer to the things that are too large for humans to grasp, yet clearly exist and affect us on multiple levels. These include the weather, global warming, plastic in the ocean, and, I argue, the effects of deep-sea mining. They seem to be contained at the ocean floor, but surpass any supposed spatial or temporal containment.

The Collapse of Distance

164 Timothy Morton, *Hyperobjects: Philosophy and Ecology after the End of the World* (Minneapolis: University of Minnesota Press, 2013).

165 Daisy Hildyard, *The Second Body* (London: Fitzcarraldo Editions, 2017).

166 Bruno Latour, "Waiting for Gaia."

167 Sara Ahmed, "Affective Economies," *Social Text*, vol. 22, no. 2 (Summer 2004): 117–139.

Hyperobjects, only perceptible in parts and through their effects, never as a whole, break down modernist notions of distance. With global heating an invisible yet palpable entity, the distance upheld by technologies such as VR becomes ever harder to maintain. In her book *The Second Body*, author and historian of science Daisy Hildyard describes how the actions of our bodies in the here and now have an effect felt remotely, far removed from the physical body itself.[165] Our bodies do not end with their physical boundaries—the skin—but have far-felt globalized, planetary, and environmental consequences. They are part of the biosphere. Therefore, attempts to separate ourselves from an avowed Umwelt are not only short-sighted but outright dangerous.

And yet, the question Latour poses remains: "Is there a way to bridge the distance between the scale of the phenomena we hear about and the tiny *Umwelt* inside which we witness, as if we were a fish inside its bowl, an ocean of catastrophes that are supposed to unfold?"[166] The denialist assumption that we can distance ourselves from the climate catastrophe is a reaction to the incommensurability of three things: the modernist conjecture that we are outside of nature; the abstract numbers as which carbon footprint, for instance, is presented; and the dawning sense that we might not be as unaffected or outside of the crisis as we thought we were. This is particularly true for Western and wealthy nations, which have subsisted on exploitative relationships with the rest of the planet to uphold such notions of distance. This ideological construct is a defense that climate change deniers attempt to uphold against the scary reality. Intersectional feminist scholar Sara Ahmed reminds us that fear is linked to expectations of what will happen in the future, rather than what is here in the now.[167] Denialist constructs never worked for the Global South and they are quickly crumbling in the Global North.

A 2005 study on people's beliefs regarding global warming and their perceived distance from weather shows the impact

of psychological distance on attitudes and behaviors.[168] If people perceive disagreement among scientists regarding data on the effects of climate change, they are less likely to accept anthropogenic global heating and less willing to take action to avert it.[169] Spatial and temporal distance, i.e. effects not affecting people soon enough, as well as alleviating actions not being effective quickly enough, also contribute to apathy. However, merely reducing this perceived psychological distance is not necessarily the best way to convince people just how urgently action is needed. If climate change is perceived as too close and too complex a subject to tackle, "it is likely to be associated with intense emotional reactions, which have the potential to provide avoidance."[170]

The conundrum outlined by Latour and studies such as the one I mention here is the need for causality and the understanding that artifactual reality exists, even if it is hardly linear or monocausal and thus easy to grasp. Feminist, queer, and postcolonial theory have contested the way that causality is traditionally understood because it naturalizes cause and effect. Causality, in fact, is a signature icon of Western modernity, of the drive to conquer and make the natural world conform to the dictates of progress.[171]

Causality doesn't take into account the complexity of different temporal and spatial scales and their relationality. Tsing shows that scalability has become impossible in the Anthropocene. If it was possible before, it was only as much as such tales were convenient for the progressivist project. Modernist progress is based on the assumption that anything can be calculated, and that in order for growth to occur, all that is needed is scaling up. In the Capitalocene, these same behaviors dismantle the modernist framework within which this paradigm was thought to work, always unfairly distributing

168 Cameron Holley and Clifford Shearing, ed., *Criminology and the Anthropocene* (London: Routledge, 2017).

169 Ibid.

170 R. I. McDonald, H. Y. Chai, and B. R. Newell, "Personal experience and the 'psychological distance' of climate change: An integrative review," *Journal of Environmental Psychology*, vol. 44 (2005): 109–118, 115.

171 Max Haiven, "The Dammed of the Earth: Reading the Mega-Dam for the Political Unconscious of Globalization" in Chen, MacLeod, and Neimanism, ed., *Thinking with Water*, 213–232, 221.

172 Elizabeth M. DeLoughrey, "Satellite Planetarity and the Ends of the Earth," *Public Culture*, vol. 26, no. 2 (2014): 257–280.

173 James Bridle, *New Dark Age: Technology and the End of the Future* (New York: Verso, 2018).

174 Haiven, "The Dammed of the Earth," 217.

175 Ibid.

176 Astrida Neimanis, "Water, a Queer Archive of Feeling" in Stefanie Hessler, ed., *Tidalectics, Imagining an Oceanic Worldview through Art and Science* (Cambridge: MIT Press, 2018), 189–198.

benefits and damages. Today, these conditions continue to be dissolved from within. If scalability is impossible in the Anthropocene, then risk and benefit cannot be calculated, and we realize that they never could. The tools and behaviors that eroded this flawed foundation are becoming blatantly useless.

Deep-sea mining, like climate change, is a distributed phenomenon. It occurs far from us mostly land-dwelling humans and it is largely invisible. It is effectuated by manifold actors, through bureaucratic structures and procedures that are difficult to grasp, arguably designed to that end. And yet, the consequences of deep-sea mining, like climate change, cannot be shut out any longer; they never could be in the Global South, but soon they will also affect first and second bodies in the North.

How, then, can we overcome such distance while sidestepping the anonymous mass of data suggesting causality and with that a continued sense of control? We now know that belief in the possibility of grasping things in their entirety, with their colonial-patriarchal histories, will not do it.[172] The more we try to represent a whole, the more we fail, realizing the immensity of the task at hand and that the data we accumulate is largely useless noise.[173] And yet, we need to avoid the trap of emotional or personal preference as it is currently happening in reactionary politics. To this end, media and social justice scholar Max Haiven suggests that we rethink causality not as "cosmic order but dense web of collective fictions to explain agency."[174] Here, "water's unimaginable causality"[175] can be helpful. Water defies the ability to chart effects and causes. Neimanis convincingly argues that water is a queer archive of feeling, an archive that both retains and dissolves.[176] It may allow for some radioactive isotopes to be traced, it may retain some heavy metals and toxins but it dissolves others. It is thus a potent metaphor. Water has been a key element also in some writers and activists' imagined technological utopias in a science-fiction, speculative way,

[177] "About," Geocinema network, http://geocinema.network.

in which our utter non-natural forms are indeed what might help us overcome sexism, racism, ageism, ableism, and other isms. In becoming other, cyborg, or alien, the writers attempt to overcome naturalized categories of the human and hierarchies of who may be more human than others. Some examples here include Octavia Butler, Youmna Chlala, and Ursula K. Le Guin. Water may help us conceive of partial perspectives. It may inspire situated stories beyond the universal.

Planetary Sensing and Cinematic Oceans

The work of the artistic research collective Geocinema offers an alternative way of looking at technology to sense the planetary processes and changes in the Capitalocene. The group comprising Asia Bazdyrieva, Alexey Orlov, and Solveig Suess considers "planetary-scale sensory networks—cell phones, surveillance cameras, satellites, geosensors—as a vastly distributed cinematic apparatus: a camera."[177] Geocinema accesses databases of imagery created around the world, live and tuned to each other, in a decentralized filming and editing process which represents the planet in an extensive yet fragmentary and consciously incomplete way.

Geocinema (Asia Bazdyrieva, Alexey Orlov, and Solveig Suess), Score by Nikita Alekseenko, *Episode 03: Framing Territories*, 2018, Full HD video, 01:46 minutes. Courtesy of the artists.

Geocinema (Asia Bazdyrieva, Alexey Orlov, and Solveig Suess), Score by Nikita Alekseenko, *Episode 03: Framing Territories*, 2018, Full HD video. 01:46 minutes, Courtesy of the artists.

Geocinema's working method proposes a novel understanding of cinema and image creation, corresponding to the way that technological devices, from the telescope to underwater cameras in ROVs, have come to represent the Earth and shaped our conceptions of our relation to it. The group highlights our mediated access to land and water, and uses the same mediating technologies to conjure new imaginaries.

In 2018, on commission from The New Networked Normal, a partnership between five European arts organizations developed to investigate art, technology, and

citizenship in the age of the internet, Geocinema developed the project *Framing Territories*. Focusing on the Digital Belt and Road (DBAR) big data program connected to the Chinese Belt and Road Initiative (BRI), the collective investigated the environmental effects of this large-scale geopolitical project. They looked particularly into the terraforming and policy-making modes which are devised with the promise to connect Africa, Asia, and Europe.

Geocinema (Asia Bazdyrieva, Alexey Orlov, and Solveig Suess), Score by Nikita Alekseenko, *Episode 03: Framing Territories*, 2018, Full HD video, 01:46 minutes. Courtesy of the artists.

Framing Territories consists of a short (1 minute and 46 seconds) video sequence construed from numerous still images stitched together to simulate a stop-motion movement along a road. The journey starts in a dry and dusty landscape then moves through more urbanized, green, and populated areas. It is entirely composed of imagery derived from billions of cell phone and surveillance cameras, and thousands of satellites and geosensors. At a certain point in the video, the images tilt so much that they eventually flip upside down, only to reverse to right side up as we travel along a highway that runs through a forest. The video ends with views of the sky and cloud formations, again drawn from the cinematic matrix of existent footage of the area. The unrelenting speed with which the images change makes it close to impossible to discern street signs, yet at times Cyrillic script on signposts reveals an approximate geographic location. The area mapped in the

video is Omsk Oblast, where the company Gazprom Neft, the third largest oil producer in Russia, is tracking territory, and in particular the Arctic, in real-time.

Data and the infrastructures supporting its recording, analysis, and dissemination are Geocinema's cinematographic apparatus. Tapping into these devices, the artists use them to sense the Earth differently. Rather than acting as filmmakers capturing an image, they rely on "readymade" material produced for other purposes and often created through automatic filming processes amassing large amounts of data through the use of satellite footage or cameras attached to cars, like the ones used to gather material for Google's Street View function. In repurposing these images, Geocinema sutures alternative narratives that undo the monolithic, objectifying, and all-encompassing projects driven by companies and governments.

Sociologist Jennifer Gabrys writes about planetary sensing in relation to the forest as a way to create other planetary narratives. The forest, its atmospheric processes, and the images feeding into our imaginaries "tell diverse stories that span the remote, the durational, the extractive, the accumulative, the inhabited, and the contested."[178] In stitching together signals derived from processes to sense the Earth, be it for empirical study, surveillance, or tracking, Geocinema brings together diverse planetary images. Their videos tell histories construed of multiple ecologies, in which landscapes are never understood as singular, but are, just like the planetary, intricately connected. In the words of the artists: "Geographies fluctuate between registers of sensing from the planetary to the local, where certain slippages provide clues to how narration doesn't always abide one to one."[179] As such, Geocinema proposes a way between modelling and perception to see otherwise, by construing from material produced for other means, bringing it together in unexpected ways.

Methods of storytelling such as these pose an alternative to the way that natural environments are usually represented—as distant. This is particularly important for areas that are relatively inaccessible for most of us, such as the deep sea.

[178] Jennifer Gabrys, "Becoming Planetary," *e-flux architecture* (October 2018), https://www.e-flux.com/architecture/accumulation/217051/becoming-planetary/.

[179] "Geocinema," The Influencers, https://theinfluencers.org/en/geocinema.

180 Octavia Cade, "Nature as Creative Catalyst: Building Poetic Environmental Narratives through the Artists in the Antarctica Programme" in Nicholas Holm and Sy Taffel, ed., *Ecological Entanglements in the Anthropocene* (London: Lexington Books, 2017), 159–176, 160–161.

181 Lisa Bloom, *Gender on Ice: American Ideologies of Polar Expeditions* (Minneapolis: University of Minnesota Press, 1993).

182 Jennifer Wild, *The Parisian Avant-Garde in the Age of Cinema, 1900–1923* (Oakland: University of California Press, 2015).

183 Neimanis, "Water, a Queer Archive of Feeling."

With respect to another remote region, Antarctica, author Octavia Cade reminds us that with access usually limited to explorers or scientists, these geographies are often mythologized.[180] Such mythologizing narratives are commonly centered on singular (heroic) events.[181] They obscure history, materialities, and indeterminate encounters. In favoring the agency of heroic explorers, these accounts construe nature as hostile, *against* human agency. Only the (male, white, Western) hero can "civilize" such nature and survive. Access restrictions, sometimes for safety and often because of governmental-corporate secrecy with respect to their regions of extractive interest, further support such imaginaries of distant, "dangerous" nature. Many Hollywood movies tap into these precise tropes, suggesting that only a superforce can save us, and that it might as well be better if we just give up and give in to our fate.

The oceans can be explored as a cinematic device, because they, too, work like a camera. They are transparent while their depths obscure. They create a sense of temporal and spatial proximity as much as distance. The cinematic projection screen is both a divisor and a portal into another world. Transparent screens reveal an image but also obscure that which lies behind. Film shown in this way is like a specter, horizontally coexisting in the same space as the audience and thereby challenging the hierarchy of representational and epistemological order.[182] The oceans can be thought of as a cinematic tool that reveals and conceals, that connects and divides matter at once. Neimanis describes water as a substance that remembers as much as it dissolves "both matters *and* feelings."[183] Film, too, captures images as light exposed onto negatives—images that may vanish over time. Water registers changes in the atmosphere. When we're immersed in it, water mediates our vision and our hearing. The ocean's fluid masses are a moving image in and of itself.

184 Nurit Bird-David, *Us, Relatives* (Oakland: University of California Press, 2017), 223.

185 Anna Lowenhaupt Tsing, *Friction: An Ethnography of Global Connection* (Princeton: Princeton University Press, 2005), 4.

186 Mary Louise Pratt, *Imperial Eyes: Travel and Transculturation* (London: Routledge, 1992).

187 Arjun Appadurai has shown how globalization benefits from the creation of locality. Arjun Appadurai, *Modernity at Large: Cultural Dimensions of Globalization* (Minneapolis: University of Minnesota Press, 1996).

The Pluripresence of Uneven Flows

As climate change brings into threatening proximity the "outside," making distant nature crash in on us, we need to be careful not to homogenize the effects thereof. We need to attune ourselves to the specificity of place and of scale, of materiality and temporality: certain actors cause larger impacts, some geographies are more vulnerable than others, and some humans and more-than-humans are more affected than others. The importance of scale-sensitivity and pluripresence is pointed out by anthropologist Nurit Bird-David when she suggests that traditionally Eurocentric disciplines need to pay attention to indigenous "scale-making projects."[184] The multiscalar perspective she proposes for the field of anthropology can be useful also when thinking about ecological scales and modes of register of the environment and impacts thereon, as in the example of Geocinema's work.

Besides sensitivity to scale, attention to frictions, resistances, and various modes of viscosity are vital for thinking through the oceanic Chthulucene. Friction, "the awkward, unequal, unstable, and creative qualities of interconnection across difference,"[185] is more useful than the liquidity that sociologist Zygmunt Bauman considers a main feature of modernity. Language and cultural theory scholar Mary Louise Pratt contends that the metaphor of modernity's flow applies only to the few.[186] While what is considered local commonly tries to tap into the flow of globalization, access to participation is unevenly mediated. For instance, exploited workers in the Global South do not partake in such flows, and neither do the wealthy who build walls of isolation designed to uphold the illusion of separable places.[187] Pratt promotes a

their lives. Primacy is not given to the human perspective and experience of the ocean, or to the occurrences we witness as viewers. Instead, the boat becomes a main character, as well as the numerous creatures that feature in the water and in the fishermen's nets. In fact, the film's credits roll includes, alongside the humans, all of the fish species and other more-than-humans whose agency, as part of the large oceanic network the film draws on, is emphasized as no less than that of their anthropoid counterparts.

The film is not a usual cinematic narrative, with a clear storyline and dialogue. In fact, there is hardly any language at all. Every now and then, the fishermen can be heard speaking, but mostly, we hear only the waves, storms, rain, and the slapping of the bodies of fish caught in the nets against the perimeters of the ship. I find the film both fascinating and difficult to watch. It is brutal and incredibly direct as many of the usual filters of cinematographic production hardly apply. There are numerous scenes with no narrative, just sensations, sounds, and movements. As a human viewer, it makes me feel moments of intense dizziness as the images and soundtrack swirl around me, created by the recording devices trembling and moving with the water.

Castaing-Taylor and Paravel both teach at the Sensory Ethnography Lab at Harvard University, an interdisciplinary department that tries to make sense of the parts of life experience that are neither easily captured by the semiotic,

Véréna Paravel and Lucien Castaing-Taylor, *Leviathan*, 2012, DCP, 1.85:1, Dolby 5.1., 87:00 minutes. Courtesy of Cinema Guild.

nor by the camera and its emphasis on the retinal. As such, the film is an interesting case trying to overcome the opposing paradigms of transparency and availability, disposal of the ocean at the hand of humans, and obscure otherness, which is often utilized in order to justify adversarial treatment of the sea. In calling attention to the more-than-human, and in adopting a novel approach to filmmaking and camera handling, the work breaks with the paradigm of what is represented and what is not.

The film is an experiment in methods of paying attention by attuning ourselves to what is going on around us, beyond the tradition of cinema apparently able to reveal a hidden truth. Noticing, here, goes beyond the retinal, the idea of a linear storyline, of removed rationality and distance, in which the eye can wander across great distances, often aided by telescopes, cameras, and so on, while staying dry and safe. Moreover, *Leviathan* affects the whole body of the viewer, and thus viscerally, intensely, precludes a position of distance. One might say that this too is brutal and violent, as it doesn't allow for the viewer to choose their own positioning and grant them agency as to how they want to pursue their own role as spectators. However, in the age of the Anthropocene, when former certainties no longer apply and our tools for understanding causalities, if always flawed, are less and less useful, we need to develop new attunements. These must verge away from a humanist subject "from whom *nothing, in principle, is hidden.*"[193] The modernist humanist subject's eye, and by extension the human-operated camera, can scan over and grasp *everything*. In *Leviathan*, it can't. Narrative agency is passed on to the boat and the fish, with the fishermen as a few of many other protagonists, and the primacy of the retinal is done away with. As such, in calling attention to how that modernist concept has been flawed from the outset, in the film, the "human" perspective is dissolved.

[193] Cary Wolfe, *What is Posthumanism?* (Minneapolis: University of Minnesota Press, 2010), 167.

Modernist conceptions of landscape mostly conceive of it as static and disregard the processes shaping it, notably labor.[194] Labor here comprises the direct interventions of early agrarian societies, planned mass agriculture, infrastructures of the Capitalocene, and the unacknowledged, often hidden, and abusive, exploitative work of colonialism.

The Ocean as Place and Space

194 Raymond Williams, "Ideas of Nature" in *Problems in Materialism and Culture* (New York: Verso, 1980).

195 Raymond Williams, *The Country and the City* (London: Chatto & Windus, 1973).

196 Tim Ingold, *Being Alive: Essays on movement, knowledge and description* (London: Routledge, 2011).

197 Williams, *The Country and the City* (London: Chatto & Windus, 1973).

The changing understandings of the laws of physics and perspective I discuss earlier when writing about the telescope and cameras as instrumental for representing oceanic space, found direct application in work altering the Earth.[195] But notions of landscape derived from seventeenth-century Dutch perspective and new inventions also eclipsed these transformations. Ingold suggests that a linguistic similarity between the words *scape* (from Old English *sceppan* or *skyppan*, meaning to shape) and *scope* (from classical Greek *skopos*, target, and *skopein*, to look) led to misconceptions of landscape as something natural, viewed from a distance, thereby obscuring landscape as something altered by humans.[196] When land was no longer only used for agriculture, but became the subject of paintings, *scape* came to be conflated with *scope*. The moderns thought of landscape as scenery, similar to how it has been mapped by cartography and incorporated into the art historical canon of painting—and later photography.

Agrarian capitalism changed nature by what was considered improvements both in "working agriculture" and in "artificial landscapes." Human-designed neopastoral landscapes functioned as entertainment for the upper classes and served the interests of Western societies undergoing extensive transformation. Cultural theorist Raymond Williams suggests that the country house and estate represent a new ideology, in which "nature" is set aside for enjoyment and exploitation.[197] By extension, Kheel draws connections between the passivity of nature and its simultaneous depiction as demonic and wild, both conceptions of which disavow its agency.[198] In a similar manner, today parts of "nature" are established as reserves for enjoyment and protection. Or, in the case of protective zones in deep-sea mining, to buffer the effects of extraction in nearby areas.

As I show earlier, the borders of such reserves are fictional and permeable. Anthropologist Arjun Appadurai's

198 Kheel, "From Heroic to Holistic Ethics."

199 Appadurai, *Modernity at Large*, 45–46.

200 Scott and Swenson, ed., *Critical Landscapes*, 6.

sketching of the processes that transcend and dissolve previous real or imagined boundaries is useful to unpack this. Appadurai introduces the terms ethnoscape, financescape, ideoscape, mediascape, and technoscape "to stress different streams or flows along which cultural material may be seen to be moving across national boundaries."[199] These scapes are fractal and overlapping, they are not stable but dynamic. Like landscapes, these scapes are constructed by the reach and limits of human sight, and thus the ability to shape them, rather than merely by specific geographic conditions. The intertwinement of the scopic and the shaping of our surroundings, even if etymologically often mistakenly put together, is convincing. That which is visible appears to be controllable, and we control things by bringing them literally into sight.

Environmental humanities scholar Emily E. Scott and art historian Kirsten J. Swenson remind us that "the constitutive forces of landscape are most often hidden from view, eluding our ability to know by standing onsite and looking alone."[200] The visual dimension of these sites is often designed to obscure the processes shaping them. This skillful fogging of the interferences in the scopic regime is certainly also true for oceanscapes. If we turn to the sea, it becomes obvious how the idea of a fixed and isolable *scape*, controllably shaped by humans for exploitation or protection, is even more inadequate than on land. Vision is limited and water does not stay still. The oceans can't be fully seen, nor shaped to our liking. Dams and water mills to harvest energy, besides mining, are attempts at forming them according to human needs, but the common failures of these interventions point to the limitation of such projects. The notion of control granted by scope (to view) and its resultant legitimation to scape (to create) dissolves.

The compound of viewing and shaping is amplified by technologies. Early tools to measure the oceans' depths are either literal fathoms, pieces of lead tied to a string, or sound beams. The registers here are haptic and sonic. Since modernity, these have been secondary to the primacy of the retinal. The inability to grasp the oceans with those visual

registers deemed worthy and considered a form of knowing may be one of the reasons why the oceans were deemed an exploitable "other." Nowadays, remotely operated vehicles and underwater cameras are available to fathom the oceans. And as (visual) technologies advance, the modernist attitude of control seems legitimized once again as we are presented with the idea of being able to view the oceans in their entirety.

Smooth and Striated Ocean Spaces through Time

As remoteness is deployed as a foundation of the objectives of colonialism and capitalism, modernity attempts to overcome this precise distance. Since Magellan and other expeditions, globalization has conceived of the oceans as the base of (uneven) capital flow. The sea is traversable, with emphasis on vectors and movements rather than fixed points, making it, in the words of philosophers Gilles Deleuze and Félix Guattari "a smooth space *par excellence*."[201] Deleuze and Guattari further show that as capitalism advanced by navigation across the open sea, the oceans became increasingly striated.[202] Astronomical discoveries made it possible to calculate a ship's exact position based on its relative location to the stars. Deleuze and Guattari define the year 1440 as a turning point for the intense stratification of the sea, after Portuguese explorers introduced some of the first nautical charts. Maps, as we have seen, were developed to lay a rigid grid over the oceans, making them measurable and traversable. Cartographic tools served to make oceanic space seem generalizable and "faraway" lands and people possible to subjugate.[203] Such Eurocentric, imperialist notions of the oceans have supported colonialist expansionism and the transatlantic slave trade, creating, in the words of scholar Denise Ferreira da Silva, "a dimension of the colonial juridic-economic architecture."[204]

[201] Gilles Deleuze and Félix Guattari, "1440: The Smooth and the Striated," in *A Thousand Plateaus* (New York: Continuum, 1987), 529.

[202] Ibid.

[203] Steinberg, *The Social Construction of the Ocean.*

[204] Denise Ferreira da Silva, "Toward a Black Feminist Poethics," *The Black Scholar*, vol. 44, no. 2 (2014): 81–97, 83.

205 Paul Gilroy, *The Black Atlantic: Modernity and Double Consciousness* (New York: Verso, 2002).

206 A few years after the publication of *Mare Liberum*, in 1635, English jurist John Selden published the treatise *Mare Clausum*, which claimed exclusive rights over the stretch of water dividing England from the European continent. In the book, Selden argued that the oceans could be appropriated just as much as territory on land.

207 The convention today covers not only the freedom of the high seas, but also the rights for territorially based national seas.

208 Davor Vidas, ed., *Law, Technology and Science for Oceans in Globalisation: IUU Fishing, Oil Pollution, Bioprospecting, Outer Continental Shelf* (Leiden: Martinus Nijhoff Publishers, 2010).

Historian Paul Gilroy shows how the diffusion of these oppressive systems across the Atlantic through flows of capital, goods, and people both dissolve and re-erect distance.[205] We see how distance and proximity are invoked alternatively as deemed convenient.

One year after Hans Lippershey's invention of the telescope in 1608, another important moment in the history of charting the oceans is established as fellow Dutchman Hugo Grotius, a jurist educated at Leiden University, published *Mare Liberum (The Freedom of the Seas)* in 1609. The treatise I briefly mention above would lay the foundation for the international law of the sea. Subtitled *The Right Which Belongs to the Dutch to Take Part in the East Indian Trade*, the book gave Grotius the occasion to claim the Dutch right to trade in the East, seven years after the founding of the Dutch East India Company. Grounding the claim to trade in natural law, Grotius argued that the sea could not be owned, contradicting the Treaty of Tordesillas of 1594, by which the Portuguese and Spanish had claimed exclusive rights over eastern trading routes.[206]

Grotius's conception would largely prevail for centuries to come, and would form the foundation for the 1982 United Nations Convention on the Law of the Sea (UNCLOS).[207] As of 2019, 168 nations have signed the UNCLOS. It is accepted almost universally, including by states that haven't signed it, but it is also continuously violated.[208] According to international law researcher Davor Vidas and biologist Peter Johan Schei, the ideology of the free sea not only led to capitalism's advancing but also effected anthropogenic

impacts on the environment.²⁰⁹ Beyond the geopolitical, economic, and ecological changes that the freedom of the seas entailed, the open ocean was also an area of psychological and emotional projection. In Virilio's words: "The open sea was to compensate for every social, religious and moral constraint, for every political and economic oppression, even for the physical laws due to the earth's gravity, to continental crampedness."²¹⁰ I outline how these projections play out in the chapter on the oceanic sublime.

 States soon sought to curb the material and ideological overflow of the open sea by seeking domination over ports and routes, as well as lands and people reached via the ocean. Capitalist conceptions of ocean space as an emptiable space of otherness, a place outside of civilization, became the area against which civilization can be measured, in turn also strengthening conceptions of civilized land by means of comparison with that which lies "outside."²¹¹ If this applies to the oceans at large, it does even more to the mythologized deep sea.

 In his study of the oceans through history, Steinberg shows how the Mediterranean view and use of the sea, from which much colonial power emanated, differs from other notions, for instance that of Micronesia. I mention earlier that, according to Steinberg, the Micronesian conception of the ocean is imbued with a sense of place. The Mediterranean, in contrast, was thought to be a force field over which states asserted their power to monopolize resources—an attitude that largely characterizes the West to this day. With the development of industrial capitalism, which then superseded the mercantilist era, the ocean was considered ever more a placeless space.²¹² Conceiving of the ocean as an empty space, its abstract and smoothly homogenized

209 Peter Johan Schei and Davor Vidas, "The World Ocean in Globalisation: Challenges and Responses for the Anthropocene Epoch" in Peter Johan Schei and Davor Vidas, ed., *The World Ocean in Globalisation: Climate Change, Sustainable Fisheries, Biodiversity, Shipping, Regional Issues* (Leiden: Martinus Nijhoff Publishers, 2011).

210 Virilio, *Speed and Politics*, 65.

211 Steinberg, *The Social Construction of the Ocean*.

212 Ibid., 112.

213 Allan Sekula and Noël Burch, directors, *The Forgotten Space* (Icarus Films, 2010).

214 Deleuze and Guattari, "1440: The Smooth and the Striated."

215 Steinberg, *The Social Construction of the Ocean*.

216 Ibid.

nature permitted ostensibly unhindered "flows" of Western intentionality and exploitation. Even though the oceans were charted, they functioned primarily as surface for traversing routes above a large void. They became, to return to Sekula, the "forgotten space."[213]

Particularly in the context of twentieth-century economic liberalism and militarism, the tension inherent in conceiving of the sea as either smooth or striated increased. Deleuze and Guattari show that the submarine, moving not only on the horizontal plane of the ocean surface, but also into the waters' depths, complicates the previously common two-dimensional gridding. While moving through space in a way that treats it as smooth, yet relying on striating technologies, the submarine controls territory and contributes to the ever more complete striation of the ocean.[214] This Western expansionist urge stops short neither at the edge of the sea or the bottom of the oceans, nor on the high seas, but reaches out into space. The conceptions of ocean space as smooth and striated coexist in a dialectic relationship in which they constitute each other.

Unlike the centuries before, the key driving forces of industrial capitalism were not states, but individuals and their corporations.[215] Over time, fixed investments in the oceans became possible in the form of oil platforms, or, as of late, the infrastructures put in place for deep-sea mining. This once again challenges the conception of the ocean space as smooth. Fixed investments away from land confuse the conceptual and legal divide between nations, their EEZs, and the high seas beyond national jurisdiction.[216] We see some of these tensions unfold in seabed mining today. As the ISA distributes exploration rights to mining companies and sponsoring states, the previously untouchable seabed of the high seas is becoming compartmentalized, imbued with infrastructure, and subject to claims of exclusive use (if not quite ownership, yet).

217 Sekula and Burch, *The Forgotten Space*.

218 Steinberg, *The Social Construction of the Ocean*, 165.

219 Michel Foucault, "Of Other Spaces: Utopias and Heterotopias," trans. by Jay Miskowiec, *Architecture/Mouvement/Continuité*, no. 5 (October 1984): 46–49.

Oceanic Heterotopias

Ships have been and continue to be crucial vessels for exploration, trade, and prospecting schemes such as deep-sea mining. If conceptions of the ocean as smooth are measured against its striation, the ship is likewise an interior to an exterior, a vessel in water. Sekula and filmmaker and theorist Noël Burch extensively studied the container ships of globalized trade. Sekula is known for his photographic and moving-image works, often made in collaboration with Burch, which rely on narrative. Through the form of the visual essay, the artist avoids the pitfalls of the captured image as a "sarcophagus of meaning,"[217] a dead yet fetishized archive. Instead, he shows connections, however fleeting, and focuses on specific stories instead of grand narratives. As such, rather than pointing toward a past moment in the photographic tradition, these essays refer to the present, ongoing movement. They evoke the oceanic *mobilis in mobile* (moving amid mobility).

Carrying closed repositories of commodities, these vessels anonymously traverse the oceans. Steinberg suggests that with the container ship, trade is in fact "reduced to *movement*."[218] For similar reasons, Foucault identifies the ship as a "heterotopia *par excellence*."[219] As a heterotopia, it not only exists outside of "civilization" but also serves the aims of capitalism. Romantic tropes of the ocean as smooth space of otherness and mysticism conceal its increasing striation through fixed infrastructural investments and other exploitative methods. Deep-sea mining, for instance, is obscured by the seafloor's mythologized remoteness and ostensible impenetrability. Intimate knowledges of ocean-users as well as techno-scientific advancements contradict such imaginaries. But they linger on in our fantasies—conveniently so for capitalism, whose workings of exploitation of land and water, humans and nonhumans, continue largely unhindered.

In Castaing-Taylor and Paravel's *Leviathan*, as the film breaks with the smoothly flowing conventions of

220 Economic geographer David Harvey similarly critiques the idea of heterotopia as necessarily freeing: "I keep expecting these words to appear on commercials for Caribbean cruises. [...] the cruise ship is indeed a heterotopic site if ever there was one; and what is the critical, liberatory and emancipatory point of that?" David Harvey, "Cosmopolitanism and the Banality of Geographical Evils," *Public Culture*, vol. 12, no. 2 (May 1, 2000): 529–564.

221 Doreen Massey also shows that air travel produces a further divide between those who travel on airplanes and the people living on islands below. She asks how the alleged connections of air travel have helped the people above whose heads the planes move: "Pitcairn, like many other Pacific islands, has never felt so far from its neighbours." Massey, "A Global Sense of Place," 25.

cinematography by absorbing the brutal tossing around of the trawler by the waves, the ship's function as heterotopia is emphasized. The lack of human language, the workers' arduous labor conditions, the impossibility of the boat to hold still and thus be grasped, and the turning of live fish into dead matter all come close to reiterating the oceans as the sublime. Yet, the artists transgress this by exploring precisely how Western Romanticism conceived of the ocean as opposite to civilization and ships as heterotopias onto which desires are projected. In *Leviathan*, the vessel is a metaphor for the tension of the ocean as an unconquerable Other and the ocean as a grid that can be colonized through navigation, militarism, and geopolitical trade agreements.

As a heterotopia, the ship serves fantasies of liberation. It is imbued with promises of taking us far from the constrictions of land, without actually fulfilling them.[220] As sites of alternate organization of space, heterotopias are in fact not only tolerated by capitalism's ordering but essentially necessary. Moreover, the ship is also a reminder of the sticky materiality of the ocean. The ocean's liquid mass carrying the ship poses resistance to the supposed unobtrusive fluidity of space and the immediate connection of nodes and places. As we saw previously, modernist ideas of unhindered, even flow are deceiving. If the focus on speed annihilates the ocean space from the imagination, air travel in particular divides the bourgeois elites from the workers on the ships, many of

whom come from the Global South.²²¹ In eliminating from consciousness the oceanic distance and materiality between them, it also eradicates from consumers' consciences the places of manufacturing. As a result, the sea—and with it the conditions of production in sites of Western outsourcing as well as labor on the ships themselves—are eliminated from social consciousness. In *Leviathan*, the sea is brought back as a material-discursive site, in which distance is not eliminated by air travel but felt across every wave, and where work is palpable and very real—at times almost too real to keep looking.

Water Like Land and Land Like Water

The sea is caught in between capitalism's need for fixity and mobility even more than land is.²²² Capitalism's production of space, particularly in the oceans, is in tension with, and simultaneously exploits, the contingent, changing, and incalculable dimension of nature-cultures. Steinberg writes that capitalism "has progressed by creating places and arranging them hierarchically."²²³ If the sea was to matter to capitalism, that is, as something other than a placeless surface to be transgressed, it had to be imbued with place. The sea thus needed to remain smooth but simultaneously become like land, with fixed territorial investments which workers would tend to not as fishermen, but like factory laborers, in a stable site.²²⁴

Conceptions of the ocean as a space devoid of places, only to later restructure it according to the needs of capitalism, can be traced to the abstraction of space and time in capitalism's ideas of nature. As we have seen, in capitalism, space and time are increasingly fragmented, homogenized, and ordered. Space, whether "natural" or urban, is both part of the production of value and necessary to produce objects of consumption.²²⁵ As capitalist production of surplus value is territorial and spatial, it is also involved in the production of space.²²⁶

222 Steinberg, *The Social Construction of the Ocean*.

223 Ibid., 22.

224 "Survey: The deep green sea," *The Economist*, special supplement to *The Economist*, vol. 23 (1998), cited in Steinberg, *The Social Construction of the Ocean*, 173.

241 Matthew D. Turner, "Political ecology and the moral dimensions of 'resource conflicts': the case of farmer–herder conflicts in the Sahel," *Political Geography*, vol. 23 (2004): 863–889.

242 The experimental area spanned a diameter of 2 nautical miles or 3700 meters, covering an area of 3.14 square nautical miles or 10.8 square kilometers, and a water depth between 4040 meters and 4170 meters.

scholar Matthew Turner shows, using the example of farmer-herder conflicts in the Sahel region, that conflicts occur more often around spatially fixed sites and resources than around more spatially diffused resources.[241] Spatial (and temporal) dispersal also makes conflicts harder to situate. Such diffusion is often employed as an advantage for resource robbery.

The diffused influence in the ocean makes conflicts hard to trace. At the same time, the seabed is becoming an increasingly fixed site. A specific extraction area claimed by a company and a sponsoring nation is treated as a demarcated zone with fixed resources. Here, a conception of place is mapped onto "nature" as a background from which assets can be disembedded. On this matrix, we can position conflicts in the deep sea as both located, since they occur around fixed resources, and hard to situate, as they are temporally diffused.

I want to look at an example of space making practices and conflict with regard to deep-sea mining. Under the aegis of the former Ministry of Science and Technology of the Federal Republic of Germany, a seabed area rich in manganese nodules in the Peru Basin in the southeastern Pacific Ocean was singled out and set aside to study the long-term effects of deep-sea extraction.[242] Spurred by increasing economic interest in seabed minerals, the so-called disturbance and recolonization (DISCOL) experiment was funded between 1988 and 1997. Further studies were supported within the framework of the European JPI Healthy and Productive Seas and Oceans as part of the pilot project Ecological Aspects of Deep-Sea Mining between 2018 and 2022. The DISCOL project began with a baseline study in 1989 and involved controlled disturbance in the ocean floor, which was plowed to simulate and research the long-term effects of deep-sea mining.

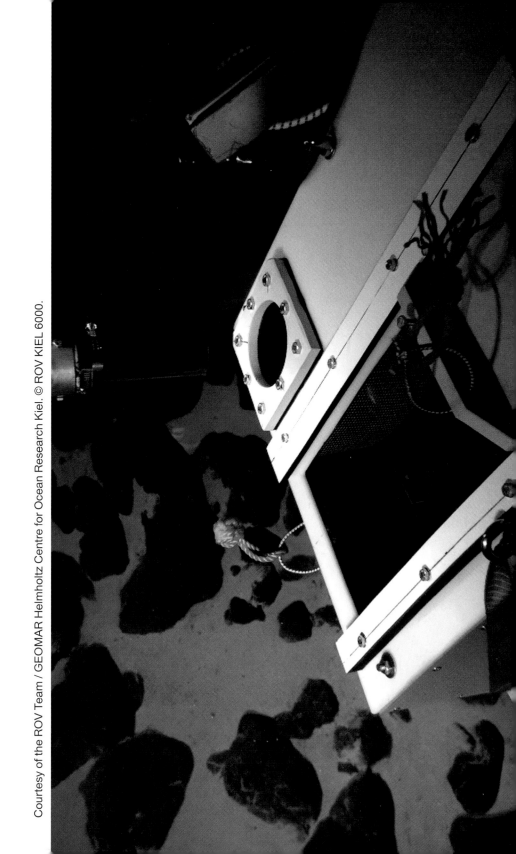

Courtesy of the ROV Team / GEOMAR Helmholtz Centre for Ocean Research Kiel. © ROV KIEL 6000.

10.18 A thin veneer of manganese covers current abraded sandstone in the Luz Strait. Coarse black sand has abraded the manganese coating at the edge of pock in the rock, 2380 m, Luzon Straits, northeast of Calayan Bank.

The rate of accumulation of manganese may be a function of the c centration of manganese in the waters and the total quantity of wa passing around the growing nodule. Although manganese concentratio in sea water appear to be fairly constant in mid-ocean, there may be si nificant local variations in the vicinity of the continental sources.

The presence of Miocene sharks' teeth, both within nodules and uncoated fossils associated with the nodules, have long suggested th these objects remain on the sea floor for long periods of time. As h already been pointed out, sediment is not collecting on top of the no ules, nor is it seen drifted or banked against them. Thus they must be mobile as the sediment and not constitute permanent obstructions to cu rent flow. On the continental rise, drifts and streamers of sediment a formed behind mounds as large as a normal nodule; but such feature are not found behind nodules lying on the deep-sea floor.

ROLL ON

Thus, the mineral gardens reveal a dramatic exception to the vast, eve veil of sediment which was previously supposed to cover the entire abys

Manganese nodules depicted in Bruce C. Heezen and Charles D. Hollister, *The Face of the Deep* (New York, London, and Toronto: Oxford University Press, 1971), 440.

Manganese-encrusted whale bone, 3500 m, Heezen and Hollister, *The Face of the Deep*, 443.

William Beebe, *923 Meter unter dem Meeresspiegel* (Leipzig: F. A. Brockhaus, 1940), reproduction no. 48.

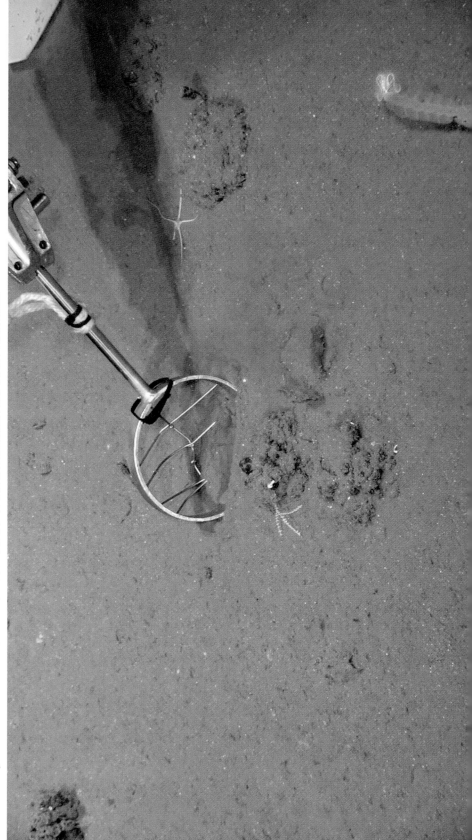

Courtesy of the ROV Team / GEOMAR Helmholtz Centre for Ocean Research Kiel. © ROV KIEL 6000.

Promotional image for Jacques-Yves Cousteau's *Le monde sans soleil* (World Without Sun), Columbia Pictures, 1964.

John Ernest Williamson, *Twenty Years Under the Sea* (New York: The Junior Literary Guild and Hale, Cushman and Flint, 1936), 32.

William Beebe, *923 Meter unter dem Meeresspiegel* (Leipzig: F. A. Brockhaus, 1940), reproduction no. 19.

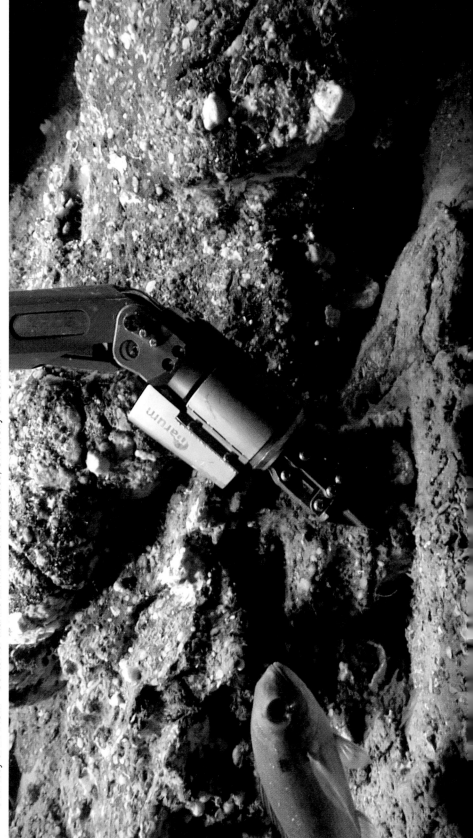

Courtesy of MARUM – Center for Marine Environmental Sciences, University of Bremen.

Manganese nodules depicted in Bruce C. Heezen and Charles D. Hollister, *The Face of the Deep* (New York, London, and Toronto: Oxford University Press, 1971), 229.

William Beebe, *923 Meter unter dem Meeresspiegel* (Leipzig: F. A. Brockhaus, 1940), reproductions no. 114–116.

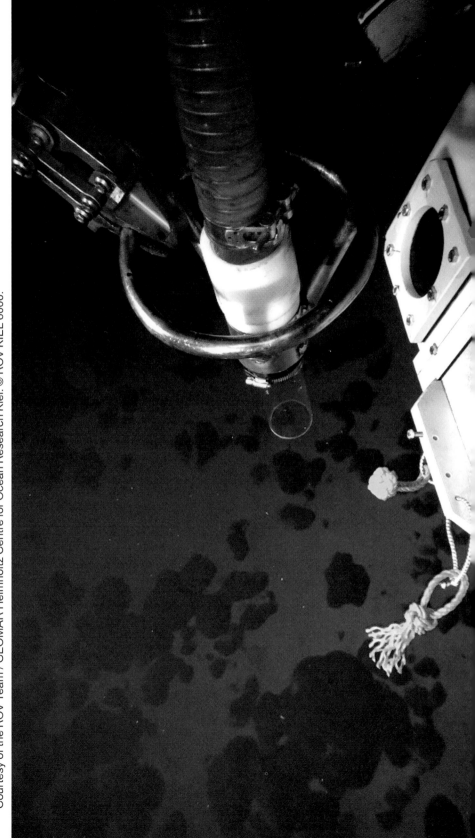

Courtesy of the ROV Team / GEOMAR Helmholtz Centre for Ocean Research Kiel. © ROV KIEL 6000.

DISCOL 1, SONNE 61, STATION 20, OFOS 2, February 10, 1989, 4:11:14. © Video Archive Material GEOMAR Helmholtz Centre for Ocean Research Kiel.

DISCOL 1, SONNE 61, STATION 20, OFOS 2, February 10, 1989, 4:11:14. © Video Archive Material GEOMAR Helmholtz Centre for Ocean Research Kiel.

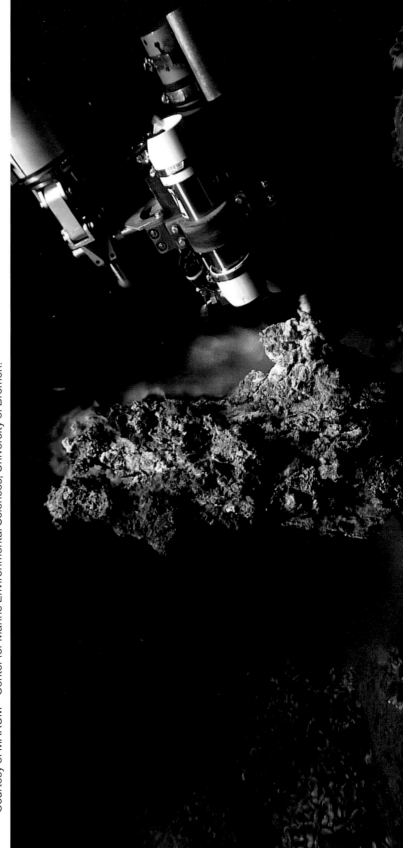

Courtesy of MARUM – Center for Marine Environmental Sciences, University of Bremen.

William Beebe, 923 *Meter unter dem Meeresspiegel* (Leipzig: F. A. Brockhaus, 1940), reproduction no. 47.

Promotional image for Jacques-Yves Cousteau's *Le monde sans soleil* (World Without Sun), Columbia Pictures, 1964.

William Beebe, 923 *Meter unter dem Meeresspiegel* (Leipzig: F. A. Brockhaus, 1940), reproductions no. 49–50.

155

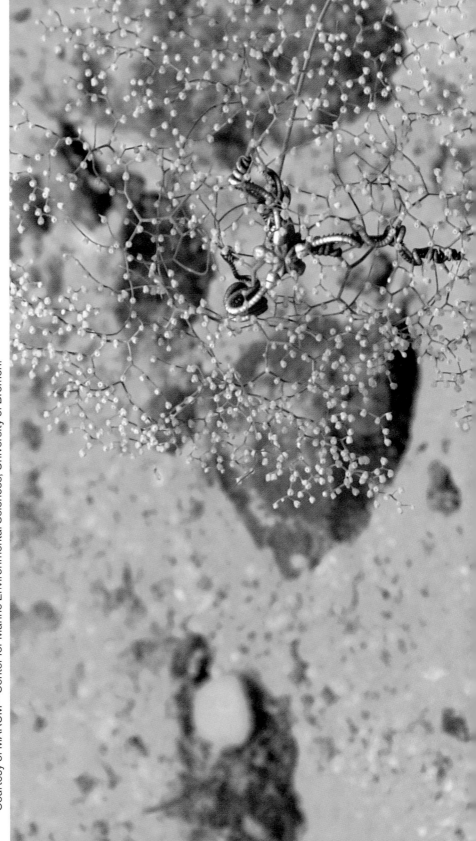

Courtesy of MARUM – Center for Marine Environmental Sciences, University of Bremen.

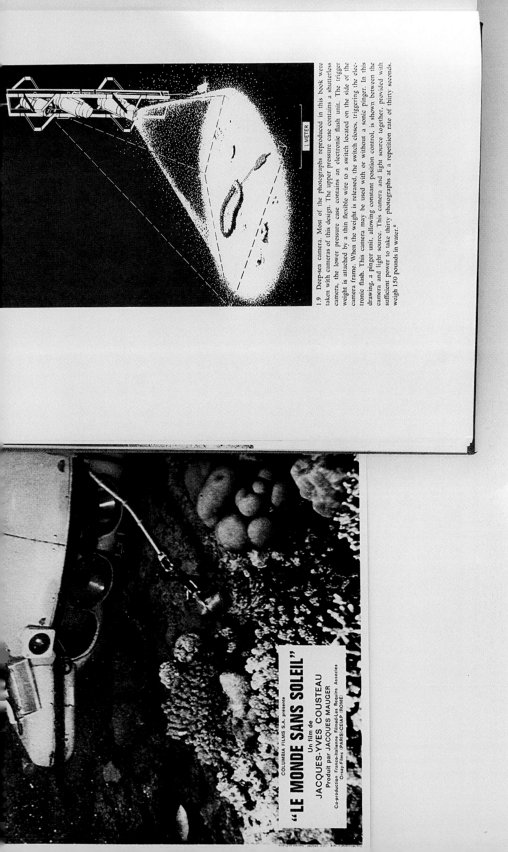

Promotional image for Jacques-Yves Cousteau's *Le monde sans soleil* (World Without Sun), Columbia Pictures, 1964.

Deep-sea camera with electronic flash and pinger unit designed to take photos every ten seconds, depicted in Bruce C. Heezen and Charles D. Hollister, *The Face of the Deep* (New York, London, and Toronto: Oxford University Press, 1971), 14.

In earlier chapters of this book I examine technologies of vision, from the telescope to VR, and how they are applied in extraction and inspire new assemblages in art. Let us stay for a moment with the myriad of human-developed technologies that are utilized to extract minerals and organisms from the seabed. I follow the lead of Haraway, who argues that we need to put more emphasis on the "embodied nature of all vision."[256] Inspired by her experiences in the sea, scholar and surfer Karin Amimoto Ingersoll shows how embodiment enables kinesthetic and affective interactions. And, like Sara Ahmed, I want to highlight the political importance of such embodiment.[257]

Technologies of the Deep

256 Donna J. Haraway, "Situated Knowledges: The Science Question in Feminism and the Privilege of Partial," *Feminist Studies*, vol. 14, no. 3 (Autumn, 1988): 575–599, 581.

257 Karin Amimoto Ingersoll, *Waves of Knowing: A Seascape Epistemology* (Durham: Duke University Press, 2016) and Sara Ahmed, *Strange Encounters: Embodied Others in Post-Coloniality* (London: Routledge, 2000).

258 Haraway, "Situated Knowledges," 581.

Via the sensory system we can try to avoid the pitfalls of the disembodied, omnipresent "gaze from nowhere"[258] of modern colonial-patriarchal exploitation. This gaze is implied in the visual regime I outline above, which allows for remote control and retinal distancing. Here, I look at how that visual regime is fostered, how it is reflected in visual culture, to then tend to how we may conceive of it and feel it differently.

In the first scenes in Linke's video *Prospecting Ocean*, we watch a young scientist operating a remote-controlled robotic arm deep down in the depths of the ocean. The camera focuses on the man's face while his gaze is fixated on a screen. We see what he sees from a similar vantage point: the recorded material is not integrated into Linke's film, but rather, shown on screens as they transmit the mediated images. From the man's concentrated face, the film cuts to the switchboard with which he operates the machinery. We see the robotic arm in the water; the scientist handling it in his office uses a tongs-like metallic hand for collecting organic specimens. His fingers move ever so slightly to adjust the direction and depth of the underwater vehicle. On the screens, as Linke's camera offers a closer shot, the acronym NTNU is legible, which stands for Norwegian University of Science and Technology, in Trondheim, on the western coast of Norway, about 500 kilometers north of Oslo. Here, Linke conducted extensive research and filmed scientists who explore the depths of the ocean with the aim of prospecting information on minerals, oil reserves, microbes, and other organic life forms.

The images on the scientist's screen depict a tiny aspect of the vast area that the ROV surveys. This scene shows two modes of mediation: the robotic arm is a stand-in for a human arm, yet the metal components react differently to the cold and the water pressure to how the nerves in a human arm

would transmit this information to the brain. Operated from the surface, the arm here becomes a prosthesis. The way it senses the weight or the touch of the items it grabs is transmitted to the scientist at the surface mediated by a camera and a screen. The camera sends images of the arm's surroundings and enables its manipulation to move and grab what the scientists deem relevant and worthy to be noted and collected.

Since these operations are extremely expensive, they require the utmost precision and discrimination of material considered interesting. There is a high risk that machinery might be damaged or lost at sea. The atmosphere evoked by the scene in Linke's film conveys the concentration involved in an extremely complex operation and the preciousness with which it is performed. We sense a certain pioneering excitement supported by the technologically advanced instruments in use. We also feel a level of banality, as the excitement is mostly spurred by the cost and novelty of the operation.

Prospecting Ocean (video stills).

The mediated imagery on the screen is diffracted from the materiality of water and the specimens collected. The hyper concentration and fascination with that which is filmed falls within the predatory practice of "hunting with the camera."[259] Yet, as Kaplan shows using the example of drone warfare, we see here a similar sensation of closeness evolve. Kaplan describes how soldiers operating drones feel intense emotions either because or despite of the distance to their target.[260] In our case, the scientists are spatially removed, but they are nevertheless also affected by what they see and feel via the robotic arm. If before the proliferation of digital technologies,

261 Aside from image-making and extraction mechanisms, the division of scientists' labor produces further disturbance. Most likely, one scientist would analyze the material collected by another scientist. Thus, the connection between the habitat of the flora, fauna, and geological formations, even if always mediated by both the robotic arm and its tactile substitution, as well as by the visual aids of the camera and screen, rarely forms part of the experience of the scientist analyzing the recorded materials.

262 Hannah Arendt, "The Conquest of Space and the Stature of Man," *The New Atlantis*, no. 18 (Fall 2007): 43–55.

263 Paul Virilio, *The Paul Virilio Reader*, Steve Redhead, ed. (New York: Columbia University Press, 2004), 149.

spatial distance was connected to emotional distance, today the changing visual regime also produces other forms of emotion and engagement.[261] And the material-discursive apparatuses (the cameras, the robotic arm) emerge along with them.

We have seen earlier, via Virilio and Harvey, that speed and time-space compression bring into intimate proximity remote times and places, without any need for the human to change position or go anywhere to overcome distance. In this vein, technologies of vision and data transmission are deployed to overcome spatial distance. The images captured in the deep sea are transmitted with little perceptible delay, making the faraway appear in the here and now. If in the Eameses' *Powers of Ten*, such instantaneity was only possible thanks to an extensive editing process, ROVs permit zooming in and out to remote spaces "live." But their moves are never frictionless. While the Eameses' cuts are seamless, in ROVs, technology does not disappear but is thrown into high relief.

Political theorist Hannah Arendt's writing on the launching of Sputnik in 1957 also notes the technological gap "between the world of the senses and the appearances and the physical worldview."[262] ROVs try to overcome such fractures by live transmission. Being remote-controlled bolsters the illusion of "remote omnipresence"[263] even through vast water masses all the way to the ocean floor. The way Linke's work reflects different manners in which technology is utilized to gauge and capture nature calls to mind the alienation of humans from nature, and how interventions aided by technology rework concepts of nature-culture. Knowledge based on mediated images shapes these concepts. Images such as the ones created through the underwater cameras in ROVs fold into the construction of scientific and technological discourses and hence into the production of knowledge and power.

In the words of Haraway, the robotic arms are cyborgian prostheses. A cyborgian perspective can be apocalyptic, but it might also be "about lived social and bodily realities in which people are not afraid of their joint kinship with animals and machines, not afraid of permanently partial identities and contradictory standpoints."[264] Technologies such as ROVs recraft our bodies, and they are generated through social and embodied interactions.[265] Haraway considers prostheses as intimate constituents of our bodies. She famously argues against organic primacy and holism—a prosthesis can be both a human eye and a robotic arm. We are machines, cyborgs, no longer composed of dualisms between organic and inorganic. As Haraway insists, we must refuse positions that are anti-science or anti-technology, but instead take responsibility for these devices, for the way they make us see, know, and act. And so, the technologies involved in image and meaning making—cyborgian components of our bodies—may also bring us closer to our joint kinship with deep-sea organisms and to a vision of the seabed that is not disembodied, but embodied through the extension of our vision in prostheses. It is not the disembodied gaze from nowhere, and its embodiment is not only organic. Nonetheless, we need to continue asking what the politics of such cyborgian vision are.

Capsized Proportions

A striking element in Linke's video includes sections of educational or promotional videos produced by Nautilus to explain the procedures of deep-sea mining to potential prospectors and local communities. One scene in *Prospecting Ocean* shows a computer screen on which a publicity video is playing. Mirrored in the shiny surface of the screen, we see Vanreusel speak about the machines utilized in the process of seabed mining and explain the operations to extract metals from the depths of the ocean. The scientist describes a first apparatus, which is sent down to prepare the benches for a second machine to grind the material for collection. The rendered imagery depicts the devices as resembling toy tractors for children, inconspicuous and almost cute, definitely not like huge Frankensteinian equipment sent to the seabed to dredge it and cause environmental havoc. The scientist describes that a first machine will move around unhindered on

the seabed. As she speaks, the computer-rendered grinding wheels start working on the ocean floor. The seabed recedes in a way reminiscent of computer games where users can alter the environment without any physical resistance. While games can be designed to evoke the empathy of the players to the characters they interact with, oftentimes they are shaped to incite a violent battle for domination or to allow players to build and alter landscapes free from limitations such as gravity, law, and to a certain extent finances. The mining machines seem to exert their force unhindered from any such limitations.

We watch the apparatus grinding away at areas of seabed while the effects the intervention causes are rendered as a few tiny snowflakes or cotton ball-like semi-transparent animated specks floating across the video. As we observe the auxiliary cutter remove parts of sediment, Vanreusel describes how it will start "moving in a continuous cutting motion."[266] Continuation implies undisturbed through material resistance, technological glitches or the likes. While Vanreusel is critical of deep-sea mining, the creators of the videos seem to expect no disturbance, or chose not to represent any signs of friction in the video. In a continuously smooth operation, we see a collecting device being lowered from the surface barge, as the bulk cutter is grinding the material then sucking it and pushing it up to the surface. A concession of white upward-pointing arrows in a tube-like contraption on top of the collecting machine signifies the ostensibly simple operation of pumping mineralized material to the Subsea Slurry Lift Pump and to the surface. The camera pans upward, following the moving arrows along the tube to the surface as if it were the triumphant finale of the operations.

The sequence of the promotional seabed mining rendering is followed by a sharp cut to a scene in Papua New Guinea, where we watch a woman grinding sawdust off a pole by hand, collecting it in a palm leaf. We see a young man with a lawn mower—another technology altering the environment, if arguably at a much smaller and less destructive scale. With these images, Linke acknowledges that the community on Karkar Island also uses technologies, but the

[266] Armin Linke, *Prospecting Ocean*, 2018, 40 minutes and 11 seconds.

disproportion makes it clear how incommensurate the abilities of Western companies are to the tools (of resistance) the local population possesses. The perpetuity of colonialism is stark in these scenes. As Haraway and many others have written, technologies themselves aren't "bad." They are part of us, in organic and inorganic ways. What matters is how they are used.

I mention earlier that the camera alters what it films. Linke's presence, his camera, and the editing process, produce specific events. But as we saw previously, the new assemblages brought about by art can be powerful when successful and sometimes damaging when not. In terms of technologies from a retina to the advanced machines utilized in deep-sea mining, we need to consider use and scale. Disembedding foods for subsistence is not the same as accumulation of capitalist surplus value. The latter is what is so destructive, not the use of machines per se. If applied negligently, they perpetuate the unequal distribution of cause and effect, of profit and damage, between the companies driving deep-sea mining and the communities opposing it.

Prospecting Ocean (video stills).

Rendering the Mining Zone

Image making techniques such as renderings are designed to make prospecting endeavors seem both realistic and attractive for potential investors, while making the environmental impact seem negligible, as the cuts and incisions in the seabed are made to look clean and non-invasive. The renderings depicted in Linke's video further call to mind the technologies and software in image making techniques that are used to picture and advertise cities. They make the world seem unimpededly penetrable, forming part of infrastructure space, or what Easterling calls "extrastatecraft—a portmanteau describing the often undisclosed activities outside of, in addition to, and sometimes even in partnership with statecraft."[267]

268 Ibid.

269 Ibid.

270 See https://en.portal.santandertrade.com/establish-overseas/papua-new-guinea/investing-3. While the law does not allow direct foreign ownership of land, deals by the government with Nautilus do grant it the right to extract from the licensed areas, for a (small) share of the profits.

271 Adam Reese, "US Blockchain Startup To Operate Special Economic Zone In Papua New Guinea," *ETHNews* (May 19, 2018), https://www.ethnews.com/us-blockchain-startup-to-operate-special-economic-zone-in-papua-new-guinea.

272 Easterling, *Extrastatecraft*, 68.

The spatial-discursive paradigm Easterling describes in relation to extrastatecraft is the "zone," referring to free trade zones, foreign trade zones, tax free zones, and so on.[268] In the case of Papua New Guinea, while not a zone per Easterling's definition, the infrastructural investments of Nautilus are supported by the country's government and the company is exempted from many of the regulations an investor would usually have to abide by. Easterling identifies tax exemptions and cheap, deregulated labor among the incentives provided by host countries to investors.[269] In Papua New Guinea, foreign direct investment incentive schemes were implemented following the country joining the Trade Facilitation Agreements (TFA) by the World Trade Organization in 2018, which expedite the transport and customs clearance of goods. The TFAs are aimed at attracting foreign investors and seem to work to that end. Capital influx in Papua New Guinea changed from negative 180 million USD in 2017 to positive 335 million USD in 2018, mainly due to mining.[270] A zone as Easterling defines it may not be far away for Papua New Guinea. In 2018, the US-based blockchain firm Ledger Atlas signed a memorandum of understanding with the government to create a free and special economic zone in the country.[271]

These schemes devised for countries' territories and EEZs resemble the high seas, which are beyond national jurisdiction, and which, similar to the zone, conform to different laws. More so than on land, policing violations in the zone is incredibly difficult and requires complex infrastructures of patrol. Easterling refers to the zones around the world as apolitical and segregated. Allowing a "controlled form of cheating,"[272] they serve as entrepôts of resources and illegal deals. In a similar way, mining in the seabed of the high seas beyond national jurisdictions is controlled through the ISA,

273 "Combined NZ-Fiji patrols inspect six vessels for illegal fishing," https://medium.com/@nzdefenceforce/combined-nz-fiji-patrols-inspect-six-vessels-for-illegal-fishing-5ec404b054f2.

274 Easterling, *Extrastatecraft*, 25.

275 Easterling, *Extrastatecraft*, YouTube video.

yet it is still extremely prone to cheating. Patrols of illegal fishing violating EEZs, for instance in Fiji, are costly and complex, and noticing and stopping illegal activities in the high seas, let alone the deep-sea, is even more complicated.[273] The seabed is an excellent hiding place for illegal workings.

If the zone falls within the spatial paradigm I identify above, of making land ever more malleable like the ocean, and the oceans ever more compartmentalized like land, it heavily relies on visualizations to entice investors by providing palpable imagery of this abstract construct. The aesthetics employed by these videos homogenize space like a rip-off of the Eameses. Easterling describes that they often begin with a zoom from outer space toward a new shiny urban center, accompanied by auspicious music, as a "deep movie-trailer voice describes the requisite infrastructure."[274] The Nautilus promotional video I discuss above follows a similar visual paradigm, among others in how effortlessly the machines are dropped and move around the seabed. Its aim is clearly to convince investors and appease regulators concerned with environmental impacts.

Easterling refers to the images of the zone as "urban porn."[275] In a way, the images we see of the seabed are similarly pornographic, I would go as far as calling them "ocean porn." There is a certain gaze being evoked, which makes the oceans seem available, just there for "us," exploitable through our desires for consumption and accumulation in fantasy and in reality. Representations of the ocean as either romanticized or dark unlit areas in which machines operate unhindered turn them into culture (over nature) and thus exploitable by economic interests and legal loopholes.

The Politics of Ocean Images

How the oceans are visualized matters. I think for instance of filmmaker Jean Painlevé's underwater photography, which revolutionized our understanding of the oceans and our relationship to them. When Painlevé shot *The Love Life of the Octopus* (1967), centering on the mating rituals of cephalopods, his camera anthropomorphized these aquatic

276 Hettie Judah, "Copulating Seahorses and a Lavish Snail Ballet: The underwater wonders of Jean Painlevé," *The Guardian* (Friday March 17, 2017), https://www.theguardian.com/artanddesign/2017/mar/17/copulating-seahorses-snail-ballet-underwater-wonders-of-jean-painleve.

277 Deutsche, *Evictions*.

278 Stacy Alaimo, "Jellyfish Science, Jellyfish Aesthetics: Posthuman Reconfigurations of the Sensible" in Chen, MacLeod, and Neimanis, ed., *Thinking with Water*, 139–164, 156.

279 Jacques Rancière, *The Politics of Aesthetics: The Distribution of the Sensible*, trans. by Gabriel Rockhill (New York: Continuum, 2004).

creatures, whose bodies, habitat, and behavior are very different from ours, making them more relatable. These images changed the popular perception of the oceans as dark and impenetrable.[276] Painlevé's filmmaking differs vastly from the computer-rendered shots of the zone, with anonymous architectures and seemingly empty, infinitely malleable space. His recordings were made possible by new technological developments like underwater cameras that enabled him to bring aquatic worlds closer to us than ever before. It was a world to be protected. But images of underwater or any other environment not previously visible to us evoke not only empathy, but also the possibility of exploitation, prospecting of what is there and can be profited from. They make the ocean seem attainable, treating it as knowable.

As Deutsche shows, images are political.[277] Philosopher Jacques Rancière further argues that to be a political subject is to be heard and seen.[278] Rancière's concept of the "distribution of the sensible"[279] applies mostly to the aesthetics of politics as a way to discuss which individuals and voices are visible, audible, and sayable at a particular moment in time. I want to further highlight his notion of the redistribution of the sensible as a political act.

Art, as an aesthetic practice, is involved in image making, as is science, in making perceptible and, according to its parameters, empirically comprehensible artifactual realities. As we have seen in the previous chapters, the ocean has largely been obliterated from the Western imaginary. This applies to the workers aboard shipping vessels and to the nonhumans in the deep sea, but also to the intricately embedded infrastructures, or extrastatecraft, hidden within discursive-material layers. Images such as renderings of the zone or Nautilus's simulation of mining endeavors are powerful

280 CAMP, *Wharfage*, a project part of the 9th Sharjah Biennial (2009), see https://studio.camp/resources/wharfage.pdf.

tools of presence-making. Their manifestation pushes aside images that do not feed into the paradigm of frictionless flow and malleable space.

The artist collective CAMP direct their attention to the colonial and imperialist logic of who and what is hidden. I first saw their project *Wharfage* (2008–13) at the Sharjah Biennial in the United Arab Emirates. In *Wharfage*, the artists focus on the large diesel-powered wooden ships that leave from Sharjah Creek, in whose duty free ports customs are waived, to sail to a conglomerate of semi-state entities which existed at the time in the region of Somalia. This zone allows traders to operate as if outside of any national border.[280] The free ports CAMP focus on are not declared as such by the World Trade Organization, but as a result of the workings of semi-states and autonomous actors. In their multipart project, made up of a radio broadcast, a publication, and the feature-length video *From Gulf to Gulf to Gulf* (2009–2013), the artists analyze the goods that travel across seas, and with that undo the anonymous paradigm of the container, of mass-produced goods arriving seemingly by magic forces from their site of production to the place of their consumption.

CAMP, *From Gulf to Gulf to Gulf*, 2009–2013, Video, projection, color and sound (stereo), 83:00 minutes. Courtesy of the artists.

CAMP, *From Gulf to Gulf to Gulf*, 2009–2013, Video, projection, color and sound (stereo), 83:00 minutes. Courtesy of the artists.

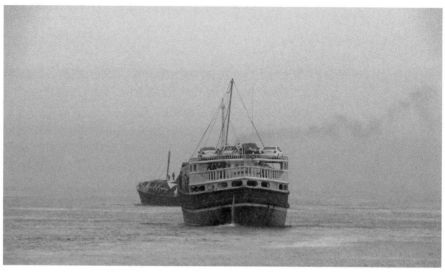

For instance, in following the vessel *M.S.V. Al Reemy*, CAMP show that it sailed on January 17, 2008 under Indian flag after having been docked at Sharjah Creek for twenty-five days, to Bosaso, Somalia, with goods including 1480 cartons of plastic sandals, seventy packages of medical supplies, and 680 cartons of cooking oil. The same ship, on October 19, 2008, sailed from Sharjah to Somalia carrying twenty-one television sets, twenty-two refrigerators, and 1000 cartons of hair dye. And, on December 24, 2008, it sailed from Sharjah to Bosaso, carrying twelve vehicles, most of them by Toyota. While the goods are listed as quantities, they allow viewers a glimpse of the lives of people living in proximity to these ports. This deviates from the mass quantifiers of globalized container trade. And they make visible the forgotten space between production and consumption.

The collective is influenced by Sekula, whose work makes visible the networks of transportation that are usually eclipsed in the capitalist sphere of hyper-connection ostensibly without materiality or trace. The traces, as existent as ever, are hidden in the attractiveness of the consumer goods that are transported across the sea. The fumes and dirt are released into the ocean, like the times when metal and trash were simply dumped into the sea. Unlike Sekula, however, CAMP also focus on the people working at sea (and which still happens commonly today). The collective have stated that they often wondered why Sekula never opened the containers to look inside.

291 Oak Lake Writers (Kathryn Akipa, Gladys Hawk, Craig Howe, Lanniko Lee, Kim TallBear, and Lydia Whirlwind Soldier), "Reflections on Mnisose after Lewis and Clark" in Craig Howe and Kim TallBear, ed., *This Stretch of River* (Sioux Falls: Pine Hill Press, 2006), 79–102.

292 Andrew Biro, "River-Adaptiveness in a Globalized World" in Chen, MacLeod, and Neimanis, ed., *Thinking with Water*, 166–184, 169.

293 Haraway, *A Cyborg Manifesto*, 42.

While technology expands the range and reach of humans' apparent control over our surroundings, it also has the reverse effect. The more we rely on technology, the more we struggle to feel in charge. Attempts at mastery over the natural world aided by modern technology have intensified feelings of uncertainty, but they have also made humans more vulnerable to social and environmental forces beyond their control.[292] As Haraway shows, technologies are deeply entangled in "militarization, right-wing family ideologies and policies, and intensified definitions of corporate (and state) property as private."[293] This does not apply to all technologies, but to the capitalist and patriarchal wielding of certain technologies. Uses irresponsive to other humans and nonhumans, as well as geology, occur at the expense of women, people of color, indigenous people, LGBTQIA+ people, disabled people, lower socio-economic classes, and so on. In many ways, rather than creating proximity by bringing us closer to others and to "nature," or to overcome the boundary between nature and culture, technology also creates and reinforces distance. This conundrum aggravates a sense of alienation, and it is perhaps here that the unrealistic treatment of the emergency of the Anthropocene is rooted: our notion of control is out of joint.

Connective Oceanic Distances

The conviction that technology can come to fix problems implies exteriority. Such exteriority is reminiscent of the treatment of nature as waste or commodity. Distance in terms of geography or culture is systematically invoked to enable and trivialize the negative ecological and social effects of extraction. Literary scholar Elizabeth M. DeLoughrey shows how the trope of the faraway "tropical" island is a common construct employed to legitimize neocolonialist endeavors. In an article on the triple hurricane system Irma/José/Maria, which devastated the Caribbean in 2017, DeLoughrey points out how the media and politicians commonly draw on

294 Elizabeth M. DeLoughrey, "Revisiting Tidalectics" in Hessler, ed., *Tidalectics*, 93–102.

295 Eric Clark and Huei-Min Tsai, "Islands: Ecologically unequal exchange and landesque capital" in Clark, Hermele, and Hornborg, ed., *Ecology and Power*, 52–67.

296 Epeli Hau'ofa, "Our Sea of Islands" in *We Are the Ocean: Selected Works* (Honolulu: University of Hawai'i Press, 2008), 31.

297 Spivak's notion of planetarity I mention earlier may help us do so, as does poet and philosopher Édouard Glissant's archipelagic thinking. Édouard Glissant, *Poetics of Relation* (Ann Arbor: University of Michigan Press, 1997).

geographical distance to justify their non-involvement and the fact immediate aid and relief efforts were not deployed after seeing the damage caused by the storm.[294] DeLoughrey calls out that such distance has hardly ever hindered colonialist and imperialist purposiveness. The US Navy had bases in Puerto Rico, in Ceiba and on the island of Vieques, which it occupied and bombed from 1941 until continuous protests drove the Navy out in 2003. The same geographical distance that is used to legitimize non-involvement and the dearth of aid provided to the US occupied territory is called upon to minimize the harm that interventions in the ecosystems are causing, and to suggest that the effects can be contained. Such harm commonly does not affect the perpetrator immediately, as it occurs far away from them, though, of course, hyperobjects tell us differently. Eurocentric patterns of the past are repeated in present-day extraction.

The notion of geographical distance goes hand in hand with the conception of cultural distance, of populations so varying in language, physical characteristics, and customs that an ostensibly insurmountable difference is conjured as justification to exploit and extract. However, material flows, spurts, and drips connect island life with the continents, the margins with the centers. As environmental studies scholars Eric Clark and Huei-Min Tsai assert, islands are never isolated.[295] Anthropologist and historian Epeli Hau'ofa urges for a reappraisal of Pacific islands, commonly thought of as small specks of land in a vast sea; instead, Hau'ofa suggests we think of them as a large sea of islands. His text "Our Sea of Islands," first published in 1993, offers "a more holistic perspective in which things are seen in the totality of their relationships."[296] Water, here, is that which connects rather than divides. Yet this connectivity does not follow the unifying narrative of homogenization. Instead, it acknowledges the nuances and specificities of all entities defined by their relationships to one another.[297]

Exchange, even if unequal in terms of economic benefits and burden of environmental disaster, and often disregarded for inter-Oceanian trade, has been ongoing and continues to this day. Global commodity chains, as Tsing brilliantly shows, occur on micro and macro scales.[298] Some of them are hidden and informal, while others are formalized and dominate our attention and the stories we tell. But isolation and distance continue to be an effective trope accompanying imperialist aims. As DeLoughrey asserts, remoteness depends on perspective: "Not surprisingly, there are few if any historical testimonies from Pacific or Caribbean Islanders bemoaning their distance from Europe."[299]

298 Tsing, *The Mushroom at the End of the World*.

299 Elizabeth M. DeLoughrey, *Routes and Roots: Navigating Caribbean and Pacific Island Literatures* (Honolulu: University of Hawai'i Press, 2007), 9.

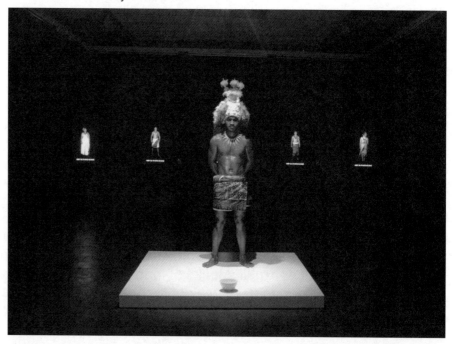

Yuki Kihara, *Culture for Sale*, 2012–15, Installation, performance, and video, Photographer: Sarah Hunter, February 21, 2014, City Gallery Wellington, Aotearoa New Zealand. Courtesy of the artist.

Artist Yuki Kihara addresses the colonialist tropes of distance in her performance *Culture for Sale* (2012–15). Her work examines notions of spirituality, race, gender, and their intersection in Oceania with a starting point in Samoan cultural history.

Erik van Doorn, research associate, Walther Schücking Institute for International Law, University of Kiel, Germany.

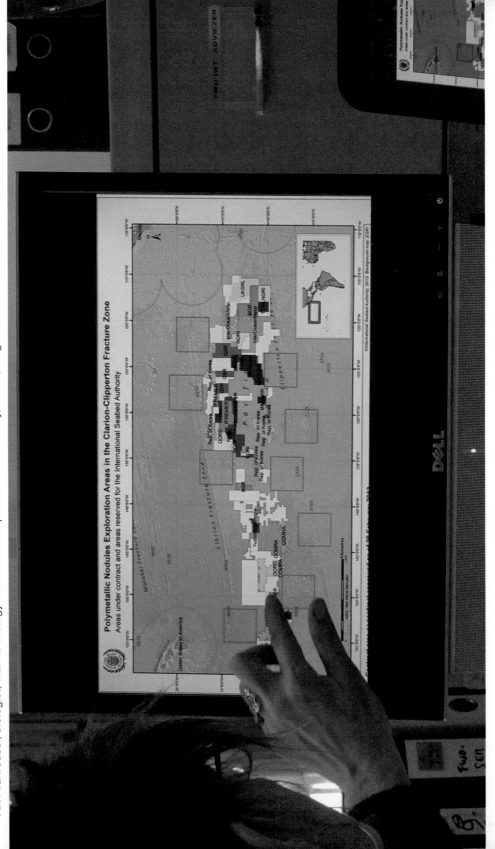

Ann Vanreusel, biologist, Marine Biology Research Group of Ghent University, Ghent, Belgium.

Michael W. Lodge, Secretary-General (former Deputy to the Secretary-General and Legal Counsel) of the International Seabed Authority, Kingston, Jamaica, filmed at the assembly of the twenty-second session of the ISA in Kingston, Jamaica.

Donald Rothwell, Professor of International Law with a specific focus on the law of the sea at the College of Law, Australian National University, Canberra, Australia. Filmed at the 77th Conference of the International Law Association on international law and sea level rise, Johannesburg, South Africa.

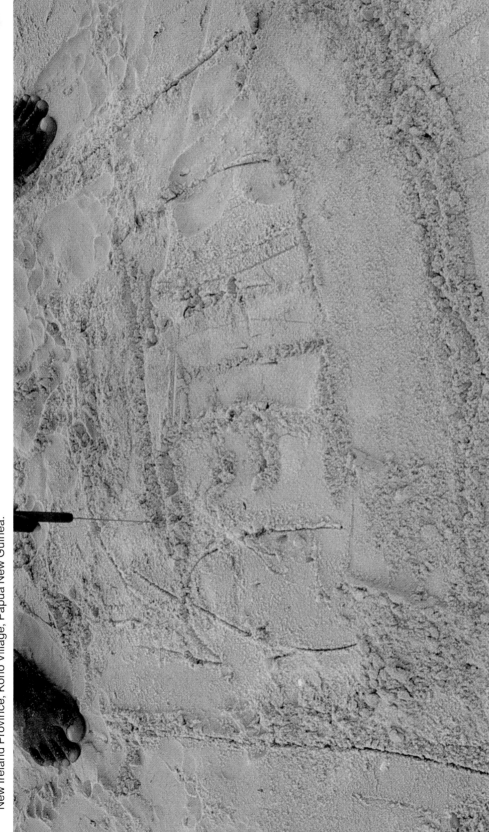

John Momori, activist, Caritas coordinator for Namatanai Parish in the west coast Barok area of the New Ireland Province, Kono Village, Papua New Guinea.

Ann Vanreusel, biologist, Marine Biology Research Group of Ghent University, Ghent, Belgium.

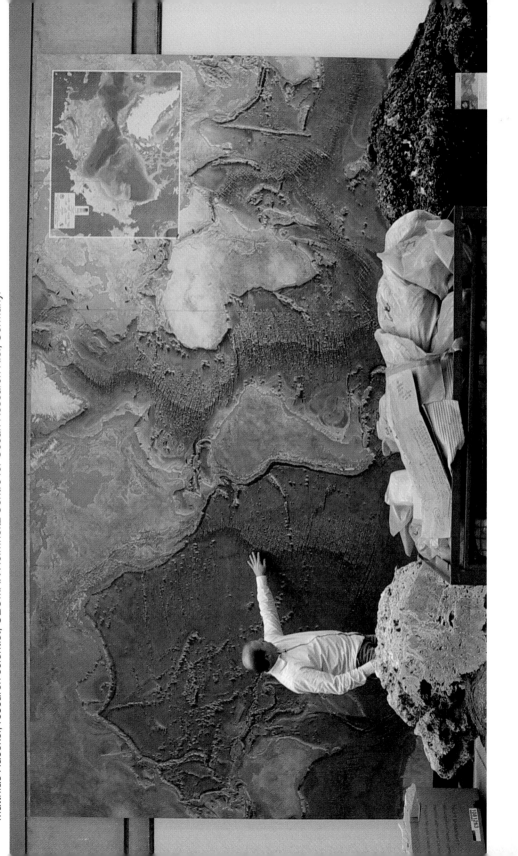

Matthias Haeckel, research scientist, GEOMAR Helmholtz Centre for Ocean Research Kiel, Germany.

An T. Nguyen, Institute for Computational Engineering and Sciences (ICES), Computational Research in Ice and Ocean Systems (CRIOS), University of Texas, Austin, Texas.

Institute for Advanced Sustainability Studies (IASS), discussion on the principle of the common heritage of mankind, Potsdam, Germany.

Kahara Palmer, and Rangitea Wohler, who are mostly based in French Polynesia. They founded the collective Ōrama Studio to create visibility for contemporary art in the region. I visited the group's eponymously titled exhibition at the Musée de Tahiti et des îles in Papeʻete, French Polynesia in 2016, which highlighted the connections as well as specificities of practices in the country. Some of their members are also involved in Oceania-wide exchange initiatives, which bring together Pasifika artists for learning and community building. The blog and community Talanoa, founded by Fiji-based Arieta Tegeilolo Talanoa Tora Rika and focusing on Pacific storytelling, is another example of contemporary initiatives that show connectedness rather than Eurocentric implied distance.[303]

Lisa Rave, *Europium*, 2014, HD video, 21:00 minutes. Thyssen-Bornemisza Art Contemporary Collection. Courtesy of the artist.

New and Old Frontiers in Deep-Sea Extractivism

In her video, *Europium* (2014), artist and filmmaker Lisa Rave explores economy, culture, and ecology in (neo)colonialist extractivist endeavors and ongoing dependencies in the Pacific. The 21-minute video work is organized according to a structure inspired by nautilus shells, whose construct of multiple camerae is mirrored in form and content of the work. The title refers to the rare-earth element which is used for its photoluminescence to authenticate euro banknotes and forms part of technologies like the computer I am typing this text on. Named after the continent of Europe, the metal is not found there, but in the waters in the Bismarck Sea, in Papua New

Lisa Rave, *Europium*, 2014, HD video, 21:00 minutes. Courtesy of the artist.

Guinea, a country with an extensive colonial past: Germany, Great Britain, and Australia, among others, laid claim on the territory over 130 years. The Bismarck Sea is also where the deep-sea mining site Solwara 1 is located.

In *Europium*, Rave refers to both historical and recent exploitation of the country's resources. She draws a connection between Western commodity fetishism and Papua New Guinean shell money. In the time before colonization, shell money was exchanged between different islands in the Pacific not as currency, but as objects endowed with value due to their provenance and the genealogy of their former proprietors. When Europeans arrived, they started to trade with locals, and the shells became a form of currency. Rave explores parallels

304 David Harvey, "Globalization and the Spatial Fix," *Geographische Revue*, vol. 2, no. 3 (2001): 23–31, 24.

305 David Harvey, "The 'New' Imperialism: Accumulation by Dispossession," *Socialist Register*, vol. 40 (2004): 63–87.

between the country's past and the present, and how its natural environment is turned into a resource. She draws analogies between how the nautilus shells became commodities, and how the minerals become disembedded from the deep-sea vents where they grew over millions of years. The rare earths from manganese nodules to europium are extracted to participate in a cycle of uneven global exchange.

If earlier we saw how technological fixes are intended to alleviate environmental urgencies, in the case of deep-sea resource grab we can speak of "spatial fixes." Harvey utilizes the term "to describe capitalism's insatiable drive to resolve its inner crisis tendencies by geographical expansion and geographical restructuring."[304] If technological fixes are utilized with the aim of solving environmental problems to the extent that the capitalist system can continue to function as before, without having to concede major changes, capitalism pushes to resolve its need for continued capital accumulation by geographical enlargement of the territory from which it draws "resources." "Accumulation by dispossession"[305] proceeds, as T. J. Demos has it, "without corresponding deposit (except in the form of waste, disease, and death)."[306] If resources in the national territories become scarce, capitalist powers push

Lisa Rave, *Europium*, 2014, HD video, 21:00 minutes. Courtesy of the artist.

the "new frontier" to other geographies. We have seen this in sixteenth-century colonialism, and still witness it today. The underlying assumption of spatial fixes is that things can be pinned down, their location and their position in the context of meaning making cemented, while the accumulative machine extends its tentacles ever more widely.

When countries like Papua New Guinea partner with companies like Nautilus—another occurrence of the nautilus shell symbol—the latter promise those governments a percentage in the financial gains. Besides that, the creation of jobs for the local population and investments in infrastructure are often part of such deals. The reality of these promises is short-sighted, since the environmental damage and long-term degradation is not sufficiently taken into account and outweighs any short-term financial benefit. Moreover, the social and cultural influence on sparsely populated islands is not sufficiently considered. Foreign workers are contracted to move to islands such as Karkar. Only 19 kilometers wide and 25 kilometers long and with a population of 50000 people, the cultural and social impact of the influx of workers will be felt strongly. And even the financial hopes are often in vain: Easterling shows that, marked off as enclave, the Export Processing Zones of developing countries usually absorb significant amounts of that economy into the enclave, rather than disseminating it into the domestic economy.[307]

The idea of progress and economic prosperity is interlaced with colonial dependency, and economically deprived countries risk environmental degradations that endanger their livelihoods. Yet we need to be careful not to reinscribe notions of modern and premodern societies, notions that Plumwood describes as "the chief myth of progress and the other ideologies which surround colonialism, namely the confrontation with an inferior past, an inferior non-western other and the associated notion of indigenous cultures as 'backward', earlier stages of our own exemplary civilisation."[308] Fetishizing and fixing the past as well as cultural traditions obscures both their liveliness and how they are deeply affected by ongoing exploitation.

[306] T. J. Demos, "Blackout: The Necropolitics of Extraction," *Dispatches*, issue 001 (October 2018), http://dispatchesjournal.org/articles/blackout-the-necropolitics-of-extraction/.

[307] Easterling, *Extrastatecraft*.

[308] Plumwood, *Feminism and the Mastery of Nature*, 16.

The way in which Rave creates a nautilus structure of embedded stories and histories mirrors the way in which material histories are related, and how the colonial past is nested into current structures. And yet, she also points to her own complicity as a benefactor of the technologies. Pointedly, Rave's work includes sequences of advertisements the artist filmed on flat screens in multimedia shops in Germany, where she is based, which often deploy imagery of serene "nature," of colorful birds and bright blue oceans, to advertise the high resolution quality of the screens. Ironically, it is exactly these environments that the extraction of minerals needed to produce the screens will destroy. *Europium* offers an analysis of the compound of ongoing asymmetric colonial interdependencies, long-term environmental damage, the role played by governments and private corporations, and the complicity of consumers.

The Nuclear Past and Present of the Radioactive Ocean in French Polynesia

If deep-sea mining in national waters is an imminent future threat, we can draw parallels to past ecocidal and genocidal colonial projects that draw on notions of separability and distance. Kheel reminds us that in order to change how nature has been exploited under patriarchal society, we need to first understand it to bring forth new ways of perceiving it.[309] To this end, I want to make a digression to the recent past to discuss the waste sites of radioactive residues in French Polynesia, which today threaten to leak into the ocean. The residues originate from 193 atmospheric and subterranean nuclear bombs detonated on the coral atolls of Moruroa and Fangataufa between 1966 and 1996 by France in its former colony, which is still incorporated as a French overseas collectivity. In addition to the threat of leaks, locals and activists claim that the tests caused a crack in the lagoon of the atoll of Moruroa, which could lead to a significant part of the coral structure to fall off and cause a tsunami reaching as far as Japan.[310]

309 Kheel, "From Heroic to Holistic Ethics."

310 See "Fangataufa and Moruroa" on Hibakusha Worldwide, https://hibakusha-worldwide.org/en/locations/fangataufa-and-moruroa. See also "Radioactive Heaven and Earth: The Health and Environmental Effects of Nuclear Weapons Testing in, On, and Above the Earth," IPPNW, chapter 9 (New York: The Apex Press, 1991).

In 2016, I visited the Tuamotus Archipelago—the island group where the tests were conducted—together with a group of artists, curators, and researchers brought together by Ute Meta Bauer aboard the *Dardanella*. During these journeys, the question of colonialist explorations often arises, brought up by organizers, participants, and people met while traveling. The fact that a Western arts institution is the initiator of these voyages has evoked skepticism, which sometimes remains, and at times has led to new friendships, alliances, and partners who generously provided criticism along the way. In Suva, Fiji in July 2017, we participated in a vivid discussion on Pacific self-determination and cultural appropriation at the University of the South Pacific, and in French Polynesia, we witnessed the ongoing effects of the nuclear past while we were also confronted with our own complicity as benefactors of imperialism.

On July 2, 2016, fifty years after the detonation of the first nuclear bomb in the Dindon zone on Moruroa, we witnessed a protest by locals engaged in the ongoing claims for reparations on the island of Makemo. Approximately 750 km from Moruroa, the demonstration on Makemo was organized by the Association 193, whose mission is to preserve the memory of the tests, integrate it into the school curriculum (which is currently not the case, as schoolbooks are provided by France), and obtain a request of pardon from France as well as compensation. Posters advertising the march were present in many sites across Makemo and other islands. They were distributed in shops as photocopied leaflets in the characteristic red hue that is the color of the group and the anti-nuclear movement. The demonstration took the form of an afternoon procession, bringing together approximately 40 inhabitants and organizers of the Association 193, all dressed in red T-shirts, who carried hand-painted banners reading *Devoir de justice, Devoir de unité* (Duty of justice, Duty of unity) and *Plus jamais ça!!!* (Never again). While the protests have been going on for years, reparations are still owed—similar to ongoing claims for justice in the Marshall Islands, where the US conducted nuclear tests. While on Makemo the protest was a major event, outside of French Polynesia and other countries with comparable histories, there is limited visibility for this struggle. News hardly reaches French or international media channels. The geographical remoteness from the administrative power in Paris, as well as the financially precarious situation of the country, further muffle the voices

[311] François Hollande is quoted: "I recognise that the nuclear tests conducted between 1966 and 1996 in French Polynesia had an environmental impact, and caused health consequences." https://www.france24.com/en/20160222-hollande-address-nuclear-test-victims-polynesia-trip.

of the protesters. When French President François Hollande visited French Polynesia in February 2016, he acknowledged France's nuclear past in the region, but failed to apologize on behalf of his country. This is still the closest France has come to publicly regretting this chapter.[311]

The construction of infrastructure, an element of extrastatecraft, is often conjured as an offering to economically deprived countries. During the nuclear tests, France built airports, runways, schools, and hospitals for French army officers and their families. These investments were commonly used as arguments for local governments to permit the nuclear tests and to justify them to local populations. However, such investments are often accompanied by lack of accountability, and provide short-term solutions while distracting from the much wider and longer-lasting damages caused.

On the day before the protests in Makemo, our group of international artists and researchers attended the "Conférence-débat sur le nucléaire" at the Conseil économique et social de la Polynésie française in Pape'ete, which brought together activists and victims from French Polynesia as well as representatives from Hiroshima, including the former mayor Tadatoshi Akiba. Together with Linke, artist Nabil Ahmed, and a group of other researchers, I interviewed the late Bruno Barrillot, a priest who had been active in the protests and fight for remunerations from the French government. Barrillot told us that it was only after twelve years of legal actions that he received access to classified documents on the tests. Documents he shared with me, among others a report titled "Service Mixte de Sécurité Radiologique" (Mixed Service of Radioactive Security) written on March 24, 1969, and declassified by a decision of the French Ministry of Defense on January 8, 2013, shows that radioactive substances released through the tests of the nuclear bombs were recorded on the inhabited island of Hao, where planes and ships were washed after the tests. Among many others, effects resulting from the

312 Service Mixte de Securité Radiologique, République Française, Ministère des Armées, Direction d'Expérimentations Nucléaires, March 24, 1969, Doc n°6_58#8DCB Retombées Polynésie de la campagne 1968, shared by Bruno Barrillot, 6.

313 Étude de la Dose Absorbée en Contamination Interne par les Habitants de Tureia au Cours du Mois Suivant le Tir Encelade, August 10, 1971, Doc n°12_58#A951 Etude contamination Tureia suite tir Encelade 1971, shared by Bruno Barrillot, 4.

314 "I-131 Radionuclide Fact Sheet", Stanford, Environmental Health&Safety, Stanford, https://ehs.stanford.edu/reference/i-131-radionuclide-fact-sheet.

CAPella, CAStor, POLlux, CANopus, and PROcyn explosions were measured on various islands, with several apparatuses in the air and in the water.[312] The report shows that the island was literally showered in potassium-40 for several days following the detonations.

Another document reveals that data collected after the explosion of the bomb Encelade on the atoll of Tureia on June 12, 1971 proved the presence of fresh fission products.[313] The report shows that the detonation contaminated a source of drinking water; the cistern in the village Fakamaru, among others, was proven to have a significantly higher gamma activity in the water. The study mentions the effects on adults, and in particular on children under seven. The consumption of one liter of water from the cistern included a dose of 1,295 millirem of iodine-131, one of the most dangerous fission products when released into the environment, which is associated with thyroid cancer. Exposure rate should not exceed 500 millirem per year.[314] Other parts of the report indicate that data was specifically taken from breastfeeding mothers and their children to study how the exposure affected their health. The report on Tureia, also declassified only following twelve years of battle by Barrillot and his colleagues by a decision of the French Ministry of Defense on December 12, 2013, reveals that despite the recorded measures, it is impossible to fully estimate the dose of iodine-131.

The nuclear tests continued well after August 10, 1971, despite reports clearly pointing out the health hazards. The fact that politicians, scientists, and decision makers had access to these documents and knew of the threats for the inhabitants' health from the outset is barbaric and could be condemned as willful acts against humanity. However, the people affected by the tests are a specific part of humanity:

315 David Pacchioli, "Radioisotopes in the Ocean: What's there? How much? How long?," Woods Hole Oceanographic Institution Oceanus Magazine (May 1, 2013), https://www.whoi.edu/oceanus/feature/radioisotopes-in-the-ocean/.

316 Analyse des données de radiocontamination pour quelques poissons pélagiques de Polynésie française, entre 1966 et 1992, Rapport Scientifique et Technique, July 1994, Doc 26-53 Contamination des poissons entre 1966 et 1992 (1994), shared by Bruno Barrillot.

subjects of a French overseas collectivity, but not European nationals. The paradigm of Western science and the tools and type of knowledge necessary for it, and the alleged absence of these tools and knowledge in the overseas territory, were used to sustain the asymmetry of power with the colonized nation. The modernist Western paradigm of nuclear power, as among the most "advanced" technologies of the time, can be applied to, but doesn't need to be explained to the colonized. They are made inferior twice, through the action itself and through the withholding of information. The islands serve as holiday paradise, and are accessed relatively easily by Europeans who have the resources to travel, but the movement is one-sided—French Polynesians are to remain on their islands and the effects in the waters are to stay in immediate surroundings (Moruroa), not Bora Bora, where vacationers go. The irony is that of course radioactive isotopes travel, they can indeed be traced very well through water.[315]

Other reports show that the tests further affected non-humans, such as fish.[316] Moreover, the way people relate to land and oceans was thoroughly disturbed by the imposition of the nuclear logic. People were removed from their land (and often moved back prematurely, before it was safe to return), and access to parts of land and ocean was restricted. When we visited Hao in 2016, zones of the island were still marked off as inaccessible, and the entire island of Moruroa continues to be accessible only with special permission from the French government.

Prospecting here aims at information on the ability of people and the environment to absorb and react to radioactive matter. Most strikingly, the out-of-sight, out-of-mind logic, supported by geographical distance, doesn't hinder colonial intentionality, which is evident here. Indigenous people and people from the Global South have continually been used as

317 Marie Roué, "'Normal' Catastrophes or Harbinger of Climate Change? Reindeer-herding Sami Facing Dire Winters in Northern Sweden" in Igor Krupnik, Douglas Nakashima, and Jennifer T. Rubis, ed., *Indigenous Knowledge for Climate Change Assessment and Adaptation* (Cambridge and Paris: Cambridge University Press and UNESCO, 2018), 229–246. Marjorie V. C. Falanruw, "Canaries of Civilization: Small Island Vulnerability, Past Adaptations and Sea-Level Rise" in Krupnik, Nakashima, and Rubis, *Indigenous Knowledge for Climate Change Assessment and Adaptation*, 247–253.

318 Stacy Alaimo, *Bodily Natures: Science, Environment, and the Material Self* (Bloomington: Indiana University Press, 2010).

319 Shiloh Krupar, "Transnatural Ethics: Revisiting the nuclear cleanup of Rocky Flats, Colorado through the queer ecology of Nuclia Waste," *Cultural Geographies*, vol. 19, no. 3 (May 2012): 303–327.

320 Hannah Arendt, *The Promise of Politics* (New York: Schocken, 2005), 158.

321 Rob Nixon, *Slow Violence and the Environmentalism of the Poor* (Cambridge: Harvard University Press, 2011).

barometers, harbingers, or canaries in the coal mine.[317] Akin to deep-sea mining, the colonialist trope of distance is employed to bolster notions of difference and inferiority, and to legitimize ecocidal and genocidal activities to this day.

Spills Beyond Space and Time

Radioactivity is only one example of the failure of the separationist idea that unwanted materials could be contained in one place. Alaimo theorizes how pollutants enter water and permeate humans' and nonhumans' skin and bodies in ways that defy the logic of separateness.[318] Alaimo calls this trans-corporeality, which is similar to viscous porosity, Tuana's term. Under conditions of trans-corporeality or viscous porosity, we are made responsive to others, be it romantic partners, the microbes in our bodies, or toxins. Geographer Shiloh Krupar shows how radioactive waste "continually crosses boundaries of bodies, spilling into the cellular matter of humans and nonhumans, creeping into the future."[319] Yet the consequences of such permeability are often obviated and ignored.

Radioactivity is invisible and its effects are not palpable until sometime later. The half-life of iodine-131 is eight days, but the half-life of potassium-40 is 1.25 billion years. Arendt argues that the atomic bomb was in part so terrorizing because the scope of destruction was uncontainable: it was "supernatural," involving an "eerily impressive symbolic power from the moment of its birth."[320] Yet, contaminated landscapes and ocean environments don't look radioactive. The invisibility and the temporal distance are what makes the material and its effects so hard to grasp, for radioactivity as much as

deep-sea mining, especially in contexts that place epistemological emphasis on the visual.

Environmental humanities scholar Rob Nixon refers to such attritional, temporally and spatially diffused effects as slow violence. Rather than a spectacular event, violence is in this case accumulative, its effects distributed over various temporal and spatial scales.[321] These characteristics make it difficult to discern (modernist) causalities. While invisibility is indeed a powerful paradigm, the atomic tests in Moruroa and Fangataufa were also highly publicized. They were celebrated as achievement of modern science and technology. The reports were not only positive. France also came under pressure from the international community, who criticized the social and ecological effects of nuclear testing. But since the media forms part of the complex of power, it is often harnessed to imperialist ends.

Meaning Making Among Dissolving Causalities

Violence doesn't only occur far away, but also in the very same lands that settler colonialists violently appropriated from indigenous peoples. The Karrabing Film Collective, a group of predominantly indigenous filmmakers, activists, and anthropologists working in the Northern Territory in Australia, address this issue.[322] The collective was founded in response to the Northern Territory National Emergency Response (NTNER) launched by John Howard's government in 2007. The NTNER was criticized for being used to advance colonialist and neoliberal capitalist projects under the guise of helping Aboriginal communities. It introduced reforms to the welfare system that resulted in funding cuts, as well as increased policing and the purchase of urban Aboriginal dwellings by the government, which were removed under the pretext of

[322] The collective currently comprises members Cameron Bianamu, Gavin Bianamu, Sheree Bianamu, Telish Bianamu, Trevor Bianamu, Danielle Bigfoot, Kelvin Bigfoot, Rex Edmunds, Claudette Gordon, Ryan Gordon, Claude Holtze, Ethan Jorrock, Marcus Jorrock, Melissa Jorrock, Reggie Jorrock, Patsy Anne Jorrock, Daryl Lane, Lorraine Lane, Robyn Lane, Cecilia Lewis, Angelina Lewis, Marcia Lewis, Natasha Lewis, Elizabeth A. Povinelli, Quentin Shields, Aiden Sing, Kieran Sing, Shannon Sing, Rex Sing, Daphne Yarrowin, Linda Yarrowin, Roger Yarrowin, and Sandra Yarrowin.

323 "National emergency response to protect Aboriginal children in the NT," report on the Australian government website (June 21, 2007), https://formerministers.dss.gov.au/3581/emergency_21june07/.

324 "Lowered Incarceration rates," The Monash University report, https://www.monash.edu/law/research/centres/castancentre/our-areas-of-work/indigenous/the-northern-territory-intervention/the-northern-territory-intervention-an-evaluation/family-violence-and-child-abuse.

325 Calla Wahlquist, "Northern Territory intervention 'fails on human rights' and closing the gap," *The Guardian* (February 7, 2016), https://www.theguardian.com/australia-news/2016/feb/08/northern-territory-intervention-fails-on-human-rights-and-closing-the-gap.

326 "Northern Territory Emergency Response (NTER) – 'The Intervention,'" *Creative Spirits*, https://www.creativespirits.info/aboriginalculture/politics/northern-territory-emergency-response-intervention. Harvey J. Sindima, *Introduction to Religious Studies* (Lanham: University Press of America, 2009), 143. Veronica Strang, "Conceptual Relations," 192.

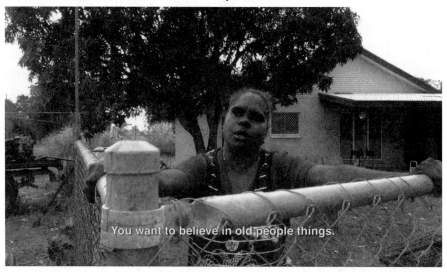

Karrabing Film Collective, *Wutharr, Saltwater Dreams*, 2016. Video, color, sound, 29:00 minutes. Courtesy of the artists.

safer housing policies.³²³ The NTNER led to the highest rate of indigenous incarceration in a decade.³²⁴ It was harshly condemned for its violation of human rights, while the stated goals, such as improving literacy rates, were not achieved and the unemployment rate rose.³²⁵ Furthermore, the NTNER made it easier for miners to get access to indigenous lands, not least because reductions of social welfare benefits increased the pressure on clans to avail their land to mining companies.³²⁶

The Karrabing Film Collective is dedicated to producing counter narratives to dominant histories, making films that highlight specific histories and moments of struggle that resonate with the members' everyday life in a settler-colonial society.

332 "ISA's secretary-general visits tonga to discuss progress undertaken for the sustainable development of deep seabed resources in the pacific," ISA website (February 15, 2019), https://www.isa.org.jm/news/isa%E2%80%99s-secretary-general-visits-tonga-discuss-progress-undertaken-sustainable-development-deep and "Pacific Island Governments Cautioned on Seabed Mining," The Maritime Executive (February 12, 2019), https://www.maritime-executive.com/article/pacific-island-governments-cautioned-on-seabed-mining.

333 "Pacific Island governments cautioned about seabed mining impacts" PIANGO website (February 14, 2019) http://www.piango.org/our-news-events/latest-news/2019/pacific-island-governments-cautioned-about-seabed-mining-impacts/.

The workshop was used as a platform to ostensibly build capacity regarding mining in international waters, but also to lobby for mining in national waters. Note that the workshop was supported by the UN. PIANGO executive director, Emele Duituturaga, who participated in the workshop, offers a sharp critique: "This workshop is pedalling deep sea mining to our governments but who will benefit? If mining was the panacea to the economic issues of the Pacific, we'd have solved all our problems long ago. Instead the environmental and social impacts of mining have made our peoples poorer."[333]

Climate change is present in data and numbers and manifests in quotidian experiences. As the oceans flood some places while others wither in draught, we need to consider the material dimensions of the ocean. To develop a more nuanced understanding of the discursive-material process that is ocean exploitation, we need to intersectionally acknowledge the relations of domination, submission, and solidarity at play in the oceans, as well as the embodied and political-economic conditions the oceans affect and are shaped by. And we need to include nonhuman actors in these conversations as well, both organic and inorganic, both alive and not.

Material-Discursive Oceans

334 Geontopower is "a set of discourses, affects, and tactics used in late liberalism to maintain or shape the coming relationship of the distinction between Life and Nonlife." Povinelli, *Geontologies: A Requiem to Late Liberalism*, 4.

335 Catherine Clement and Julia Kristeva, *The Feminine and the Sacred* (New York: Columbia University Press, 2001), 13.

336 "Biopower (the governance through life and death) has long depended on a subtending geontopower (the difference between the lively and the inert)." Povinelli, *Geontologies: A Requiem to Late Liberalism*, 5.

337 Ibid.

Povinelli puts forth the term and concept "geontopower"—contrasting components of nonlife (geos) and being (ontology)—in an attempt to expand and update Foucault's notion of biopower. If biopolitics govern through life and death, geontopower regulates relations through a discriminative distinction between life and nonlife.[334] Today, power does not only hinge on the categorization of *bios* ("the life to be told, capable of being written"[335]) and *zoe* (bare life, stripped of its meaning to organs and zoological life which can be cashed in on and exploited). In the geontopolitical age, power is obtained through ontologically drawing and cementing distinctions between that which is alive, and that which is not. While this is not a new development of the twenty-first century, it is becoming increasingly obvious as of late.[336] Today, this form of power through separations is growingly evident across the globe and urgent for us to comprehend, as we face a planetary crisis.

If geontology is a Western construct that measures all existence by whether it is alive or not, it also judges people by their ability or willingness to adopt the same distinguishing measures. These include Western divisions between humans and nonhuman animals, who are both alive, but valued differently (and some humans are valued and treated differently than others), and insentient objects, which are not considered alive.[337] If people's cosmologies are not congruent, like cultures that don't differentiate in the same way between living things with agency and nonliving things without intentionality, it is used as a basis and legitimation to dismiss them as premodern. This includes the relationship to land and

338 "materialization is an iteratively intra-active process whereby material-discursive bodies are sedimented out of the intra-action of multiple material-discursive apparatuses through which these phenomena (bodies) become intelligible." Barad, "Getting Real" 108.

339 The epipelagic, or sunlight, zone, extends from the surface 200 meter deep. The mesopelagic zone, also known as twilight zone, is located between 200 and 1000 meters. The bathypelagic midnight zone lies between 1000 and 4000 meters; the abyssopelagic zone, or abyss, between 4000 and 6000 meters; and the hadalpelagic zone, or trenches, reach from 6000 meters to 11000 meters at its deepest.

sea, which in many communities is not considered insentient or empty, but imbued with agency.

A focus on materiality, not as separate but as part of discourses and apparatuses of observation that bring it about, and thinking life and nonlife together, can be useful to better grasp the scope and stakes of climate change and in particular how it affects the oceans.

Seawater

Barad shows us that the technologies with which we observe material-discursive phenomena intra-act with them. They materialize in a process of mutual emergence.[338] We've explored the macro perspective of how the oceans have been conceived throughout history. In order to grasp what is at stake in ocean prospecting and how such endeavors are construed, let's zoom in on the micro level of intra-active processes.

Water is material-discursive. Far from simple, water is a complex, active compound. On average, seawater consists of 96.5 percent water and 2.5 percent salts (chloride, sodium, sulfate, magnesium, calcium, and potassium). One percent is made up of other substances, including atmospheric gases, microscopic particle matters, and dissolved organic and inorganic materials. At different depths, seawater may include plankton, mix with sediments swirled up by currents near the ocean floor, or sea creatures burrowing holes or interacting in different ways.

Depending on levels of pollution and other factors, there are fewer or more micro-organisms such as plankton present in the water. Oceanographic convention divides the ocean into five different layers, from the sunlit surface to the deepest parts, which is, at the moment, the Mariana Trench off the Japanese coast, at a depth of 11000 meters.[339] Seawater moves and cannot be contained in the same spot. Philosopher and archaeologist Alison Wylie writes: "Waves propagate and interact even in the simplest of circumstances. […] Waves are

generated in many different ways: by river or tidal currents, by snags and obstructions under water, by wind and by traffic on the surface, and, on rare and catastrophic occasion, by grinding shifts in tectonic plates."[340] Even the boundaries of the ocean shift constantly. They depend on and interact with the surrounding material and realities including their networks of connection.

Anthropologist and science studies scholar Stefan Helmreich shows how water is conceived as that which moves faster than culture. In the nature-culture divide, the latter is grounded in land, and in European practices of agriculture. Water is channeled through dams, and when it inundates them threatens to overflow such cultured divides.[341] Rising sea levels in Kiribati, the Maldives, Bangladesh, and Miami are pertinent examples.[342] Cultural attempts to channel water, to fights its "otherness" as that which floods (cultured) land with its established boundaries and agri*cultural*, commodified, terrains, further highlight conceptions of the ocean as a non-cultured other. As that which moves faster than land, it threatens fixity and needs to be contained.

Saltwater is a conductor of electricity, the freely floating salt ions pulled apart by water carrying electricity through it. Seawater has a higher density than non-saline water. Its boiling point is higher and its freezing point lower. When it dries up the salt crystals clump together, yet salt is hygroscopic and absorbs water vapor from the surrounding air, liquidized

340 Alison Wylie, "Afterword: On Waves" in Pamela Geller and Miranda Stockett, ed., *Feminist Anthropology: Past, Present, and Future*, (Philadelphia: University of Pennsylvania Press, 2006), 167–176, 173.

341 Stefan Helmreich, "Nature/Culture/Seawater," *American Anthropologist*, vol. 113, issue 1 (2011): 132–144.

342 In a very obvious way, we can already see how this is true. The example of rising sea levels poses a huge challenge to established laws, and proves that naturalized laws are overturned, being affected by the continuous flow of matter. In a meeting of the International Lawyers Association in Lopud, Croatia, in 2017, Davor Vidas, David Freestone, and others discussed the challenges of sea level rise. They mostly affect small island states, or great ocean nations, like Kiribati, but also cities like Miami, Venice, and New York. The questions expand beyond the legal dimensions. For instance, for islanders in Fiji, the spiritual and cosmological worlds are closely connected to the material world. Creation myths refer to a specific sand bank, and if it is submerged in water, the changed landscape will affect the mythologies and systems of knowledge.

343 Apparent abstractions are also the base upon which quantifying modes like fishing quota are developed. While it is perhaps the most practicable tool currently available to limit overfishing, such definitions and restrictions by quota presuppose an isolable cause-and-effect relationship. To this end, living entities are spoken about in terms of mass, not as specifics, not as specific fish, but a biotic bundle of foods or other commodities.

once again. Saltwater with higher salinity is beneficial to coral growth, while lower salinity, along with higher temperatures, diseases, and storms, can lead to bleaching. Saltwater is sticky, it smells, and we can taste it. As such, seawater infringes the modernist paradigm of the retinal, the distant from the body, immersing us in the transversal nexus of particles, compounds, and processes of changing aggregates. It is prone to overflow, it trickles through our hands, it evaporates. It is full of living organisms, a messy reality that is impossible to separate, garden, groom. If air is filled with bacteria, water, with its connective materiality, its stickiness, and its electrical conductivity, overflows categorizations of life and nonlife. They dissolve and become one. Hence, ocean water does not only dissolve cultured boundaries of land, but also divisibility between life and nonlife. In the age of geontopower, water remains an annoyance to modernist attempts at dividing.

Embodied-Material Techniques

Let us return once more to Linke's *Prospecting Ocean*. In the video, we can see how techno-scientific apparatuses are deployed to overcome not only the purported distance between the water surface and the ocean floor, but also to divide life from nonlife. The ROV retrieves a specimen from the seabed and isolates it from its surroundings. It seems as if the sample taken from the deep sea can be studied separately from its surroundings, and that the effects of its absence from the ecosystem it formed part of, are insignificant. The modernist idea that knowing is isolable from its specific material context is incontestably present in these scenes.[343]

Looking more closely to the video rendering and animation produced by Nautilus can provide us with further clues to how materiality is often forgotten. An analysis of the

344 Keller Easterling, "Active Form" in Dana Cuff and Roger Sherman, ed., *Fast Forward Urbanism* (New York: Princeton Architectural Press, 2011).

345 Lewis Mumford, *The Myth of the Machine (Vol. I): Technics and Human Development* (New York: Harcourt, 1967).

visual culture present in this video provides a vantage point from which it becomes evident that we need to attend to the viscosity and sticky materiality of things, with their living-nonlivingness, rather than their smooth and disembodied abstractions. The video shows the disturbances of the seabed as negligible: I describe above that the seabed is flattened by the machines, and this is pictured in the animation as an effortless operation. Amplified by the basic computer-generated imagery (CGI) renderings, the seabed sediment seems to recede from the machines before they even touch it. While this is possibly due to technological restrictions in visualization and the financial resources allocated to the promotional video, it seems that clear emphasis lies on depicting the machines as reliable and advanced. The environment, in contrast, is rendered as an abstract and lifeless background, a stage without proper characteristics of its own, against which the agency of human will unfolds in the form of exploitation.

This video is typical for the rhetoric and conceptions surrounding ocean extraction and mining operations, in which a conceptual, possibly purposeful, blindness toward the overflowing, uncontainable, and very material effects is in play. While the worth of the extracted material is made measurable on the market, spurring the extraction endeavors in the first place, the remaining sediment, that which could be measured but has been deemed worthless in financial terms, is stripped of its vitality and of its connection with any other "assets." The conditions making these gross misconceptions possible hinge, to come back to geontopower, on the separation of life and nonlife as marker and divider.

What happens to these resources when they are dis-embedded, and how does this change the material conditions of place as well as the relationships between things, "object forms," and "active forms"?[344] Historian and philosopher of technology Lewis Mumford speaks of the "megamachine"[345]

346 Lewis Mumford, *Technics and Civilization* (Chicago: University of Chicago Press, 2010).

347 Ibid., 9.

348 Jussi Parikka, *A Geology of Media* (Minneapolis: University of Minnesota Press, 2015).

of mining to discuss how (land-based) mining developed alongside modern capitalism to become fully established by the sixteenth century.[346] Mumford refers to the moment when nonorganic technological inventions came to exert increasing impact on nature as the paleotechnic age. "Machines have developed out of a complex of non-organic agents for converting energy, for performing work, for enlarging the mechanical or sensory capacities of the human body, or for reducing to a measurable order and regularity the processes of life."[347] The shift from "paleotechnics"—the locomotive, the coal mine, the steamship—to "neotechnic" automation—modern cotton spinning, automatic machines such as the bottle maker or the automatic stoker—was a further development, speeding up and making more efficient processes that were in need of significant capital investments, which in turn contributed to the furthering of the technological inventions.

Media theorist Jussi Parikka refers to these new infrastructures as weaving Earth, labor, and the technological together.[348] Yet, as metallurgy and other technological advancements enabled extraction, they are still reliant on the materiality of the assets they extract. If complete automation or independence of material processes has not yet occurred for land-based extraction, the same is true for the sea. We rely on the material conditions and processes, on the mineral geology, of the Earth. The rush for the minerals targeted in deep-sea mining is a sign of the advancements in our technologies and the increasing demand for more. Mining is capital-intensive and it is spurred by ever greater need for the mineral legacies of the geological past, resulting in higher demand for rare earths to further advance our technologies.

A tool is not only the technology or object, but the moral, economic, and political choices that bring it into being. As such, we must understand the effects of deep-sea mining that tools have enabled both in an immediate way, defined by sediment being moved around, but also in the way that these interventions will change moral, political, and cultural positions. In addition to questions of space and place, the temporal aspects must be considered. Parikka speaks of the

349 James J. Gibson, *The Ecological Approach to Visual Perception* (Hillsdale: Lawrence Erlbaum Associates, 1986): 127.

350 McKenzie Wark, "A Geology of Media: On Jussi Parikka," *Public Seminar* (February 27, 2017), http://www.publicseminar.org/2017/02/parikka/.

351 Giuliana Bruno, *Surface: Matters of Aesthetics, Materiality, and Media* (Chicago: The University of Chicago Press, 2014), 2.

352 Ibid.

353 Cultural theorist Claire Colebrook contends: "The political appeal to *materialism* is always twofold: we must both recognize how bodily life has unfolded historically to produce certain relations, and we must acknowledge that freedom from those relations requires recognition of our materiality." Claire Colebrook, "On Not Becoming Man" in Alaimo and Hekman, ed., *Material Feminisms*, 63.

deep-time of media, in terms of the metals that are utilized to create technologies and the effects they in turn impose on our ontologies and epistemologies. Deep time includes the geological "affordances"—what the environment "*offers* the animal, what it *provides* or *furnishes*,"[349] but is also enabled by organic-inorganic processes. Media theorist McKenzie Wark refers to this as three natures: first, what is commonly perceived as "nature," the second nature created by processes of collective human labor through history, and a third nature of information.[350] The three natures are closely intertwined and co-affect, or afford, each other.

Technologies cannot be disentangled from the geological and biological entities and processes that bring them about. In considering the intermingling between geological materials and technologies, enabled by their affordances, in the words of visual cultures scholar Giuliana Bruno "there is potential for a reinvention of materiality in our times [..., which] is visibly and actively pursued in the arts."[351] According to Bruno, materiality is about relations and how they bring about, and imprint themselves, through different media.[352] Acknowledging these relations and how they have brought about living and nonliving entities, we can work toward undoing the hierarchical order implicit in such separations, and think them together.[353]

This applies also to how "nature" reacts to disembeddings. Extraction produces new material-discursive conditions, which cannot be separated from the particular ecosystem from and with which they emerge. We have seen that we need to conceive of sites such as the seabed as active.

[354] Elizabeth Grosz, *Architecture from the Outside: Essays on Virtual and Real Space* (Cambridge: MIT Press, 2001).

[355] Haiven, "The Dammed of the Earth," 215.

They cannot be understood as an abstract resource, but they act on the technologies of extraction, on discursive-material conditions, on numerous nonhumans, and on us. As much as divisions of life and death, or life and nonlife, don't work, we can't extract ourselves from the affordances of matter.

The Seabed as an Architectural Complex

If deep-sea mining is changing the topology of the seabed, producing wider resonating effects, we can speak of it as a form of architecture. Feminist theorist Elizabeth Grosz argues that we need to rework the apparent divide between human-made architecture and nature.[354] As long as we consider architecture as a cultural paradigm, "nature" and affordances upon which it relies remains unacknowledged and the nature-culture divide is reinforced. In thinking of nature as exceeding the passivity of a resource, we retire notions of it as a non-agential other.

If views of nature and architecture as human-made constructs cannot be thought apart, and we need to even consider a third nature of information atop and intertwined with the first two, then we need to understand extraction such as seabed mining as producing new nature-cultures. Marks in the ocean floor, as we have seen with the example of the DISCOL project, are cultural complexes, architectural expansions of human impacts on the ocean floor. The definition of architecture could also be expanded to the molecular level, as in human creations of nuclear fissions as an intervention in the molecular architecture. Seabed interventions are, like "architectural" interventions on land, exercises of power, physical and ideological. Helmreich discusses how humans' conception of water is channeled through dams. Max Haiven considers dams as "fundamentally *cultural* edifices: not only do they organize waters but they organize meanings and relationships."[355] Dams, like seabed interventions, are architectural in that they impose human-propelled changes in their surroundings. Their social effects are comparable too.

Artist Carolina Caycedo traces the environmental, social, and political effects of damming, and shows that we cannot

think them apart. Her project *Be Dammed* (ongoing since 2012), consists of moving-image essays, drawings, sculptures, performances, and direct actions. I saw an iteration of it at the 32nd Bienal de São Paulo in 2016, where the artist discussed the privatization of water and in particular the Bento Rodrigues dam in Minas Gerais, Brazil. The dam's failure on November 5, 2015 resulted in a flooding that killed nineteen people and had disastrous effects on nonhumans and land as well. Beside forceful displacements, mainly of indigenous people in the area, the corporations behind the dam's construction promised the creation of jobs, which disappeared when the dam was completed. On top of the ecological disaster, the dam also meant economic disaster. We can draw analogies between dams and seabed mining both in terms of their disastrous effects and through their architectural interventions. When thought as architectures, they allow us to look at the dissolving boundaries between natural environments and culturally built ones, and at the compound of biology-geology-technology.

Aquatic Bodies that Matter

In the seabed, as in many other places—the radioactive Pacific, land-based mines, a tsunami wave—the biological and the cultural seep into one another. Life and nonlife in the Anthropocene can no longer be kept apart. The solvency between natural and cultural bodies, both life and nonlife, is evident in Susanne M. Winterling's multimedia work *Glistening Troubles* (2017), which I showed in the exhibition "Tidalectics." The work consists of computer-generated imagery of dinoflagellates presented on flat screens and mirror columns just taller than human average, into which samples of sea organisms cast in transparent epoxy were inserted. On an additional flat screen, an interview with a fisherman in Falmouth, Jamaica, gives insights into the medicinal properties of the algae, which are used by local communities to treat skin diseases. When the algae bloom due to warming waters, they become toxic; Winterling has referred to this as an "alarm system."[356] The algae are known to light up when touched or moved, reminiscent of the touchscreen technologies

[356] Winterling, in conversation with Stefanie Hessler, Hamburger Bahnhof—Museum für Gegenwart, Berlin, October 28, 2017.

357 Barad, *Meeting the Universe Halfway*, 392.

358 Stacy Alaimo and Susan Hekman, "Introduction: Emerging Models of Materiality in Feminist Theory" in Alaimo and Hekman, ed., *Material Feminisms*.

surrounding us today. The mirrors include the viewer in the work, and conflate the worlds of the computer-generated algae and the human bodies within the same image plane. As such, they point to what Barad refers to as "having-the-other-in-one's-skin."[357] Becoming sensitized to our coexistences, or in fact co-constituency, with other organisms is political. Alaimo and feminist political scientist Susan Hekman suggest that in turning to materiality and its emerging relations, we can form new alliances that are not predefined by social groups.[358] We can neither extricate individuals from these webs of relations, nor reduce them to personal relationships.

Throughout the book, we have seen how framing and borders are modernist constructs. They fail epistemologically and overflow ontologically. Modernist views attempt to dam such overflows. And rather than treating them as accidental, we should think of their permeability, or viscous porosity, as a setup through which we can negotiate our onto-epistemologies with others, both human and nonhuman, both alive and not, in the Chthulucene.

Susanne M. Winterling, *Glistening Troubles*, 2017, Mixed media and CGI installation (detail). Thyssen-Bornemisza Art Contemporary Collection. Image courtesy of the artist. Photo: Jorit Aust.

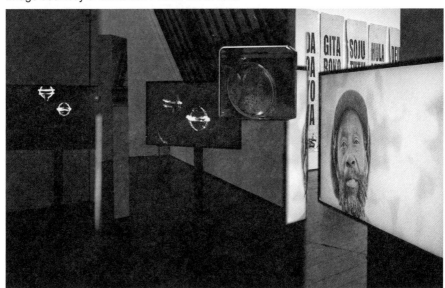

368 Marjolijn Dijkman and Toril Johannessen, *Reclaiming Vision* (2018), 26:37 minutes, scene at 00:09.

369 Bennett, *Vibrant Matter*, 20.

370 Jane Bennett, "The Force of Things: Steps toward an Ecology of Matter," *Political Theory*, vol. 32, no. 3 (June 2004): 347–372, 349.

sample and the particles on view. What we see are not only "organic" organisms, but also particles of cleaning agents, oil, pigments, and microplastics. In the final credits, they are listed among items such as the microscope or a microneedle. Just as apparatuses evolve along with the phenomena they observe, here the viewed is also affected by the technologies and methods to view and record it.

The artists explicitly state in a text preceding the video that any resemblance to scientific research is coincidental.[368] This is both a tongue-in-cheek gesture and an attempt to liberate from the grips of science the patterns of use implied in its technologies. The artists scrutinize the aesthetics of science, the tools used, overlaid with the soundtrack of music, often considered one of humans' most "cultured" achievements. For example, in a scene about halfway through the video, the organisms and other particles are given a background, a grid, as if to measure the distance they travel and their patterns of behavior. The use of the grid and measuring device is also a comment on the tendency of science to quantify, discipline, and regulate the overflowing liveliness of matter. With the video, Dijkman and Johannessen cast away ideas of scientific objectivity and distance, showing in a direct way how the pipette intervention changes the scene. The organisms that are observed are far from passive. Their agency matters, vibrantly. Cleaning substances and microorganisms co-affect each other, changing each other's chemical composition and behavior. So do organisms among each other. The liquid hybrids squirt over the material of the apparatuses on view. They affect not only the material technology, but also their "culture," or the primary way they were devised for scientific use.

Reclaiming Vision shows the dance of what Bennett calls vibrant materiality, "as much force as entity, as much energy as matter, as much intensity as extension."[369] Bennett's thing-power "focuses on energetic forces that course through humans and cultures without being exhausted by them."[370] It allows us to better grasp, if always partially, the myriad of multiscalar connections with other human and nonhuman

371 Stacy Alaimo, "Oceanic Origins, Plastic Activism, New Materialism at Sea" in Serenella Iovino and Serpil Oppermann, *Material Ecocriticism* (Bloomington: Indiana University Press, 2014), 186–203, 187.

372 Chen, "Mapping Waters," 276.

373 Sylvia Earle, *Sea Change: A Message of the Oceans* (New York: G.P. Putnam's Sons, 1995), 15.

bodies, and with nonlife. It allows us to conceive of kinships and repulsions between things we don't usually consider together, without subduing their specificity. In Dijkman and Johannessen's video, these alien qualities don't stop being strangers to each other, but they become intimate strangers within. As such, they go beyond notions of the posthuman and dissolve the distinctions of life and nonlife.

Transcorporeal Sea

In the artworks I mention, the oceans are presented as a particularly rich realm to discuss bodies that are not either/or but many at once. Alaimo's trans-corporeality, "a new materialist and posthumanist sense of the human as perpetually interconnected with the flows of substances and the agencies of environments,"[371] is useful here. From this perspective, we can begin to let go of conceptions that portray overflows as accidents, and messy ecotones as impure, but consider them as both necessary and the rule. Water is a "responsive and promiscuous solvent."[372]

We come from the sea, and our bodies still carry the oceans in them. Marine biologist and activist Sylvia Earle connects the distant evolutionary past with the immediacy of living human bodies when she writes, "Our origins are there, reflected in the briny solution coursing through our veins and in the underlying chemistry that links us to all other life."[373] This doesn't only throw the question of how we change the oceans into relief. If we still carry the sea in us, and if our livelihoods depend on it, how do the discursive materialities of plastic, radioactivity, and other pollutants in the sea also transform us? Once we acknowledge our second bodies, in the words of Hildyard, which don't end with our skin, and we understand ourselves as "bodies of water," as Neimanis has it, we can begin

to fathom modes of being that don't frame bodies as discrete entities in the political, patriarchal, and medical-industrial complex. Boundaries of bodies disappear as much as divides between organism and environment, and life and nonlife.

In thinking the ocean's materiality as transcorporeal in Alaimos's sense, co-emerging with evolving discursive, ideological, political, and economic conditions, we can see how it defies complete normalization and categorization. Its unfixed materiality poses resistance to notions intended to grasp and shape it in its entirety. Even though such attempts persist, water stays elusive to their all-encompassing grip. Biological mutations, anthropogenic toxins as well as climate change counteract normalization. The algae blooms that Winterling addresses in her work, and the chemicals that Dijkman and Johannessen focus on, are but two examples. I don't want to romanticize toxicity and the likes, but direct our attention to the agency of water and of material agents that are both nonhuman and not necessarily alive. In acknowledging their presence and that of the (sometimes human-made) effects on the oceans and by extension on us, we can sharpen our ways of noticing the processes at work. Doing so may help us to devise ways of thinking and being for a posthuman oceanic Anthropocene.

The New Ocean Frontier Is Closing In

Before leaving this sea of thought, I want to offer a critique of the new frontier rhetoric, to tend to the oceans as far beyond our urges for control and exploitation. If we can rid ourselves of the new frontier illusion, perhaps we can finally grasp that we are neither outside of nature, nor unaffected by its changes. Nor are we, the unfairly contributing and benefitting Anthropos, the sole drivers of change, but we need to consider the numerous multiscalar and multicausal overflows as they dissolve old framings.

Throughout this book, the new frontier rhetoric has haunted us, from the deep-sea mining endeavors criticized in Linke and Rave's works, to an ever-larger overview granted by space travel discussed in Charles and Ray Eames's and Rose's videos, to the territorial claims grappled with in Geocinema's sutured moving images, and the violence of settler colonialism in the Karrabing Film Collective's video essays.

The new frontier rhetoric is indeed a recurring one, from the Gold Rush in nineteenth-century Australia, Brazil, and the

United States to the Space Race and recent moves toward deep-sea mining.³⁷⁴ In fact, Steinberg shows that conflicts about ocean space and airspace are analogous.³⁷⁵ We've further looked at the colonialist tendencies in the hurries for land grab, which now also extends to ocean space. Often depicted as a battle of civilization against uncivilized land and sea, the scopic regime and material-discursive processes have supported this expansion with depictions of the oceans as monstrous Leviathan, which is still just one of many examples.

Frontiers are complicated, they are "uneasy places."³⁷⁶ They are ecotones where binaries such as nature and culture or us and them reveal themselves as deeply flawed. Frontiers are zones where notions of race, gender, and nationalism are amplified and complicated through claims of expansion and possession. As historian Patricia Nelson Limerick shows, frontiers and the rhetoric surrounding them are both "ethnocentric and nationalistic."³⁷⁷ Tsing refers to frontiers as "an edge of space and time: a zone of not yet."³⁷⁸ They are places in the making, and in this making they produce violence. Appropriation and subjugation also changes the colonizer, casting unstable ideas of fixed identity. Spurred by the attempt to continuously move them forward, frontiers conjure dreams as much as they garner fear. We have seen earlier that landscapes

374 In his July 15, 1960 acceptance speech of his presidential nomination, John F. Kennedy said: "We stand today on the edge of a New Frontier—the frontier of the 1960s, the frontier of unknown opportunities and perils, the frontier of unfilled hopes and unfilled threats. [...] Beyond that frontier are uncharted areas of science and space, unsolved problems of peace and war, unconquered problems of ignorance and prejudice, unanswered questions of poverty and surplus." https://www.jfklibrary.org/about-us/news-and-press/press-releases/50-years-ago-senator-john-f-kennedy-of-massachusetts-wins-presidential-nomination-at-democratic-nat.

375 Steinberg, *The Social Construction of the Ocean*.

376 Tim Sherratt, "Frontiers of the Future: Science and Progress in 20th-century Australia" in Deborah Bird Rose and Richard Davis, ed., *Dislocating the Frontier: Essaying the Mystique of the Outback* (Canberra: ANU Press, 2005), 121–142, 129.

377 Patricia Nelson Limerick, *The Legacy of Conquest: The Unbroken Past of the American West* (New York: W. W. Norton & Company, 1987), 21.

378 Tsing, *Friction: An Ethnography of Global Connection*, 28.

379 On historian Frederick Jackson Turner's controversial frontier thesis from 1893, without wanting to go so much into these parallels: "Turner's frontier thesis, in this respect, had two functions. First, it served as a legitimisation and celebration of the processes of American colonisation and the dispossession of the lands of indigenous peoples. […] Second and more significantly, Turner's frontier thesis, having established the legitimacy of settlement and dispossession, then idealised the agrarian past while crystallizing growing public concerns about the future of the nation." Elizabeth Furniss, "Imagining the frontier: comparative perspectives from Canada and Australia" in Bird Rose and Davis, *Dislocating the Frontier*, 26.

380 Harvey, *Spaces of Global Capitalism*, 88.

381 Peter B. Larsen, *Post-Frontier Resource Governance: Indigenous Rights, Extraction and Conservation in the Peruvian Amazon* (New York: Palgrave Macmillan, 2015), 2.

need to be considered as dynamic and overlapping, and defined by human reach rather than geography alone.

Frontier rhetoric aggravates the supposed separability of an inside from an outside, in which that which lies beyond the frontier is supposed to be made a part of it. If the objective of the frontier ever became accomplished, it would lose its function. The notion of the frontier is not aimed at satisfaction, but at ever farther expansion.[379] Yet, if we are deeply entangled with the material-discursive entities surrounding us, then the rhetoric of a new frontier becomes ever more contradictory and untenable. It presumes that there is a beyond which can be incorporated into "our" world, a world at our disposal for dispossession by accumulation, for extraction. In Harvey's words, "In transforming our environment we necessarily transform ourselves."[380]

If we want to laud the widespread evolution of sustainability discourse in recent years, we mustn't forget that these are also products of globalization, and sometimes part of the very problem. Environmental governance researcher Peter B. Larsen uses the term "post-frontier" to describe "the host of new regulatory technologies, practices and institutions that nominally close, yet more accurately characterize and restructure, contemporary resource frontiers."[381] Even if extraction is continually advanced, the language accompanying it speaks of sustainability, social equity, and environmental protection. Larsen shows how the focus of conferences such as the United Nations Conference on Sustainable Development (Rio+20) in 2012 turned toward positive outcome with formulations such as "mining activities

382 United Nations Sustainable Development Goals Knowledge Platform, see https://sustainabledevelopment.un.org/index.php?menu=1259.

383 Scott and Swenson, eds, *Critical Landscapes*, 201.

384 Steinberg, *The Social Construction of the Ocean*, 180 ff.

should maximize social and economic benefits as well as effectively address negative environmental and social impacts."[382] The ISA's language to push for deep-sea mining is very similar. Such conceptions ignore the material-discursive constructions of "resources," and their embeddedness in a larger network of deep entanglement. They further romanticize notions of prehistoric landscape in the same way that people living in supposed harmony with them are exploited and fetishized. They are proof of the greenwashing Scott and Swenson outline as a publicity strategy "that promotes a false image of reversible environmental damage and preservationist ethics to market everything from petroleum to dish soap."[383]

With regard to seabed mining in the area of the high seas which is defined as beyond national jurisdiction and set aside as common heritage of mankind, extraction is frequently presented as a way to redistribute financial gains to developing countries.[384] However, countries such as the USA during Ronald Reagan's administration or Margaret Thatcher's UK opposed any such regulations of free-market capitalism, which is one of the reasons why the US has still not signed UNCLOS. And, as we have seen, the benefits are unlikely to reach those mostly in need of it. What's more, the environmental damage will far surpass any positive effects. It is striking that even when listing the positive effects, sustainability discourse does not even entertain the possibility of not mining at all. Instead, we find ourselves jumping ahead to mitigating the effects and maximizing the outcome.

If we are part of the material-discursive entanglements from which extraction pulls, any such attempts, no matter how far removed from the coast or the surface of the oceans, also change ourselves. Pushing ahead for a "new frontier" means pushing toward our own eradication, besides that of many other organic and non-organic lifeforms. This is true for the macro level of rising sea levels, which threaten the existence of entire geographical regions above water, as much as for microscopic scales. If the distinctions between life and nonlife regulate relations today, we will soon return to a situation of nonlife, or "lifelessness."[385]

385 Povinelli, *Geontologies: A Requiem to Late Liberalism*.

386 Alaimo "Oceanic Origins," 187.

387 Serenella Iovino and Serpil Oppermann, "Material Ecocriticism: Materiality, Agency, and Models of Narrativity," *Ecozon@*, vol. 3, no. 1 (2012): 79–80.

388 The dilemma Andrew Biro refers to: "[C]an we claim that appeals to nature are always in fact appeals to culturally specific ideas of nature, and yet still maintain an ecologically grounded defence of nature?" Andrew Biro, *Denaturalizing Ecological Politics: Alienation from Nature from Rousseau to the Frankfurt School and Beyond* (Toronto: The University of Toronto Press, 2005), 6.

Swim On

The artworks I have drawn from throughout this book consider the ocean as a space which cannot be represented, but which produces its own representations, like a cinematic device, a time-based medium, flowing over the Earth. It registers and, if we treat it right, also dissolves.

I want to end this book by returning to the depths of the ocean, as if our journey with Rachel Carson at the beginning had taken us all the way downward and under to the seabed. Dwelling here in saltwater and muddy sediments, from within their irregular streams, I want to discourage us "from taking refuge in fantasies of transcendence and imperviousness that render environmentalism a merely elective and external enterprise."[386] Such fantasies we can no longer afford.

So, where does this leave us, how do we part ways? I hope that this book encourages readers to construe other narratives, swim with the scientific-poetic writing of Carson, and with the artworks I describe. These alternative stories include perspectives of humans and nonhumans, of nature-cultures, of life and nonlife, dissolving the boundaries of these old binaries. Such "storied matter,"[387] as cultural theorist Serenella Iovino and environmental humanities scholar Serpil Oppermann have it, can create narratives in intra-action with us humans. And as we co-invent these narratives, through art, we can draft new beginnings.

Let's learn to sense ourselves as nature-cultures, emerging with nonhumans as much as with matter. And let's acknowledge the complex specificity of situated and embodied ways of knowing and being, while strategically defending ecological ideas, as this is ever so urgent.[388]

Art can provide a framework that is accessible in ways other than tables and statistics. Let's enrich our stories with speculation, with audacity, letting ourselves be stirred as we go. Let's combine science with art, and thinking with feeling. Let's find small narratives amid the vast sea of data, and perhaps make them grow. Once we think we're done, let's start again. And in the water I feel pressuring on my body, I continue to swim.

Colophon

Stefanie Hessler
Prospecting Ocean

Published by
Thyssen-Bornemisza Art Contemporary
The MIT Press

This publication and Armin Linke's *Prospecting Ocean* film and installation were commissioned and produced by TBA21–Academy with the generous support of Thyssen-Bornemisza Art Contemporary. This book is an expansion of the research for the eponymous exhibition curated by Stefanie Hessler at the Institute of Marine Sciences of the National Research Council of Italy (CNR-ISMAR), Venice, May 23–September 30, 2018.

Editorial Assistant
Eleni Tsopotou

Head of Publications
Eva Ebersberger

Managing Editor
María Montero Sierra

Copy Editor
Orit Gat

Graphic Design
Mevis & van Deursen with Line Arngaard

Printing
Drukkerij Tienkamp, Netherlands

Paper
Munken Lynx Rough 100 g/m
Munken Arctic Matt 115 g/m
Sulphate board 300 g/m

Library of Congress Control Number: 2019935753
ISBN 978-0-262-04327-4
10 9 8 7 6 5 4 3 2 1

Thyssen-Bornemisza Art Contemporary Privatstiftung
Köstlergasse 1, 1060 Vienna, Austria
tba21.org, academy.tba21.org

The MIT Press
Cambridge, Massachusetts
London, England
http://mitpress.mit.edu

Stefanie Hessler's Acknowledgments
My deepest gratitude for the tireless support and the spirit of collaboration to Francesca Thyssen-Bornemisza, chairwoman of TBA21, and Markus Reymann, cofounder of TBA21–Academy, as well as to CAMP (Shaina Anand and Ashok Sukumaran), Lucien Castaing-Taylor and Véréna Paravel, T. J. Demos, Marjolijn Dijkman and Toril Johannessen, Orit Gat, Geocinema (Asia Bazdyrieva, Alexey Orlov, and Solveig Suess), Martin Guinard, Victoria Hindley, Armin Linke and his collaborators (Giulia Bruno, Giuseppe Ielasi, Renato Rinaldo, Kati Simon), Karrabing Film Collective, Yuki Kihara, Sandor Mulsow, Astrida Neimanis, Brittany Nelson, Elizabeth A. Povinelli, Filipa Ramos, Lisa Rave, Helene Romakin, Rachel Rose with Lucie Elwes and Gavin Brown's enterprise, Florian Schneider, Davor Vidas, Susanne M. Winterling, and Daniela Zyman.

Postcards:
Armin Linke, *AWI Alfred-Wegener Institute, laboratory HGF-MPG Joint Research Group for Deep-Sea Ecology and Technology, Bremerhaven, Germany*, 2017. Thyssen-Bornemisza Art Contemporary Collection.

Armin Linke, *Twenty-second session of the International Seabed Authority Assembly, Kingston, Jamaica*, 2016. Thyssen-Bornemisza Art Contemporary Collection.

Back cover: Armin Linke, *Chisholm Laboratory at the Massachusetts Institute of Technology MIT, freezer containing the genome archive of the* Prochlorococcus *bacteria, Cambridge, USA*, 2017. Thyssen-Bornemisza Art Contemporary Collection.

© 2019 the artists, the authors, the photographers, and TBA21–Academy. All rights reserved.
No part of this book may be reproduced in any form by any electronic or mechanical means (including photocopying, recording, or information storage and retrieval) without permission in writing from the publisher.

Exhibition Credits

The *Prospecting Ocean* film and installation were realized in collaboration with Giulia Bruno (camera, editing), Giuseppe Ielasi (sound, editing), Renato Rinaldi (sound), Kati Simon (project direction), Kuehn Malvezzi (architecture), Mevis & van Deursen (graphic design), and additional support from Linke's studio: Nicholas Boncardo De Leo, Elena Capra, Laura Fiorio, Ferial Nadja Karrasch, Sarah Poppel, Martina Pozzan, Elisa Scaramuzzino.

A part of the research was made possible through the project of the *Year of Science 2016*17*— Seas and Oceans, a program of the German Federal Ministry of Education and Research. The exhibition was made possible in collaboration with CNR-ISMAR, and institutions such as GEOMAR Helmholtz Centre for Ocean Research Kiel; MARUM – Center for Marine Environmental Sciences, University of Bremen, and NTNU Norwegian University of Science and Technology.

Armin Linke
OCEANS. Dialogues between ocean floor and water column, 2017
Four-channel video installation, color, sound
Dimensions variable
40:00 minutes, loop
© ROV video archive material: GEOMAR Helmholtz Centre for Ocean Research Kiel and MARUM – Center for Marine Environmental Sciences, University of Bremen
Commissioned and co-produced by TBA21–Academy. Thyssen-Bornemisza Art Contemporary Collection.

Armin Linke
Prospecting Ocean, 2018
Main film: two-channel video installation, color, sound
56:00 minutes, loop
Lectures: two-channel video installation, color, sound
240:00 minutes
Commissioned and produced by TBA21–Academy. Thyssen-Bornemisza Art Contemporary Collection.

Armin Linke's Acknowledgements
Special thanks go to all interview partners, institutions, and to all those who contributed to realize this project, especially to Francesca Thyssen-Bornemisza, Markus Reymann, Stefanie Hessler, and to TBA21–Academy; CNR-ISMAR; Fundació Sorigué, Lleida, Spain; and Armin Linke Studio.